Kurt Schwitters

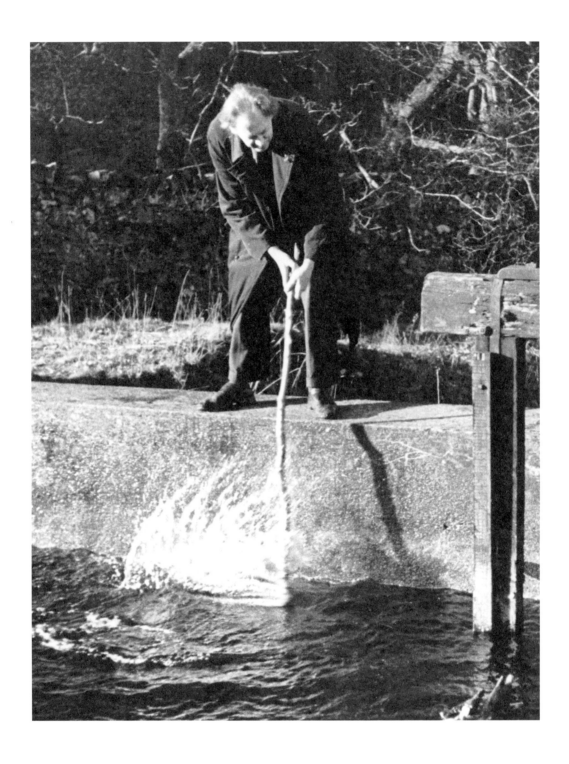

Schwitters in exile
November 1945

Kurt Schwitters

I is Style

With contributions by:
Rudi Fuchs
Siegfried Gohr
Gunda Luyken
Dorothea Dietrich

And texts by:
Kurt Schwitters
Hans Arp
Rudolf Jahns
Georg Muche
Hans Richter
Tristan Tzara

Stedelijk Museum
Amsterdam

NAi Publishers
Rotterdam

Content

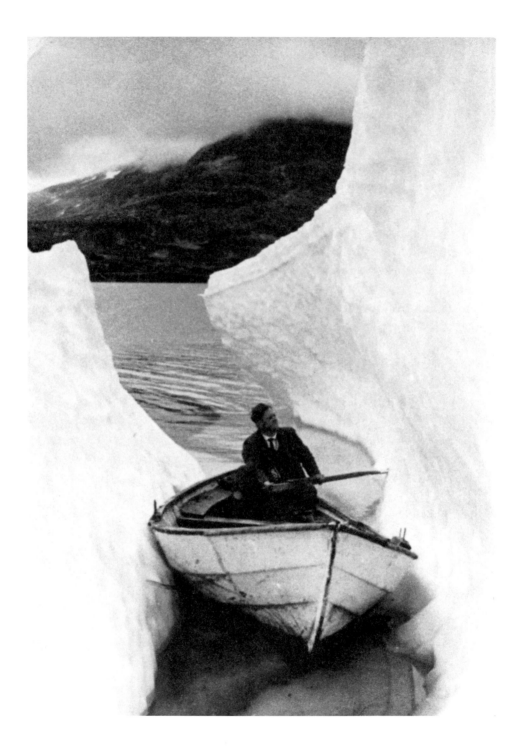

Kurt Schwitters
on the Djupvand
ca. 1935-36

Conflicts with Modernism

Rudi Fuchs

or the Absence of Kurt Schwitters

My title, at least the first part of it, *Conflicts with Modernism*, reflects the extraordinary and almost polemical circumstances in which present art seems to find itself. Within the body of artists, critics, scholars and other enlightened observers there has always been discussion about artistic and aesthetic issues that confronted and challenged the art of a particular time. In some historical periods and places, like the early Renaissance in Tuscany, there was sufficient consensus about the general purpose of art (it had to embellish and instruct) for the theoretical debate to be on a particularly high and detached intellectual level. But when the consensus slowly withered away, and when during the course of the nineteenth century the classical tradition was no longer able to maintain its normative authority, the tone and method of the artistic debate began to change. It rapidly became more intense, more critical and also more apodictic. It was then that whole movements began to be rejected and damned before they had barely appeared and even before a single individual picture had been discussed. This happened to Impressionism, to Fauvism, to Cubism – to every movement really – and such forms of summary execution continue to the present day. In most cases the rejection was only short-lived. The moment an art movement was rejected, by public uproar or by conservative critics, who then and now invariably claim to defend the *real* values of art, defenders also appeared on the scene, likewise claiming to defend the *real* values of art now seen from a modern and contemporary point of view. The characteristic fact of the twentieth century is that we have come to see art in terms of artistic argument and conflict.

There is little doubt that the circumstances of the contest in

which art is perceived tend to damage the precision and sensitivity of the critical judgement on the quality of *individual* words of art. Grand debates, such as the conflict between the abstract and the figurative, always end in ideological argument. Quite often the sharpness of the ideological argument obscures the physical evidence of the individual painting, which frequently is much less unequivocal than theory would want it. The argument then constitutes a screen through which certain qualities in art are superbly visible while others are obliterated.

The situation in twentieth-century art has become so critically tense (or perhaps one should say, so lively) because, in the absence of the common ground of tradition, the individual artist or each distinctive group of artists who are in sympathy with each other's purpose, has had to stake out his own ground and then defend that singular individual position. That at least, is the situation *in principle*. In reality, points of view on matters of style and artistic approach often merge, forming, if not a tradition then at least, a general aesthetic direction. Consequently, the situation is never completely clear and linear. At the centre of all this, however, that grand figure remains almost untouched: the individual artist as master of his own imagination, who claims to be unique. As the contemporary artist lives his life in spiritual argument with other art, everybody around him or her is tacitly urged to take sides. The traditional pluralist position of criticism and of the museum has become suspect and the schematization of aesthetics has now, finally, led to a very odd notion: that there are *right* pictures and that there are *wrong* pictures and that you have to be very careful as to where your allegiance lies.

It is altogether possible that a late fifteenth-century painter in Florence may have disliked the paintings of a Venetian contemporary simply because they were different from his own. That form of mild competition is far removed, however, from the more present situation in which, for instance, Donald Judd, an artist I hold in the highest esteem, flatly rejected the art of Georg Baselitz, an artist I hold in equally high esteem. Here we encounter an aesthetic conflict of an entirely different order. Judd said, in effect, that his work is right and that the work of Baselitz is wrong. How, I want to ask, can such an absolute judgement come into being? Most likely

Judd would deny that his rejection of the art of Baselitz was inspired by certain artistic assumptions that are embedded in the American description of Modernism. I believe that he had much too fine a mind to succumb to coarse forms of aesthetic chauvinism. He simply said that, in his view, Baselitz's work is just bad painting, as painting goes. That leads, however, to the question of how this view is constructed.

It is not a conflict between an American and a European artist; that would be altogether too vulgar. But what it *does* involve, however, is a particular American interpretation of twentieth-century artistic developments that have certainly also informed Judd's notion of radical art. In a famous, if not notorious interview in 1967, Judd and Frank Stella discussed, among other things, the state of European art. They found very little to agree on, apart from Yves Klein. One of the things they talked about was the so-called figure-ground relationship in painting, which Europeans had not been able to solve as radically as American artists had, beginning with Jackson Pollock and Barnett Newman. The implication of their remarks was that they believed that truly advanced art had to be abstract or at least somehow observe the 'rules' of Abstract Art as did the Pop artists. This was an observation that by then was fairly common to the definition of the central issues in Modernist art. The greatest American critic, Clement Greenberg, identified Cubism as the most powerful and effective artistic 'language' of the twentieth century. As early as 1944, he also said that 'the full logic of Cubism' is abstraction. In his obituary of Piet Mondrian, also in 1944, Greenberg wrote: "Mondrian was the only artist to carry to ultimate and inevitable conclusions those basic tendencies of recent Western painting which Cubism defined and isolated." He adds: "Those whose point of departure is where Mondrian left off will no longer be easel painters." That was, of course, a prediction that would include not only Pollock and Newman but also, eventually, Stella and Judd.

Clement Greenberg's description of Modernism (which is really not a theory but the day-to-day accumulation of observations and experiences by the pluralist critic-at-work) was based upon his belief in the fundamental importance of Cubism. It also came from his intimate contact with the best artists of his time, whose

work and purpose he was able to clarify. Because of those contacts with living artists, Greenberg, in his best period, was never dogmatic. Apart from the classic Cubists, he named other artists as major figures – Matisse and Miró for example. Greenberg's orientation was almost exclusively towards Paris, which he named 'the fountainhead of modernity'. It was from there that artists had begun what, in retrospect, could be called the great purification of art. Radical art was supposed to gradually remove all the superfluous elements from its medium, finding vital inspiration in the specific qualities of that medium. In the end it would possibly become abstract, the 'ultimate and inevitable conclusion'.

These views, to which many have contributed (but of which Greenberg, the best writer, became the most eloquent spokesman) were very influential in the world of Western art. European museums, for instance, continued to reflect particular local circumstances but by the mid-sixties, their central aesthetic policies had become oriented towards the American version of Modernism, which, for that reason became international. Many European artists also began, in the course of the sixties, to accept the beautiful logic of Modernism. Others, like Georg Baselitz, were in conflict with it.

Although developed from a particular interpretation of Cubism (the interpretation leading to abstraction) other developments in early twentieth-century art, such as Italian Futurism or Russian Constructivism, could, without great difficulty, be accommodated within Modernism in so far as they too ultimately derived from Cubism. One great movement began, however, to be virtually excluded: German Expressionism. When Modernism, as a style, or as an approach or even as a mentality, was first formulated in the 1940's nobody in America, and indeed Europe, had any reason to think kindly about Germany. I do not believe, however, that resentment was the decisive factor, though it certainly contributed to the post-war neglect of German (and Italian) art in general. The problem must have been located, rather, in the nature of Expressionism itself. Whereas Cubism was careful, controlled and even gentle, and its subject matter almost pastoral, Expressionism was nervous, coarse and reckless. Cubism seemed to be carefully constructed; it tended to objectify the picture by its structural logic.

That is why it was able to suggest a clear way into abstraction. Cubism was methodical and could therefore be used as an effective *model*. Expressionism, on the other hand, was individual and idiosyncratic. It did not have a method for constructing a picture. Expressionism seemed impulsive and inconclusive. Instead of opening up other possibilities, as Cubism seemed to do, Expressionism pivoted upon itself. It was useless to the idea of Modernism, which held the notion that there was something logical about art-making.

I believe that a description of modern art's general development is utterly incomplete when it cannot include Expressionism as a vital force. This is why I propose that we take another look at the work of a great German artist who worked on the periphery of all movements: Kurt Schwitters (1887-1948). In the ongoing discussion about the central themes in modern art, he has thus far been either relatively absent or been presented as a curious outsider. He was much more important than that.

As it happened, Clement Greenberg reviewed an exhibition Schwitters had in a New York gallery in 1948; he mildly praised the artist, placing his 'little collages', for example, among the 'heroic feats of twentieth-century art'. Greenberg set Schwitters firmly in the tradition of Cubism – and consequently his works in that tradition were considered to be the best. According to Greenberg, the later works done in the late thirties and forties, 'show great decline', and 'the effort towards greater variety of texture and colour gain results in discordances'. Yet, Schwitters effectively broke the Cubist mould in order to experiment with an expressiveness that differed from the balanced and orderly sort seen in Cubism or Post-Cubism – and that *also* differed from the open but slightly static expressiveness of most Abstract Art of the time. In so doing, he demonstrated that there was another artistic way out of Cubism than the 'logical' conclusion: abstraction.

Schwitters' art, especially his work in the later years, began to develop in an opposite direction to Mondrian and other major abstract artists. Schwitters began to load the surface of the painting with coarse rugged materials. During the later years, this method of building and constructing paintings (instead of fluently painting them) was more decisive, in temperament as well as

objective, than in the earlier work where a more traditional sense of beauty is visible. What is so wonderful and impressive about the later (and most important) work of Schwitters, is the extreme roughness, what Greenberg called 'discordances'. It is really art made by hand. It is put together, entirely conceived by practice.

Cubism was invented, of course, by the painter's eye. But is also had a discreet intellectuality to it, which later continued more strongly in Abstract Art. Abstract Art, in its various formal manifestations, aimed at a serene, still form of purity. Abstract Art was literally out-of-this-world and, therefore, mostly utopian in its aesthetic and political outlook. Abstract Art undoubtedly came from Cubism, but only by *developing* one particular side of Cubism. By breaking up the image, and then rearranging it in little flattish elements, a Cubist picture balances on the implicit mobility and nervousness of the pictorial construction and, at the same time, on controlled orderliness. In most Abstract Art the orderliness became more important than the nervousness. The best Abstract Art is indeed an art of balance and proportion – and wonderful stillness. But Schwitters was mainly inspired by Cubism's mobility. By breaking up the already broken image even more, he literally broke up the pictorial surface, which in Abstract Art in the 1930's had become light and fragile. Obviously, a painting by Mondrian is also made by hand, but its handwriting tries to be even. The painting is much more, to use old-fashioned words, the immaterial projection of an inner vision. Schwitters' works are very material: in this sense he brought art back to the physical practice. What Schwitters actually accomplished (and why he must now be seen as a radical and central figure) was to introduce the Cubist idea of flexibility into the different context of Expressionism, thus giving it a greater toughness. The recklessness and roughness of Schwitters' art reveals Expressionism as an essential and inspiring part of his aesthetic attitude. In his later work we frequently find the pointed angular shapes that are so typical of Kirchner's or Schmidt-Rottluff's paintings and that bring vital restlessness to their surfaces. Such shapes, and also the way in which they are joined and placed, were never a part of the vocabulary of Cubism, where surfaces were generally more even, subtly tuned, and, in Braque's case even gentle. Unlike the light colours

of Cubism, which are luminous and silvery, the colours in most of Schwitters' work are dark and dense in the nature of Expressionism.

For a while it seemed that Schwitters accepted Cubism as a flexible and efficient method of construction, a method that also permitted a particular 'looseness' that he apparently liked very much. Spiritually and aesthetically, however, he always stayed close to Expressionism. There is great vitality in Expressionist painting, and it was that vitality and wildness that Schwitters infused into his reluctant Cubism, making his work really explosive and moving it away from the quiet contemplative quality that characterizes classic Cubism as well as Abstract Art.

Unlike Mondrian (and unlike many contemporary abstract artists who reflect Mondrian's attitude), Kurt Schwitters was never fanatic about purity. He was a very 'impure' artist. And, when I speak of Schwitters' absence, I also mean to say that the very idea of impurity (or the idea of compromise and aesthetic contamination as a source of inspiration) is largely absent from Modernist artistic consciousness. Modernism's insistence on abstraction and on the way to arrive at it, by stripping the medium of its unnecessary or impure elements, had to result in a very rarefied idea of an artwork as thing of extreme clarity, physical elegance, balance, intelligence and perfection. Indeed (in America and Europe), this classic Modernist description accompanied a production of art in which those qualities were the most highly valued – also outside the immediate context of Abstract Art. In that context, the consciously impure artist, a juggler like Schwitters, is seen almost as a renegade. It is the proper logic of Modernism that Baselitz is a bad painter and, for instance, Robert Ryman a good one. But if we were to look from a different point of view, at a history that includes Schwitters and through him Expressionism as well, one could considerably widen the scope of what is right or wrong in art with historical justification.

Possibly the great achievement of Schwitters was that he discovered *disorder* as an expressive force in art. Not only did he literally break up the soft surface of painting, he shattered it in such a way that the works give the impression of great agitation. With that agitated disorderliness (which is *not* an order out of control)

Schwitters constructed his late works, giving them that wonderful manœuvrablility of form that makes them so restless. It is the artist completely immersed in the *practice* of his art. There is little sense of style. Style always suggests a particular order, method, some kind of formulated aesthetic objective, whereas Schwitters' practice tried to solicit chance and the unexpected. In addition to the intellectually clear and serene attitude of the major abstract artists from Mondrian onwards, it is essential to recognize the absolute validity and sharpness of Schwitters' art and to consider his position (that explosive mixture of the Cubist and Expressionist sensibilities) as fundamental in twentieth-century art.

There has never been much doubt about the *quality* of Schwitters' work, but he was primarily seen as an individual who was somewhat on the fringes. Again, unlike Mondrian, there was little single-mindedness in his career: there was always too many things he wanted to do at the same time. That easily raises suspicions of amateurism. He had no great interest in the finally chiselled ultimate artwork. He was the practical and poetic magician.

A revaluation of this paradoxical position is also relevant to the present situation in art. There is a great deal of discussion, for instance, about the paintings of Georg Baselitz. Some critics say his work is an inflated and unoriginal version of old Expressionism. I do not agree with that view, particularly as it often also implies that Expressionism in itself was already inferior or less resourceful than Cubism. That, at least, was the general view of classic Modernism. But if one reads Expressionism through Schwitters (as one can read Cubism through Mondrian), it changes one's perception of the movement. Instead of the mere heaviness and bluntness and the rhetoric, one begins to see the flexibility and the wonderful quickness of Expressionist paintings. Schwitters continued with *those* qualities and was thus, even when transforming them, a true heir of Expressionism – much more so then of Cubism. Baselitz in turn is, of course, an heir to that *transformation*. Expressionism cross-bred with Cubism, which produced a particular alternative to Abstract Art and to the assumption that Abstract Art is the logical consequence of Cubism. Rather than emptying the picture of subject matter and increasing its pure opticality – as was the great strategy and achievement of Abstract

Art (at least in the Mondrianesque tradition: the Constructivist approach was somewhat different) – Schwitters made the surface opaque, dense and heavy. He found in that heaviness the elements for the articulation of intriguing images.

The relative absence of Kurt Schwitters among the great heroes of modern art has distorted the interpretation of artistic tradition in the twentieth century and has prevented the perception of particular qualities that are of at least equal importance and value as those of abstraction, whatever the persuasion. Primary among these qualities is the expressiveness of the shattered surface and the agitated image. These aspects, indicated and partly realized by Expressionist artists, were the true force of Schwitters' art. Schwitters maintained the heaviness of the surface, tough like a ploughed field, at a time when artists around him began to make it light. Matisse wanted it light in order to make it more fluently decorative; Picasso wanted to use the light field for playful drawing; Mondrian wanted his vision to be disembodied, while the Constructivist side of abstraction could not allow coarse materiality to infringe on the sharp angularity of their constructions.

In the 1940's some of these tendencies, all aspiring to lightness, came together in the work of Jackson Pollock and other Abstract Expressionists. Pollock's wonderful overall paintings had their beginnings in the tender fluctuating surface of classic Cubism, in a bit of Matisse, but maybe even more in Mondrian's last paintings, the *Boogie-Woogies* done in New York, in which he gave up the tight grids of the earlier work for something more open, lighter and more vibrant. That vibrancy, breathing life into the colour, is the exemplary quality of the great Abstract Expressionists. It was also the beginning of the soft pictorial fluency and the versatility of drawing, not only in the work of Jasper Johns but also in those of many younger artists, and constituted an important aesthetic tradition in late twentieth-century art in Europe and in America. In the other major tradition, the hard-edged and constructed abstractness from the Russian Constructivists and the Bauhaus to Judd, it was a particular clarity and sparseness of design that became aesthetically prominent. In both traditions, therefore, the dense, agitated, coarse surface with its impure expressiveness became virtually anathema. For a long time the aesthetic con-

sensus in modern art tended toward the light and clear. Not only was Schwitters in conflict with that modernist consensus but so was Georg Baselitz, both as his logical heir and because of his invention of a new appearance for the hectic and dramatic surface. When he began to turn the motif upside down, he again gave the surface a strange disorderliness by that operational intervention on logical perception.

Like Schwitters' construction of coarse surfaces, Baselitz's intervention had little refinement: it was an abrupt blunt move but also a very effective one. It permitted him to make wildly agitated paintings of great material density, paintings that do not seem to quiet down. That makes them very different from classic Modernist paintings which usually try to attain forms of balance; Baselitz likes the surface to be sharply disruptive and aggressive. He is as different from Jasper Johns as Schwitters is from Mondrian. Like Schwitters, Baselitz works with a singular and independent artistic purpose. The undeniable force of his painting should cause us to review our tradition and revise our aesthetics as far as necessary.

Kurt Schwitters' studio in Hanover, ca. 1921

The Stature of the Artist
Kurt Schwitters

Siegfried Gohr

There are three artistic achievements in particular that come to mind when the name Kurt Schwitters is mentioned: *Materialcollagen* [Material Collages], 'Sonate in Urlauten' [Sonata in Primal Sounds] and *Merzbau* [Merz Construction]. Despite all attempts at a plausible reconstruction from photographs of the original, this last piece, destroyed in World War II, must be considered lost. The second piece is left to us in the form of an audio recording in which we hear the artist himself performing his sonata. Although this method of documentation would seem to offer hope of a more accurate rendition of the sonata, it fails to pull the actual character of the event into the present day. The perception of the later happenings is affected by the same problem. These particular event have many elements in common with Merz evenings and Schwitters' ideas for a Merz stage.

The fact that Schwitters gained a great deal of recognition in his own day and again after 1950, mainly through his assemblages and collages, is due, obviously, to the body of work that constitutes our knowledge of Modernity. In contrast to the 'Sonate' and Merz, Schwitters found the collage techniques already developed after World War I having been invented by Picasso and Braque in 1912. A fantastic variation by Max Ernst came to prominence during World War I and a political variation came from the Berlin Dadaists Hannah Höch and John Heartfield. At the same time as Schwitters took to using scissors, paper and paste, the Zurich Dadaists centred around Hans Arp also discovered this new technique and in addition named chance as co-creator of their work. Arp later made a friendly and ironic comment about his colleague Schwitters, 'The Greek gods had nectar and ambrosia; Kurt Schwitters' nectar and ambrosia is paste.'

His collages distinguish themselves from the works of his contemporaries, some of whom have similar approaches to his. Yet at the Paris Retrospective of 1995, one could get the impression that his contribution to the flair for the modern movement consisted merely of his ironic/witty variation of Dadaism and Constructivism. As long as Schwitters' later works, i. e. his work after 1930, remain mostly unexamined, the stature of Kurt Schwitters as an artist will remain a mere shadow. It is only in recent years that we've come to see evidence of the complexity and uniqueness of his personality and his work. This will never be fully understood if he is continued to be interpreted as just a side road to the main road of Modernism.[1]

Admittedly there have been efforts since the early 1980s to place *Merzbau* at the centre of attention and through a new interpretation of his lost 'Kathedrale des erotischen Elends' [Cathedral of Erotic Misery], as Schwitters himself once called it, to gain access to the 'romantic' Schwitters. An attempt at this was undertaken at the 'Der Hang zum Gesamtkunstwerk' exhibition. The use of the word 'Kathedrale' alone would seem to have justified this.[2] Schwitters' *Merzbau* has been used as evidence of a romantic undercurrent in the art of German Modernity. In recent years, this theme has given ever more credibility to the increasingly romantic interpretations of German art from 1800 onwards, for example at the 'Ernste Spiele' [Serious Games] exhibition in Edinburgh and Munich.[3] This new suggestion for a comprehensive interpretation replaced that of a lasting expressionism that had been chosen as the concept for the 1985 exhibition at the Royal Academy in London entitled 'German Art in the Twentieth Century'.[4] With the help of his self-chosen title 'Kathedrale des erotischen Elends', it would appear that Schwitters allowed this larger connection to fit. Thereafter he would no longer be the Carl Spitzweg of the German Moderns, as his opponent Raoul Hausmann once pejoratively described him, but a new Caspar David Friedrich, one whose cathedral, however, was not imagined to be in an exalted landscape but rather in a room in an ordinary home of some citizen of Hanover, who had allowed it to grow into his residence as a wild plant might encroach, insinuating itself into the landscape. That one can find traces of the romantic in Schwitters' work is beyond a

[1] The retrospective curated by Serge Lemoine took place at the Centre Georges Pompidou in 1994/95 and attempted to create a certain revaluation, which however, from the perspective of the exhibition arrangement, was not really effective.
[2] Harald Szeemann (ed.), *Der Hang zum Gesamtkunstwerk*, exh. cat. Zurich 1983, in particular pp. 16-19.
[3] Christoph Vitali (ed.), *Ernste Spiele. Der Geist der Romantik in der deutschen Kunst 1790-1990*, exh. cat. Haus der Kunst, Munich 1995.
[4] Christos Joachimides and Norman Rosenthal, *German Art in the Twentieth Century*, exh. cat. Royal Academy, London 1985.

doubt, the question is whether these traces really have been incorporated into his work with any prescience on the part of Schwitters.[5] Schlegel's 'Romantische Ironie' and the never-ending working process used by Schwitters show parallels which will be dealt with later. But those two, often repeated, terms 'Kathedrale' and 'Gesamtkunstwerk' seem to be highly questionable when applied to Schwitters working concept.[6] Also the comparison of Schwitters most famous poem 'Anna Blume' with Novalis' blue flower shows at the same time a coming closer to and a distancing from understanding. Schwitters as an example proves that the art historical method of comparison, as far as the Moderns are concerned, suggests more the proximity of conceptions rather than the ability to actually make them analytically plausible. That which appears to be the same is not necessarily led by the same intent. If one goes back to the manufactured argument about the idea of the cathedral in Schwitters' work, one comes to the earlier Merz sculptures such as *Haus Merz* (1920) and *Schloß und Kathedrale mit Hofbrunnen* (1922) which are indicative of a developed urban ambience and absolutely not a 'total work of art' to which after all, both music and poetry would have belonged. The *Merzbau* at Waldhausenstraße 5, which was begun about 1923, is directly connected to the architectural vision of Merz sculpture and remains as precisely representative of that genus than would be admitted by those who perceive it as belonging to the retinue of the Romantic. This corresponds to the observation that, even for his most advanced assemblages, Schwitters was loathe to discard the concept of composition. This is also true of his 'Ursonate'. Even with his tendency to expand the artistic occupation to new and until now unoccupied fields, Schwitters still held on to the limits of the individual genres, although he greatly enlarged their territories.

The most important argument for limiting the use of 'Kathedrale' and 'Gesamtkunstwerk' to interpret all of Schwitters' works is the person of Schwitters himself. He is a 'one-man movement' in the midst of many groupings of classical Modernity. Kurt Schwitters is Merz, not Dadaism, nor Surrealism, to which he had few ties, nor Constructivism. Whoever would indiscriminately put Schwitters in any of these schools mistakes his status and his ambitious designs which cannot be understood in linear terms.

[5] Beatrix Nobis, *Kurt Schwitters und die romantische Ironie. Ein Beitrag zur Deutung des 'Merz'-Kunstbegriffs*, Alfter 1993.
[6] Dietmar Elger, *Der Merzbau. Eine Werkmonographie*, Cologne 1984.

The argument for a romantic Schwitters touches on a far-reaching dimension of him that is, however, misleadingly interpreted in terms of the historical romantic. The search for a deeper understanding leads to the late works and to some widening of earlier interpretations that had been sacrificed to the idea of a 'modern' Schwitters. On the one hand is the question of how the expressionistic earlier works can be integrated into our overall understanding. On the other hand, there remains the task of assessing the great number of 'realistic' portraits and landscapes, if one doesn't accept the simple answer: that these are bread and butter, a substitute for the impossibility of making a living, in exile, as a typographer. However, if one becomes convinced that the realistic pictures reveal deeper problems within him then his conception of an artwork is called into question anew and fundamentally. For it can be shown completely that the approaches used in Merz art influence the realistic works and that, conversely, the problems of the realistic works have an influence on Merz art. The attempt could be made to identify both works with Schwitters' living situation at the time of the creation of each. On the one hand, here is the upright citizen in a bourgeoisie setting, and on the other hand, is the outsider and avant-gardist. Escaping this dilemma, however, is not so easy and Schwitters is certainly not the only one who created his work in what are two seemingly incompatible styles, since the same can be said of Mondrian, for example, or later, of Kelly.

In his time, Mondrian executed his drawings and water-colours of flowers side by side with the strict geometrical work, as did Kelly. For Schwitters, there was another case that he could have been immediately aware of, namely Wilhelm Busch, a fellow native of Lower Saxony. Along with the famous picture stories such as 'Max und Moritz' which Schwitters the poet sometimes played upon, Busch also left behind a very extensive collection of realistic portraits and landscapes. While his drawings often used modern solutions to the depiction of movement, or advanced similar surrealistic *Groteske* Busch painted completely in the tradition of a realistic painter, who stressed brown tones heavily, a totally different œuvre, hardly compatible with that of the sketcher.

Then there still is the question of the type of artist that Schwitters both embodied and created for himself, when on one side his

work is modern and on the other side traditional. It seems helpful to me to attempt a comparison with the type of artist who is seemingly estranged from the world as was, for example, Max Beckmann. Both artists came from the same part of the German countryside. Although Beckmann was born in Leipzig in 1884, his family hailed from the Brunswick area of Hanover and only a career move had led Beckmann's father to move to Saxony. Stylistically speaking, hardly a single road leads from one artist to the other and yet both have something in common: in the case of Schwitters I could call it the 'one-man movement' or Merz. In Beckmann's case, this is admittedly expressed in the abundance of self-portraits.

Beckmann never ventured outside of the area of painting, never in the direction of collage or assemblage. Though there are a few meaningful sculptures along with his paintings. Yet he was definitely not unaffected by such problems as modern post-cubist depictions of space and the *Prinzip Collage* [Principle Collage] as a break from the painterly surface. Beckmann tied his spatial problem directly to the problem of individuality as seen from a philosophical perspective. This is shown in the self-portraits which simultaneously mirror a concrete reflection on top of one's own social position. The self-portrait claims a special place in the painter's œuvre. More than once, he recalls Rembrandt in quotations, who was probably the first to hand down not only his physiology but also a detailed depiction and allegorization of his position in society. As distinct from Max Ernst's figure 'Loplop' and different from Picasso's minotaur identification, Beckmann's self-portraits stay closer to the role-playing out of reality that the artist adapts for reasons of self-knowledge. This is comparable with Schwitters in that the relationship between Merz art and artist-self is very close to his own life's and historical experiences. The artist does not escape into a private, mythological language as Picasso does, rather he allows the harder resistance of reality to be felt. Mythological disguise and role-playing are different from one another in the degree of their appropriation of reality. In this respect, Schwitters is much more comparable to Beckmann, to whom there would appear to be no stylistic connection, than to Max Ernst or Hans Arp, although art history repeatedly mentions Arp and Schwitters in the same breath.

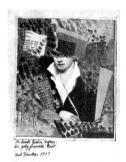

Kurt Schwitters
Ein fertiggemachter Poet,
1947
30 x 20 cm
Collage,
private collection

A few examples can help better illuminate Schwitters' view of himself. From the earlier years comes the drawing *Der Einsame* [The Lonely One] (1918). This is an allegory for the artist that works like an involuntary plan-for-life, since Schwitters' tireless activities should, in the final analysis, serve in overcoming his artistic and existential isolation. A collage from 1937-38 contains, almost covered with abstract pasted surfaces, a photographic portrait of the younger Schwitters. He looks out of the collage as if from behind a fence, one that locks his mouth and allows only his watchful eyes to be seen, gazing into some indeterminate distance, which we can surely conclude to be the future. Again it is Beckmann whose self-portraits since 1935 look similarly tense and distracted as they gaze into the viewer's room. The 'Blick aus dem Bilde' [View from the Picture] (Alfred Neumeyer), that old topos of painting, changed itself 'lifted to the level of an actual motif' into a look into one's own historical period. This look goes through the viewer, through an eerily historical space that threatened the artist's existence. Ten years later, Schwitters created a collage, rich in cross-references, entitled *Ein fertiggemachter Poet*, [A Done Poet Done In], which must be seen as an allegory for his situation in England. The artist incorporated the reproduction of a painting into this collage, something that was to appear more often in later years. The *fertiggemachter Poet* turns out to be a portrait of Percy Bysshe Shelley, painted in 1819 by Amelia Curran. Naturally, Schwitters had the poet's tragic life in mind: he received no recognition in England and fled to Switzerland. He drowned in 1822 at Viareggio. Such a tragic fate must have moved Schwitters, who was in a similar situation in English exile. For apart from the attention and support of friends, he found little resonance there, neither as a poet nor as an artist. The double meaning of the title describes the subject matter of the collage, on the one hand, with the incorporated illustration which is 'done in' i. e. disguised abstractly. On another level, the use of Shelley refers to Schwitters himself. In the way that we are barely able to discern Shelley's portrait just before it becomes totally covered by abstract shapes and slips into oblivion, so does Schwitters see his work sinking away under an uncomprehending environment. Special notice ought to be taken of the fact that Schwitters compared himself with a romantic poet *par excellence*. Merz and

Romanticism meet here in the aforementioned motif of loneliness, which Caspar David Friedrich also raised to the level of an impressive motif. The resignation is palpable and this, again, is comparable to the later Beckmann, also in exile but in New York. In the year of his death, 1950, came *Selbstbildnis in blauer Jacke* [Self-portrait in Blue Jacket]. The resistance against space, of which Beckmann spoke his whole life long, is nearing its end. If one compares this late portrait with the much-heralded *Selbstbildnis im Smoking* [Self-portrait in Smoking Jacket] from 1927, an air of resignation permeates this last self-portrait. The artist is not broken, but he is no longer looking at the viewer, challenging and urging as once was the case. His gaze wanders in the distance and his figure almost melts into the canvases that can be seen behind him, albeit only from behind. The pictures no longer speak to the viewer. The artist waits and looks into another time that he himself will not live to see. Independent of the different tragic lives of these two German artists, which both ended in exile, there is one area of common ground. That is their insistence upon adhering to the *Künstler-Ich* [Artist-I]. The concurrence can be seen not only in the self-reflection, which has already been stressed, but also that both of them continued to allow the validation of the 'Artist-I' as author and, in fact, on the basis of their historical trouble, they pushed it. That is why with Beckmann we have the emphasis on 'Form' and 'Peinture', while for Schwitters the concept of composition, as in music, still has validity. In spite of all the Merz chaos in Schwitters' work, one should not allow oneself to be fooled by this ground current. Visual works, in Schwitters' sensibility, do not yet burst their frames. He certainly shifted borders, but he leaves composition intact as an approach of the 'Artist-I'.

When he makes comparisons to his method of composing, the names of classical composers since Bach and Beethoven are cited. Among his contemporaries, he names Paul Hindemith, who founded the theoretical preservation of form in modern music. Therefore it is not a surprise to find that 'Sonate in Urlauten' is true to the composition of the classical sonata in which there are four movements of different tempo and temperament. Schwitters also set about the traditional sonata in order to deconstruct the form of the musical event. Similar to Beckmann, form is an

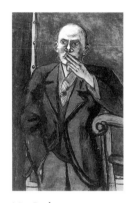

Max Beckmann
Selbstbildnis mit blauer Jacke, 1950
139,5 x 91,5 cm
St. Louis Art Museum

endeavour, something to be worked toward, like a release from chaos and from the incomprehensibility of the word, an abyss into which Schwitters was in constant danger of falling.

Both men, Beckmann just as much as Schwitters, answered the pressing historical situation not with some utopia along social lines, but rather with a personal style/self will. For Beckmann, this artistic desire was often paired with some pathetic gesture. For Schwitters, it was less about pathos than about an intensity sprung from an existential seriousness. For Beckmann, pathos was almost never the only thing but was mixed with an irony and role-playing that the artist brought onto the scene for the 'Zirkus Beckmann' [Beckmann's Circus]. With Schwitters, a twin irony joins picture magic and thing magic, which forms the basis or the result of a sense of intensity that the viewer of a work of Schwitters feels. Admittedly there is the question of whether both artists possess the same concept of irony. Of course, there is the attempt to tie the progressive irony in the way that Friedrich Schlegel thought of it, to Beckmann or Schwitters. This seems problematic to me. The romantic irony was seen as a productive moment in a self-progressing universal poetry: that fragment in which the impossible pushed the completed into visual contact with a new aesthetic. One cannot speak of Beckmann in connection with this type of irony. In Schwitters' case, the thought of the progressive, unfinishable advance in solo work doesn't apply since Schwitters explicitly holds to the composition as foundation. Yet it is abundantly clear that Schwitters' – not just in some titles – takes on an ironic even destructive energy which isn't to be found in Beckmann. The whole work of Schwitters would be easier to grasp from the point of view of the unfinishable since the relationship between life and work has an openness, about which Schlegel was the first to think in radical terms. The relationship of the artist to his work has been characterized by Schwitters in a revolutionary manner so that new, open art forms after 1955 were able to find a certain support in him. Irony and composition are not mutually exclusive in the work of the elders, and so there is an odd ambivalence from the progressive working strategy and style which continues to attach itself to the author of Merz.

If one compares irony as used by Schwitters once more with Beckmann, then we see that it is the ironic which undermines the

pathos and sometimes, especially after 1930, makes it even seem absurd, but it is also an expression of reservation. Beckmann often gives a sarcastic character to details in his work which can go over and above irony. In all triptychs, besides the first, *Die Abfahrt* [The Departure] and the last *Die Argonauten* [The Argonauts], the emotional performance of a world theatre is criss-crossed using scenes which make it possible to give the composition credit on an emotional level and with regard to its content. Beckmann's irony stands against a backdrop of Schopenhauer reception that attributes a fundamentally negative character to the world.

In the case of Marcel Duchamp, this is very different. His concept of irony, succeeding with Dada in modern art, is a different interpretation than those of both his contemporaries. Beckmann should be seen as his polar opposite. Schwitters actually met Duchamp once in Hanover when he was there in 1929. Duchamp's irony is in the tradition of French scepticism which did not make its first appearance at the Enlightenment but could already be seen in the essays of Montaigne. Appropriately, Duchamp uses irony to call into fundamental question certainties regarding the status of art, although he himself was tirelessly occupied and well on his way as an artistic figure. The proverbial silence of Marcel Duchamp, who seems to have interrupted his work, stands in stark contrast to the need to communicate and the need to have an effect which can be seen in Schwitters as Merz artist. Duchamp is the first artist to retreat into a kind of anonymity as creator. He gained prominence for the ready-made approach. Even though it seems definite that Duchamp carefully shaped ready-mades, his effect is based upon disapproval of creativity in the old sense and retreat as creator, although this and avoidance of the art system were repeatedly and artfully stage-managed by him. Duchamp embodied once again and in an eminent manner, the artist as magician and ironist, as elegant socialite and intellectual. Nicolas Poussin while head of the French tradition took on exactly this last artist-figure *Pictor Doctus* from the Renaissance and cultivated it for his own time of the seventeenth century. It would seem that none of the more obvious approaches of Duchamp can be compared with those of Schwitters, though it would be worth the attempt to analyse the type of eroticism that both artists bring to their work.

The result could prove that Duchamp incorporates erotic themes before metaphors, and that Schwitters' 'erotic misery' stems from existential, i. e. life's, experiences. Neither were bachelors but in the erotic fantasies they trace the unbridgeable gaps of modern society which push the traditional roles of the sexes further and further from power. Duchamp allows us to observe his thoughts in which there is a constant rededication to the borders between creator, art and life. He does this playfully and with a life affirmation that certainly can accompany the sceptic.

Schwitters can only articulate his artistic situation with a doubt-ridden seriousness that is devoid of wit and irony and which is tied to the pessimism of Wilhelm Busch and Arthur Schopenhauer. That is why Schwitters touches on something unnameable on the other side of the aesthetic phenomenon of his work, which he himself once termed mysticism. This means that Schwitters is no longer seeking the truth in art. Art takes the place of truth so that by way of a mystical experience this will come into focus within the viewer. Naturally, there is the danger of confusing this type of property in a work with that of the romantic. Instead there is an unexpected proximity, form this angle, to Ludwig Wittgenstein, whose circumstances also forced him go away to England and Norway. With the exception of their understanding of 'style', the artist and philosopher come close to each other.[7] For Wittgenstein, the search for the truth was less important than the style of the thought itself and therein lies similarity with the personal style desire of the Merz artist Schwitters. Both men think or shape aesthetic lifestyles. While Wittgenstein retreated to Norway to lead a monkish existence, as it were, living in a hut he built himself high over a fjord, Schwitters found himself in isolation from the beginning and all of his attempts to overcome this involuntary monasticism failed upon the circumstances of his life.

The Danish painter, sculptor and art writer Per Kirkeby was one of the first from the new art to draw upon Wittgenstein; he had also written about both Schwitters and Wittgenstein in Norway. By 1967, Kirkeby had already dedicated a short book to the philosopher with the odd title *2.15*.[8] It turns out that section 2.15 from *Tractatus logico-philosophicus* was the basis for his own text. For Kirkeby and his artist friends, Wittgenstein was something of a holy man,

[7] See Lambert Wiesing, *Stil statt Wahrheit. Kurt Schwitters und Ludwig Wittgenstein über ästhetische Lebensformen*, Munich 1991.
[8] Per Kirkeby, *2.15*, Kopenhagen 1967.

someone who had given away his wealth in order to dedicate his simple life to philosophy. Kirkeby recognized that Wittgenstein had not pursued any philosophical system, rather, like a poet, he brought together comments, thoughts and observations. After this realization, Kirkeby was able to use Wittgenstein's style of thinking and perception fruitfully in his own work for 'Style is the very person himself', as Wittgenstein put it. And this style is not forever fixed. Style and existence belong together but for none of those named does style become method; instead it becomes an expression of the prevailing existence. Kirkeby unfolded wider than Schwitters, whose realistic landscape paintings he found to be as similarly abstract as those of C.D. Friedrich and C.G. Carus, a style-desire that takes from different media. With both, Schwitters and Kirkeby, the existence of the artist finds a non-expressionist route to expression and to intensity. In Schwitters' case, one can point to the parallel of his existentialism arising with his later work in Paris. Kirkeby retains an emphasis on the aesthetic look when assured his own morality, the act of thinking, when impelled by morality, did the same for Wittgenstein. Like Schwitters, Wittgenstein and Kirkeby each touch on a mysticism which the philosopher summed up in the famous sentence 'That which can be expressed at all allows itself to be expressed clearly, and that which one cannot speak of, one should keep quiet about.'[9]

So far in this perspective we have a sketch of Schwitters in which he appears more and more as an artist with a stature, who separates himself from current categorizations in the stylistic understanding of art history. His work feeds on a search for sovereignty, as described by Georges Bataille, who is of the same period but without great similarity in detail. The search was built upon an almost imperative desire to communicate, yet ended tragically in either insurmountable distance or in the abyss, as promised in 'Erotic Misery'. Although in later years, Schwitters raised his assemblage concept to the level of outright crass materialism, taking on inferior materials and traces of the life world. The author's communication with the world remained one of misery. In the end, he saw himself as the 'done poet done in' who hides himself like the woman who often embodied truth but to whom the distance remained unnavigable.

[9] Ludwig Wittgenstein, *Tractatus logico-philosophicus*, Frankfurt am M. 1963, preface.

Schwitters and America

or Planning a Career
in the Land of Boundless
Opportunities

Gunda Luyken

First Contacts with the New World

In the year 1920 the American painter and Maecenas Katherine Dreier saw the work of Kurt Schwitters for the first time during a trip to Europe. She discovered his amazing collages in Herwarth Walden's Berlin Gallery 'Der Sturm' and was, as she said herself, "even more intrigued by them than by the watercolours of Klee".[1] In the same year she arranged Schwitters' participation in a group show of the Société Anonyme in New York.[2]

When she held out the prospect of a one-man show in America to Schwitters in 1925, he was very pleased and replied: "I gladly agree to an exhibition of my work in your Society and I am already looking forward to it. What I would like best is to come to New York, perhaps to give lectures, but that will be too expensive, as, unfortunately, I cannot afford it."[3] But Schwitters did not give up that easily. After a few practical suggestions, how the exhibition could best be realized, he developed the idea of a sponsored lecture tour: "Would it perhaps be possible to interest an impresario in organizing a series of Merz-evenings in America? I believe that would be a great success. The impresario should guarantee the travel and accommodation expenses for the period required, including meals."[4]

When the artist discovered a little later that his one-man show had been postponed in favour of an international exhibition of modern art, he was bitterly disappointed. But he soon realized the value of an international group show and he offered Katherine Dreier to help her with the organization of the exhibition and the selection of the German participants. Katherine Dreier, never having met Schwitters in person, felt rather uncertain about her

[1] Katherine Dreier, *Kurt Schwitters. The dadas have come to town!*, 25 December 1947, Visitors' folder for the Kurt Schwitters exhibition at the New York Gallery, The Pinacotheca, 19 January-end February 1948.
[2] At this exhibition works by Wassily Kandinsky, Man Ray, André Derain and by the American artist Marsden Hartley were shown.
[3] Kurt Schwitters to Katherine Dreier, 15 August 1925, quoted from: Ernst Nündel (ed.), *Kurt Schwitters. Wir spielen, bis uns der Tod abholt, Briefe aus fünf Jahrzehnten*, collected, selected and commented on by Ernst Nündel, Ullstein, Frankfurt am Main, 1975, p. 96.
[4] Kurt Schwitters to Katherine Dreier, 15 August 1925, quoted in: Ernst Nündel, *op. cit.*, p. 96.

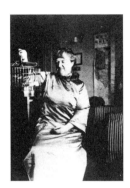

Katherine S. Dreier,
ca. 1922

[5] Katherine Dreier, cata-
logue article 1950, quoted
from: *The Société Anonyme
and the Dreier bequest at
Yale University. A Catalogue
Raisonné*, ed. by Robert
L. Herbert, Eleanor S.
Apter and Elise K Kenney,
Yale University Press,
New Haven and London,
1984, p. 596.
[6] Katherine Dreier, in:
exh. cat. *International
Exhibition of Modern Art at
the Brooklyn Museum*, 1926,
p. 34.

response to this generous offer. Secretly, she was afraid that Schwitters might have doubts about her authority as coordinator of the exhibition. Hence her reserved reply: First of all, they should thoroughly discuss the matter before making any decisions. In April 1926 Dreier travelled to Hanover to make preparations for the exhibition and they met for the first time. Later she wrote about this meeting: "We, including his lovely and rare wife Helma, became friends instantly. His generous personality, his quick wit, his delightful sense of humor, his tolerance, could not but endear him to all who came in contact with him."[5] Dreier's initial anxiety, about Schwitters seizing control from her, proved to be completely unfounded and, after five days of close cooperation she decided to include the abstract artists suggested by Schwitters, such as Friedrich Vordemberge-Gildewart or Cesar Domela, in her exhibition. Schwitters himself would be represented with eleven Merz works. Marcel Duchamp, who had adviced Katherine Dreier on the selection of the French artists, showed his *Large Glass* in Brooklyn for the first time. In her preface in the catalogue Katherine Dreier paid tribute, both to Duchamp and to Schwitters for their magnanimous commitment to the exhibition. As for Schwitters' artistic talent she said: "One of the most brilliant and original painters and thinkers of today. Not only versed and gifted in the art of painting, but also a writer. His fairy stories have a charm equal to those of Grimm and Hans Anderson. His most original work is the creation of the 'Laut Sonate', a sound poem made through the reiterations of numbers, consonants, vowels and sounds with amazing effect. He was also the first to create a new technique for his pictures in the choosing of materials other than paint. These pictures he calls 'Merz-Bilder'."[6] The last seven pages of the special issue of the exhibition catalogue contained advertisements offered free of charge to the seven most progressive institutions promoting modern art. This promotion equally favoured Kurt Schwitters' 'Merzzentrale' in Hanover and Herwarth Walden's Galerie 'Der Sturm', the Bauhaus in Dessau or Alfred Stieglitz' intimate New York Gallery. But Schwitters was not only represented in the catalogue, he also featured prominently in the exhibition itself.

For her exhibition Katherine Dreier chose an unusual presentation of the art works: in order to display the various avant-garde

movements as a unity, she refrained from the customary presentation of artists by country. She also believed the strict alphabetical order of art works favoured by Marcel Duchamp to be inadequate.[7] She much preferred to distribute the works one by one over the various exhibition rooms. An installation shot shows an oil painting by Joseph Stella next to a work by Jacques Villon, and a collage by Georges Braque beside Franz Marc's oil painting *Rehe im Wald*.

In addition, Katherine Dreier transformed four smaller exhibition rooms into a model apartement made up of a library, a living room, a bedroom and a dining room. The walls of the library were decorated with fairly small 'Merz' collages by Schwitters and a water colour by Hans Arp. This model apartment served Katherine Dreier first of all as a didactic instrument, which was intended to show visitors how modern art could be integrated in an average household. With her presentation Katherine Dreier also tried to encourage the public to admire art not only in a museum, but to make it part and parcel of daily life. The bedroom and the library in particular were to stimulate the public not to look upon art mainly as an object representative of a style, but to embrace it as an enrichment of their private lives. Contrary to the Bauhaus style, Katherine Dreier refrained from establishing a link between modern art and contemporary furniture.[8] For the interior of the rooms she deliberately chose traditional period furniture that, with its cosy atmosphere, would help to overcome initial resistance towards modern art.[9]

Although the exhibition in Brooklyn did not make as many headlines as the comparable 'Armory Show', staged 13 years earlier, the number of visitors indicates a remarkable success. In a mere seven weeks 52,000 persons saw the exhibition. Subsequently the exhibition was shown in the Anderson Gallery in New York, and later in the Albright Gallery in Buffalo and finally in Toronto. Schwitters, who monitored the reception of the exhibition in Germany, wrote to Katherine Dreier: "Your catalogue is a huge success. It shows up everywhere. Everybody asks: 'Are you also in it?', which proves the significance of the exhibition. I believe this is the most comprehensive exhibition of modern art ever."[10]

Although Katherine Dreier continued to promote Schwitters, he also tried to establish contacts with other American museums

[7] Cf. the exhibition arranged by Marcel Duchamp of the 'Society of Independent Artists'.
[8] A striking counterexample to Dreier's homely decorated model apartment is presented by Mies van der Rohe's home furnishing inspired by the Bauhaus. Hans Richter, who was a friend of both Kurt Schwitters and Mies, described the famous architect's apartment, situated in Chicago: 'In its living room there are half a dozen of the finest Klee oil paintings; there are two enormous Mies sofas for people his size, a couple of beautiful Mies chairs, a long table that Mies uses to put his whisky glasses on, a lamp and nothing else ... The other rooms in this five-room apartment are practically empty. The dining room is a ballroom, without any furniture, only a table and a few chairs at the far end, that seem to vanish in the total emptiness, as if one observed them through the wrong end of a pair of opera glasses ... The bedroom is like a monk's: a bed, two chairs and a bedside table. Only in the built-in cupboard there is something: twelve Schwitters

collages of the best quality." In: Hans Richter, *Köpfe und Hinterköpfe*, Verlag der Arche, Zürich, 1967, p. 74.
⁹ Katherine Dreier acquired this furniture in the popular Brooklyn store Abraham and Strauss, fully aware of what she was buying. *The New York Times* described the furnishing as "good old mahogany and other furniture of the 19th century inspiration", cf. Elisabeth L. Cary, Experimental Art at the Brooklyn Museum', in: *The New York Times*, 21 November 1926, section 8, p. 1, Cary was the only critic who reported on the model apartment.
¹⁰ Kurt Schwitters to Katherine Dreier, 4 May 1927, in: Ernst Nündel, *op. cit.*, p. 114.
¹¹ Kurt Schwitters to Galka Scheyer, 17 January 1926, Archives of American Art (AAA), Galka Scheyer Papers, reel 1905, frame 626-627.
¹² Helma Schwitters to Galka Scheyer, 3 May 1930, AAA, Galka Scheyer Papers, reel 1905, frame 628-629.
¹³ Kurt Schwitters to Katherine Dreier, 29 January 1927, in: Ernst Nündel, *op. cit.*, p. 111.
¹⁴ Cf. *The Société Anonyme and the Dreier Bequest at*

and galleries. For instance, in January 1926 he wrote to Galka Scheyer (1889-1945), who originally came from Braunschweig and had settled in California as an art dealer in 1924: "What have you been able to achieve for us? After all, it must be quite difficult to introduce modern art in America. You may be interested in my current activities. I cannot make a living out of art and I now occupy myself with a variety of things. Of course, I continue to paint and to nail, but in particular I write grotesques and art reviews for newspapers, I organize evenings and draw commercial art for newspapers."[11] In May 1930 Helma corresponded with Galka Scheyer: "We are very pleased that you are willing to arrange an exhibition of my husband's work together with his colleagues, really he is something special, but on the other hand he has already had an exhibition with Baumeister und Schlemmer in Dresden, and with Moholy und Lissitzki in Hanover, and therefore he likes the idea of an exhibition together with these four. As far as prices are concerned, we are prepared to quote lower prices for this exhibition in California, that is in the west of America, than those we quote here in Europe, but only for you at your exhibitions. The prices are the same for all works and come to 80 marks or 20 dollars. If you would sell Kurt's works, we would be very happy if you could send us the money in dollars." Helma did not forget to mention that the prices were net prices. She continued: "Kurt works very hard, the art is our diversion, for it is impossible to make a living out of it in Germany … Kurt has a lot of very interesting work, such as a column, an Ursonate, various types of literary work, and also paintings."[12]

Even though Schwitters knew by then how unresponsive America was to his art, he wrote again to Katherine Dreier in January 1927. This time he tried to find out when a one-man show in New York might be possible and concluded by asking her: "Could you let me have the addresses of Harold Lloyd or Buster Keaton or Charlie Chaplin? Just once I would have liked to try and present a grotesque film in America."[13] Katherine Dreier then suggested to make Schwitters' grotesque 'Zoologische Gartenlotterie' into a film. Unfortunately this project never materialized.[14] Since Katherine Dreier valued Schwitters' grotesques highly, she repeatedly urged him to have the stories translated into English and to

have them published as a book. In May 1927 the artist advised her that some of his texts had now been translated. In the meantime, at a lecture in Paris, Schwitters had met the publisher Eugène Jolas (1894-1952), who edited the literary magazine *transition*: "He introduced himself to me and wants to publish some of my work in every issue. He says it would help to smooth the way for me in America."[15] In the year 1948 Katherine Dreier still regretted that the imaginative stories had not been published as a book. The humour of the grotesques reminded her of Lewis Carroll or of the Gilbert and Sullivan operas and for that reason she was convinced that publication, especially in the English speaking world, would be worthwhile.[16]

Schwitters also tried at an early stage, to make the 'Ursonate' known in America. When, in 1925, he had hopes of coming to New York for a one-man show, he already mentioned it: "My sonata in primal sounds (35 minutes) would certainly interest Americans with a feel for music. In a few days I will send you a gramophone record, on which I have recorded parts of my sonata. The rendition is, of course, not perfect, but you will be able to get an idea."[17] In spring 1926 Katherine Dreier had the opportunity to attend an authentic performance of Schwitters' 'Lautsonate' in Prague. In September Schwitters informed her as follows: "In my opinion the sonata should now go to print, because it has become something very unusual, and yet quite comprehensible at the same time. The only important thing is that the edition must be exemplary, that it is well thought-out and perfect. Please let me know if you could consider it being made in America through your intermediary, and that you do not mind if I have parts published in magazines in advance. And when would it be possible to start printing in America ... Right now I am busy developing the design in broad outline and I will send you a sketch as soon as possible. With this sketch and the manuscript the typesetting can be done in America under *your supervision*. I will still have to see to the correction, if necessary perhaps twice, and then everything can be printed in America and we shall be ready."[18] Schwitters gave exact instructions, how he visualized the print. For instance, he insisted on two-colour printing. "I would think red and black. The text for reading will be in black, the clarifying descriptions in red."[19]

Yale University. A Catalogue Raisonné, op. cit., p. 596.
[15] Kurt Schwitters to Katherine Dreier, 4 May 1927, in: Ernst Nündel, *op. cit.*, p. 114.
[16] Katherine Dreier, *Kurt Schwitters. The dadas have come to town!, op. cit.*
[17] Kurt Schwitters to Katherine Dreier, 15 August 1925, in: Ernst Nündel, *op. cit.*, p. 108.
[18] Kurt Schwitters to Katherine Dreier, 16 September 1926, in: Ernst Nündel, *op. cit.*, p. 107.
[19] Kurt Schwitters to Katherine Dreier, 16 September 1926, in: Ernst Nündel, *op. cit.*, p. 108.

Although Schwitters already had firm ideas regarding the design, the form in which the sonata would finally appear was not yet clear to him. For instance, he considered a folder system, in which the sonata would be published on single sheets, printed on one side only: 'The advantage would be that one could put the single parts next to each other for comparison. And here comparison is the most important, for one cannot fully enjoy the whole, unless one can absorb the relation between all parts in one's mind.'[20] His elaborations ended with the remark that the sonata was his most comprehensive and most important poetical work.

Although Katherine Dreier was convinced of the importance of this plan, the attempt to have the sonata first printed in America, failed. But it still should be mentioned that, on the occasion of a recitation evening of the Société Anonyme in 1928 Katherine Dreier recited Schwitters' sound poem.[21] She later wrote: "Many of his poems which are just numbers, one would think would lend themselves to be recited in any language, but the volume and roundness or sharpness of sound, for instance in English, is so different from the German sound, that a totally different conception is born."[22]

In June 1927 Schwitters confronted his American benefactress with another project. He had worked out a new typeface and enclosed a photograph. "But this is just for you, for I would like to find a type-foundry, but I do not want some type-founder who gets carried away and produces something similar himself. Maybe you could help and find a business relation in America. I also would like to ask how the planned translations of my grotesques and fairy tales are getting along?"[23]

Although, from 1925 onwards, Schwitters had been seeking possibilities to exhibit in America, to publish and to hold lectures, most of the projects he pursued first seemed to miscarry. On the other hand he succeeded in building up lasting, even lifelong friendly relationships with influential personalities such as Katherine Dreier and Alfred H. Barr Jr. of the Museum of Modern Art in New York. Both of them bought the first works for their collections in the twenties respectively the thirties.

Katherine Dreier obtained her first work even before she had met Schwitters. In 1922 she decided to buy the collage *Merzz 19* and

[20] Kurt Schwitters to Katherine Dreier, 16 September 1926, in: Ernst Nündel, *op. cit.*, p. 108.
[21] This refers to the lecture 'What the New Vision Brought to Painting, Music, Sculpture'. Almost ten years later Walter Gropius wrote to Schwitters in a letter from America: "... You would really have enjoyed to hear Xandi Schawinsky recite your 'Ursonate'. He probably is your best interpreter." Walter Gropius to Kurt Schwitters, 17 September 1937, Houghton Library, Harvard University, Cambridge, (Mass.), bMS Germ 208 (1521) Schwitters-Gropius Correspondence.
[22] Katherine Dreier, *Kurt Schwitters. The dadas have come to town!*, *op. cit.*
[23] Kurt Schwitters to Katherine Dreier, 27 June 1927, in: Ernst Nündel, *op. cit.*, p. 118-119.

paid Herwarth Walden 4000 marks for it. At the time, this was the
equivalent of two dollars.[24] For the Brooklyn exhibition the Amer-
ican lady received four paintings, a sculpture and 25 collages from
Schwitters. The sculpture and two paintings she returned to
Schwitters after the exhibition. *Merz 1003, Pfauenrad* (1924) und
Ovale Konstruktion (about 1925) she kept so she could exhibit them
again should an occasion arise. Two years later she paid Schwit-
ters 250 dollars for the 25 collages and two albums with litho-
graphs. By then each collage cost approximately nine dollars.

How differently Schwitters' works were valued, compared with
those of Paul Klee or Franz Marc, is evident from extracts from
Katherine Dreier's correspondence. In a letter to the management
of the Brooklyn Museum she mentioned the high value of Franz
Marc's oil painting *Rehe im Wald*: "Since this painting has a market
price abroad of $ 5000 and is heavily insured, will you take special
care of it? There are only two paintings on the market by Franz
Marc, of which this is the more important of the two."[25]

After the close of the Brooklyn exhibition Katherine Dreier
tried to sell works by Paul Klee to the museum. She wanted to
know: "Are the trustees considering the Paul Klee works I left in
your office – the price was $ 150 each – there need be no hurry as
to payment – but I would like to see that the Brooklyn Museum
acquired *one* thing from the exhibition … so do take one …"[26]

For an exhibition Katherine Dreier organized in 1930 for the
New School for Social Research in Manhattan, Schwitters again
sent her a large number of collages, and the *Relief mit rotem Segment*
as well. Katherine Dreier retained the relief and twelve of the col-
lages. In the meantime she had acquired some 40 works from
Schwitters, whereas the Museum of Modern Art, which today
owns one of the largest collections of his works, had not yet
bought a single one. Not until 1935 did Alfred H. Barr Jr. acquire
the collage made in 1922, *Santa Claus*. In 1936 another two collages
were purchased. The work *Hansi, Schokolade* (1918), which the mu-
seum acquired through the Berlin Galerie Nierendorf, then cost
them 40 Reichsmark. In a letter from the museum it says: "From
what I can gather in the Registrar's files Alfred H. Barr Jr. was
responsible for purchasing it and several other collages by Schwit-
ters for the Museum, which were included in the exhibition *Fant-*

[24] Cf. *The Société Anonyme
and the Dreier Bequest at
Yale University. A Catalogue
Raisonné, op. cit.*, p. 597,
no. 620.
[25] Katherine Dreier to
Herbert B. Tschudy,
Deputy Director of the
Brooklyn Museum,
26 August 1926, Brooklyn
Museum Archive,
Katherine Dreier Corres-
pondence.
[26] Katherine Dreier to
William Henry Fox Esq.,
Director of the Brooklyn
Museum, 15 January 1927,
Brooklyn Museum
Archive, Katherine Dreier
Correspondence.

astic Art, Dada, Surrealism, 1937."[27] But Alfred H. Barr Jr. was not just interested in Schwitters' collages. During a visit to Hanover he had also seen Schwitters' *Merzbau* and it made a lasting impression on him.[28] At the time, Schwitters did not have the faintest notion of the importance of the fact that Barr had personally seen the *Merzbau*.

Schwitters in Exile

Just like the romantic artist Eugène Delacroix longed for Italy in the first half of the 19th century, Kurt Schwitters longed for America in the beginning of the 20th century. Both artists made numberless attempts to travel to the country of their yearning; both were denied their dream by fate. Delacroix, still a young man, studied English painting in London in 1825 instead of the classic art in Rome, whereas the political situation in Germany forced Schwitters into exile in the mid-thirties, first to Norway, later to England.

Surprisingly, only a few authors report on Schwitters' political conviction after Hitler seized power. Hans Richter, for instance, refers to a letter addressed to Tristan Tzara; in it Schwitters announced a mysterious 'shipment': "This shipment, said Tzara, was a photo album; the cover had been cut open and gummed down again and microfilms were hidden in it. These microfilms from Hitler's Germany showed the Hitler posters, that were torn down and hanging from the walls in Hanover, food coupons for minimal quantities of food and various other items. The enlargements of these microfilms, of this clandestine document, was later published by Tzara in the French magazine 'Regards'. If Schwitters had been caught, he would certainly have been sent to a concentration camp and would probably have died there. So, he literally risked his life ... But he had not forgotten the fee 'for the print' in his letter to Tzara!"[29]

In Norway Schwitters met the American doctor Elmer Belt, who later reported on the circumstances surrounding the artist's escape from Germany: "In the summer of 1939 in the very vanguard of World War II, Mrs. Belt and I were travelling in the mountains of Norway. There, in a small Norwegian village, we met this blond, blue-eyed refugee from Germany ... He made a bitter joke

[27] Judith Cousins to Annegreth Nill, 26 March 1979, Museum of Modern Art, Archives of the Department of Drawings.
[28] Cf. Kurt Schwitters to Alexander Dorner, 12 December 1937, in: Ernst Nündel, *op. cit.*, p. 140.
[29] Hans Richter, *Dada-Kunst und Antikunst. Der Beitrag Dadas zur Kunst des 20. Jahrhunderts*, with an epilogue by Werner Haftmann, Cologne 1978, p. 158.

of his exit. At a gathering of artists he had been asked, possibly to test his loyalty, to comment on newly painted portraits of Hitler and Goebbels. He walked out on the stage with the portraits and said: 'Well, here they are, friends, shall we hang them or stand them against the wall?' After this remark he quickly departed to Norway, at the earnest urging of his friends. A courageous teenage son, who would not join the Hitler Youth Movement, was with him, and he had brought out with him also a few of his paintings. These he was offering for sale. Some of the paintings were excellent portrait studies, in a representational style. Many were experimental efforts, featuring the new free expressions of shape and form in space. He said, 'The reason for leaving Germany is this art form. It does not please Hitler who knows well how to put paint on the side of a barn but not how to put paint on canvas. He can see nothing in this.'"[30]

Even before Schwitters fled Germany in the beginning of 1937, he saw that he would have problems with his art and he suggested to Alfred Barr that he would realize a sculpture for the Museum of Modern Art. Barr answered: "I wish very much that we might carry out the project which you propose but unfortunately the Museum has no space nor funds. Believe me, I regret very much that we cannot do anything. I am delighted to have the photographs of your room [he refers to the *Merzbau*] taken by your son. They are at present on exhibition ... I am sending to you, care of Dr. Freudenthal, a catalogue of the exhibition."[31] Although Schwitters probably did not realize at the time that Alfred Barr had included his work in the important exhibition 'Fantastic Art, Dada and Surrealism', this consolidated his reception in America. In the exhibition catalogue Alfred Barr honoured the artist in a special article, which was to be the most extensive information on Schwitters in the English language for a long time.[32]

In the meantime the former director of the provincial museum in Hanover, Alexander Dorner, had also migrated to the USA. Schwitters requested him in 1938 to approach Alfred Barr again on the subject of the sculpture: "Yes, please ask Barr. I asked him to let me have a chance to do a sculpture, which pleased him so much in Hanover. He declines politely. But from Ernst he bought photographs of my Merzbau, without paying for them. And he

[30] Elmer Belt in: Kate Traumann Steinitz, *Kurt Schwitters. A Portrait from Life*, University of California Press, Berkeley and Los Angeles 1968, p. VII-VIII.
[31] Alfred Barr to Kurt Schwitters, 10 December 1936, Museum of Modern Art, Department of Painting and Sculpture.
[32] The exhibition catalogue was so much in demand, that a third edition was already printed in 1947.

fails to respond to reminders. Please try and remind him again. We could certainly use the money ... Norway is a beautiful country to live in, but for art there are no prospects. So, in spring I will have to travel ... If everything goes well, I would like to come to the USA for 2-3 months in autumn '38. Perhaps you will be able to help me, exhibition, lecture, publisher, gramophone records of my sound sonata."[33] As early as August 1937 Schwitters had written to Walter Gropius: "I wrote to several people, also to Dir. Barr, if they might help me to shape a Merzraum somewhere outside Germany, so that at least something will be preserved in case, through a mischance, my room in Hanover would be destroyed. The result was negative. Apart from good advice I received nothing. Neither did I succeed in finding a record company willing to record my sonata or some of my grotesques. I do not write to you to complain, because I am always in a good mood, even if things are turning out badly for me, but perhaps you could advise me or help me. After all, it is possible that in America, where my work has been exhibited so often, I may have some success, if I had the opportunity to get there. Who could arrange a lecture, who could give me a chance of a room, even if it were only a small nook???"[34]

In Germany Schwitters had worked time and again on realizing lecture tours and one-man shows in the New World. In May 1927, for instance, he wrote to Katherine Dreier: "Hopefully, you will then as we agreed, that is the prospect you very kindly held out to me, push through the trip to the USA for us. It would make me terribly happy, because I would like to visit America, above all, at least once in my life."[35] Before his emigration Schwitters' main purpose was to expand his field of activities in America and open up a new market for his work, which was only valued by a small circle of connoisseurs. In exile Schwitters could neither pursue his bread-and-butter job as a commercial graphic designer, nor sell his art in Germany. More than ever he was now depending on purchases abroad. In Norway he tried to eke out a living with realistic landscape paintings and portraits he frequently produced for American tourists. The difficulty Schwitters had with the recognition of his abstract works becomes clear from a letter he wrote in 1939. In it Schwitters described his experiences with the export of his art works to France: "The customs official was desperate, he

[33] Kurt Schwitters to Alexander Dorner, 12 December 1937, in: Ernst Nündel, *op. cit.*, p. 140.
[34] Kurt Schwitters to Walter Gropius, 7 August 1937, quoted from: 'Neun ungedruckte Briefe und Postkarten von Kurt Schwitters an Walter Gropius', Gerhard Schaub (ed.), *Kurt Schwitters. 'Bürger und Idiot'. Beiträge zu Werk und Wirkung eines Gesamtkünstlers, mit unveröffentlichten Briefen an Walter Gropius*, Fannei & Walz, Berlin 1993, p. 156-157.
[35] Kurt Schwitters to Katherine Dreier, 4 May 1927, in: Ernst Nündel, *op. cit.*, p. 114.

did not know whether they were pictures, woodware or even arms. I got the impression he had an inner struggle with two options, either to have me arrested as a spy, or to call the lunatic asylum. Finally he did not want to make a fool of himself and accepted they were paintings, especially because another customs official knew me personally and confirmed that I was an artist."[36]

To Katherine Dreier he painted a vivid picture of his life in exile: "Nevertheless I like being in Norway, for it is a country of unparalleled beauty ... I paint landscapes and portraits, model portrait, glue and paint abstract pictures and glue abstract plastic art; besides, I write poetry in German ... Yesterday I sent you my regards through a young American dancer, Betty Lindemann, who intends to visit you and tell you about me ... What distresses me most of all is that I cannot live in my *Merzraum* and that it may be given up to destruction. For that reason I ask you once more, can you keep your ear to the ground again, to see if anyone in America is willing to give me an opportunity to shape a three-dimensional room? ... Dear Miss Dreier, can't you buy the painting from me that you liked so much in Hanover? Here, it is incredibly difficult for me to earn enough money to live on. But only, if it is not too inconvenient for you."[37]

When Katherine Dreier came to Hanover again in June 1937 Schwitters was unable to meet her personally: "Helma will tell you why I have to stay here ... But, in any case, please visit my studio! You are one of the few for whom it was built, who can understand it."[38] On her visit to the studio Katherine Dreier acquired a wooden sculpture, measuring about 130 cm, for which Helma asked her 40 dollars.[39] Schwitters elucidated: "Later I did similar Merz sculptures, specially in England ... The first Merz sculpture possesses Miss Dreier. It is a grave monument for my father, after 1931. I was in Norway when Miss Dreier visited me last in Hanover, and she bought it from Helma, who didn't know that it was meant to be a grave monument."[40] If Schwitters had been in Hanover himself, he would never have surrendered this sculpture to Katherine Dreier. All the same, he was convinced that the work was in good hands with her and asked her for photographs.[41]

Schwitters' artist friends in Switzerland and America also helped to sell his work abroad. And Schwitters thanked Käthe

[36] Kurt Schwitters to Henriette, Ernst and Esther Schwitters, 16 June 1939, in: Ernst Nündel, *op. cit.*, p. 152.

[37] Kurt Schwitters to Katherine Dreier, 24 July 1937, in: Ernst Nündel, *op. cit.*, p. 137-138.

[38] Kurt Schwitters to Katherine Dreier, 18 March 1937, in: Ernst Nündel, *op. cit.*, p. 136-137.

[39] Cf. *The Société Anonyme and the Dreier Bequest at Yale University. A Catalogue Raisonné, op. cit.*, p. 602.

[40] Kurt Schwitters to Margaret Miller, 11 December 1946, Museum of Modern Art, Archives of the Department of Drawings.

[41] Cf. *The Société Anonyme and the Dreier Bequest at Yale University. A Catalogue Raisonné, op. cit.*, p. 603.

Steinitz, a close friend, who had migrated to America with her family, with the words: "You went to a lot of trouble and expense in your kindness in recommending me to this gallery and I am very grateful to you, but I cannot do anything with it yet, before the gallery writes to me. So please tell them that I am willing to let them have about 10 of the best Merz drawings at a price of, say, 20 dollars each, as well as my books at a price of 1 and 2 dollars respectively on consignment. This is on condition that the gallery writes to me to inform me of their terms and that they exhibit the works once at an exhibition to be agreed on in advance. Only in this way I will have some guarantee that they will not be left and lost in some cupboard, as once happened to me in America. The consignment I would like to limit to one year and only extend it if, in the meantime something has been sold. Please be good enough to speak to Mr Sorter again."[42]

Schwitters, who liked to ask his artist friends for their advice in business matters, enclosed in his letter a copy of a purchase inquiry from the Berlin Galerie Nierendorf. Although the government union branch had expressly granted him permission to make abstract work in his studio and to sell his work if anyone asked for it, even the pictures that had been designated as culture-bolshevism, he was afraid that in this case it might be a Gestapo trick.[43]

In Norway, too, Schwitters never stopped thinking about a trip to America. In July 1938 he turned to Katherine Dreier again: "Can you tell me more about Gabo? Where does he live? Who is his wife? ... But maybe I will come to America myself one day and will do it myself. I should be over there just once in my life. Maybe you know somebody who would like to have portraits that are true to nature; I can paint a good likeness and, if I had several commissions for portraits I could finance my trip."[44] In February 1940, however, the political situation had become polarized so much that it made Schwitters contemplate fleeing again. He now considered migrating to America: "But the only country that will give me a visa without too many problems is Haiti. There they will paint me black and have me work on a plantation. But that is hopeless and no one can ask that of me. But it is not just an urge to get away from Norway, but I clearly feel I am being pulled in the direction of

[42] Kurt Schwitters to Käthe Steinitz, 15 February 1938, in: Ernst Nündel, *op. cit.*, p. 143-144.
[43] Kurt Schwitters to Käthe Steinitz, 15 February 1938, in: Ernst Nündel, *op. cit.*, p. 143-144.
[44] Kurt Schwitters to Katherine Dreier, 22 July 1939, in: Ernst Nündel, *op. cit.*, p. 148-149.

the USA. And there is no other country where I have such good relations. I also feel I will be very successful there. And therefore I have filled in forms applying for an entry permit for myself, Ernst … and Helma from Hanover."[45]

For the emigration to America Schwitters needed both sponsors and guarantors who were to vouch for his moral integrity. For this purpose he had already contacted Käthe Steinitz from Norway. "And you are the first one I ask if you could give me such a guarantee, perhaps also for Helma. For the time being I have some money, even if it is not more than 500 dollars … But I have many paintings that can be sold in the USA, that is realistic as well as abstract works. I have been able to sell many realistic paintings to the USA. In addition, I have quite a lot of friends in the USA, who would help me in an emergency and I am convinced that I will not be a burden to anyone … One may also ask Miss Dreier, Dorner, Barr or the Museum of Modern Art, Gropius, Hilla von Rebay or the Guggenheim Foundation, Moholy, Albers or the Black Mountain School and Elmer Belt. You may ask who Elmer Belt is. He is the senior medical officer in a hospital in Los Angeles (or San Francisco?) and lives in Hollywood. I met him and his family in Olden, he was quite thrilled with my paintings and promised to help me to come to the USA. But what is the value of promises for a guarantee? I now intend to write to all the names I mentioned separately. To Miss Dreier I wrote already in July, when the situation was not yet so tricky as it is today. She has not sent me a word in reply … Anyway, give me your advice and write soon. I must get away from here and one cannot ask from me to go back to that place where I am persecuted because of my art. Who will help me, before it is too late?"[46]

In spring 1940 Schwitters managed a narrow escape with his son Ernst from the German troops. They fled on one of the last ships from Norway to Scotland. In October Schwitters wrote from an internment camp on the Isle of Man: "Dear Käthe, You know that I have been interned here since 19.06.1940. I could be released as an artist of extraordinary significance, but this I will have to prove. So now I ask you to obtain the relevant confirmations as soon as possible from important people in the USA, for instance Gropius, Dorner, Barr, Bier, K.S. Dreier, Moholy. They should each

Käthe Steinitz and
Dr. Ernst Steinitz, ca. 1925

[45] Kurt Schwitters to Käthe Steinitz, 26 February 1940, in: Ernst Nündel, *op. cit.*, pp. 157-158.
[46] Kurt Schwitters to Käthe Steinitz, 26 February 1940, in: Ernst Nündel, *op. cit.*, pp. 157-159.

[47] Kurt Schwitters to Käthe Steinitz, 11 November 1940, Schwitters-Steinitz Collection, National Gallery of Art Library, Washington. In an earlier letter to Käthe Steinitz Schwitters had already hinted at assistance from the Museum of Modern Art. He commented on the new construction plan of the museum, saying: "That looks very pompous indeed. Do you believe it possible that such a museum, that produces such art, commits itself to artists? ... A museum that really wants to promote modern art might give the artist a guarantee, on certain conditions, so that he can get on with his life and his creations. Or do you believe that the museum is more interested in the artist's death, in order to see the price of his paintings go up?" Kurt Schwitters to Käthe Steinitz, 26 February 1940, in: Ernst Nündel, *op. cit.*, p. 160.
[48] Laszlo Moholy-Nagy to Käthe Steinitz, 27 February 1941, Schwitters-Steinitz Collection, National Gallery of Art Library, Washington.
[49] Margaret Barr to Käthe Steinitz, 11 March 1941, Schwitters-Steinitz

send it to me in the camp, so that I can start the release procedure soon. Secondly I must furnish attestations that I am to be considered as an England-friendly foreigner. Moreover, affidavits confirming I was persecuted by the Nazis because of my art are essential. It would be very important to Ernst and myself if we could each have proof from Ille about my socialist activities. Please be a darling and get me these soon ... I haven't heard from Helma at all. Please write to her again and say that I am well and that I miss her, and send me news ... My portraits turned out incredibly beautiful. Does it make sense to migrate to the USA? If so, arrange for the affidavits."[47]

Käthe Steinitz contacted the persons mentioned by Schwitters immediately. Laszlo Moholy-Nagy regretted he could not help, but assured her he would do his best to find a solution for Schwitters. On 27 February 1941 he informed her: "Yesterday Mr. O. Kaufmann and Professor Laszlo Gabor of the Kaufmann Department Stores in Pittsburgh were here. I spoke to them about Schwitters, whether it would be possible to get an affidavit and when I told them that they would not be involved with money, they said that it would not be difficult to get an affidavit for him. Would you get in touch with them immediately, saying that you have the data and I advised you to do so. I have also another case before me where I am interested to help, but this case is very much more risky than Schwitters, who is able to earn his living if necessary."[48]

Käthe Steinitz was also successful in enlisting the gallery owner Sidney Janis as a financial guarantor, and Piet Mondrian, among others, vouched for Schwitters' artistic qualities. In spite of all that Käthe Steinitz received a rejection from Margaret Barr in March 1941, from the Museum of Modern Art: "I am in charge of all the refugee cases that come to the Museum. I am quite au courant with the case of Schwitters up to the period in which my husband wrote him a letter that was supposed to be helpful in getting him out of the concentration camp ... In a general way let me say that the Museum has endeavoured during the past months to help artists who were in danger – most of them in southern France. I do not see at all how you can hope to get an emergency visa for Schwitters who is in England. I do not think the State Department considers England dangerous."[49]

In fact, in October 1940 Schwitters was still in the internment camp on the Isle of Man and wrote to Käthe Steinitz again in an impatient tone: "My dear Käthe, you have done a lot for us and especially for me. I am very grateful. But we are still not in the USA. Ernst lives in London as a photographer's assistant with Esther, and I am still interned. I cannot leave for the USA, because the regulations have changed. Now money for the journey and an affidavit are not sufficient, but one must also have two guarantors and be especially invited from there. Please do everything you can to get this organized. First of all for me and, if in any way possible, also for the children. I have so many friends in the art world there, and they know my disposition. Kaufmann has the money for the trip if necessary, if I should not be able to pay in pound sterling. Please help me, in order to get us invited. Helma will then come later and I will work there and soon pay back the people who lend me money. But finally I must get out of this internment and further away from Norway, I want to be with all of you. Please get it done quickly and write to me about the outcome. Maybe my art is in danger and I, of course, with it. At last I would like to work on my abstracts again and find appreciation for them. Who knows what will happen? Will you write to Helma, in case I would be released?"[50]

Even though Käthe Steinitz continued to commit herself to Schwitters' case in an examplary manner, she failed to succeed in arranging the artist's entry into the USA. Finally Alfred Barr informed Schwitters in January 1942: "It was very nice to get your letter of December 6th and to learn that you are safe and well. I wish that it were possible for us to do something to help you come to this country, but I have talked the situation over with Mrs. Steinitz and we have both reached the unhappy conclusion that there would be no possibility of getting your visa approved by the State Department because of the whereabouts of your immediate relatives. The State Department is very strict on that point and no applications are any longer considered for people whose relatives are in the occupied zones."[51]

When Schwitters was released from the internment camp, he first moved to a suburb of London. He made a fresh start trying to make a living with Portrait painting. But the continuing world war

Collection, National Gallery of Art Library, Washington.
[50] Kurt Schwitters to Käthe Steinitz, 22 October 1941, Schwitters-Steinitz Collection, National Gallery of Art Library, Washington.
[51] Alfred Barr to Kurt Schwitters, 18 January 1942, AAA, Barr Papers, reel 2168, frame 511.

prevented him from getting enough commissions for portraits. In February 1942 he turned to Alfred Barr once again and asked him to buy one of his works for the museum.[52] Barr's reply was brief, but decisive: "I wish that we could be of help to you by buying another of your works, but we already have three and I am afraid that I could not persuade our Committee to purchase another sight unseen."[53]

In June 1943 Schwitters became even more dispirited. He confessed to Käthe Steinitz: "It is difficult to write letters, when somehow one is not well ... Now, you will want to know what is wrong. All sorts of things. What saps my energy most is not having any possibilities of earning money. After I had made a few very well paid portraits in the fall of 1942, I did not get any new commissions since November. I have tried everything, but in vain; I also wrote to Dr. Barr and Moholy for help, but without success. It is not possible to live for months on end without any income and it is even worse if one becomes dependent on one's children. I can stick it out for another three months, but then it is all over. It makes me so listless to write this. Another thing is, that I have not heard from Helma for eighteen months. Is she still alive? Has she been harmed? Of course, this worries me very much."[54]

Eventually Schwitters found out that Helma had died in September 1944. In despair he wrote to Käthe: "Poor Helma. How lonely she must have been. And before she died, she saw our four houses in ruins. My studio and the work of my life does no more exist. And I go on living. My sonata in sounds exists only in my voice and shall die with me. Isn't it sad. For what did I actually live? I don't know."[55]

At the time, Schwitters' only ray of hope was his new, young companion in life, Elisabeth Thomas, whom he called Wantee. He explained to Käthe Steinitz: "My friend is Wantee. She came to help me packing, when ... Ernst left for Norway, I would not have known how to manage it alone, since the cat would not have helped me much. It was a bit sad to leave the house, where I was happy, but when I packed, it was so empty without Ernst and without the pictures, that I was glad to leave. I gave a picture to the neighbor for taking the cat, ... and we went with Wantee and 23 parcels to Ambleside. My pictures and many good sculptures wait

[52] Kurt Schwitters to Alfred Barr, 12 April 1942, AAA, Barr Papers, reel 2168, frame 509-510.
[53] Alfred Barr to Kurt Schwitters, 14 May 1942, AAA, Barr Papers, reel 2168, frame 508.
[54] Kurt Schwitters to Käthe Steinitz, 7 June 1943, Schwitters-Steinitz Collection, National Gallery of Art Library, Washington.
[55] Kurt Schwitters to Käthe Steinitz, 24 June 1945, Schwitters-Steinitz Collection, National Gallery of Art Library, Washington.

now in the loft for a new exhibition. I had one in London last December and sold four small pictures *and* got five commissions. Herbert Read wrote excellently about my work. Do you think I should exhibit once in the USA? What possibilities are there? ... I paint sceneries and abstract. In three weeks I sold for more money than we used, and I hope that I can live here. ... Where lives Moholy? Gropius? Do you think I could after the war come for some time to USA with Wantee? I need her and am lost without her. She looks very well after me. I think Helma would be glad that she does it. She understands art and loves my collages."[56]

Schwitters and the Museum of Modern Art

In April 1946 Schwitters heard from a friend in Hanover, that parts of his bomb-damaged *Merzbau* eventually might be salvaged. His reply was enthusiastic: "I was *thrilled*, and I mean really thrilled, when I read that part of the *Merzbau* could still be buried under the ruins. Whatever the circumstances, I will try and come to Hanover to salvage it ... When those people start to clear the site, they must absolutely ... wait until I arrive, for the *Merzbau* is made of plaster of Paris and could easily be damaged. However, by working slowly I am sure I can save parts. And it is certainly worth it, because it is my *life's work*. And in the opinion of people abroad it was seen as a new art form. I will try to interest American capital in some fragments; I would dig up what remains or pieces, like they do with antique stones, and sell them to America. I could make a living from it, while digging up and, in any case, *I am the owner of my work*, and *I have a claim on it*, not to have it destroyed by rubbish disposal units ... There were also *many pictures in the studio*."[57]

Schwitters also immediately contacted Oliver Kaufmann in Pittsburgh, who had already offered to help him once before and he declared: "In Hanover I built, before Hitler's time, a studio, called *Merzbau*. This *Merzbau* has been reproduced very much, also in the book *Dada, Surrealism, Fantastic Art* of the Museum of Modern Art, N.Y. ... I would like to go to Germany for restoring the *Merzbau* ... Could I come with you to an agreement, that you give me for this purpose some money? For example that I give you pictures for the money and use it for restoring the studio. (Prices of the pictures in the value of my recent London Exhibition). Or

[56] Kurt Schwitters to Käthe Steinitz, 24 June 1945, Schwitters-Steinitz Collection, National Gallery of Art Library, Washington.
[57] Kurt Schwitters to Christof and Luise Spengemann, 25 April 1946, in: Ernst Nündel, *op. cit.*, pp. 193-194.

would you prefer that you own with me half and half the *Merzbau*, after it would be restored, I don't know how to do it. Anyhow, I need urgently $ 3000, and don't know any person to give it to me."[58]

In principle Oliver Kaufmann was willing to support Schwitters financially. But he made it a condition that his nephew, Edgar Kaufmann, who worked as a curator in the Museum of Modern Art, should endorse Schwitters' plan on behalf of the museum. The museum decided to let Schwitters have a stipend of $ 1000 for the renovation work. Schwitters received this news on his 60th birthday and he was overjoyed. He could hardly believe that people who did not know him, could be so kind.[59] The letter from the museum read: "It is the understanding of the Trustees that you have two alternatives: to return to Hanover to restore the original *Merzbau* or to go to Oslo to resume work on the second *Merzbau* … The choice of these projects is left entirely to your discretion."[60]

However, Schwitters soon discovered that, after a visit to Germany or to Norway, he would not be allowed to enter England again without further ado. Therefore he proposed to the museum that they should make a sum of $ 3000 available to him instead of the $ 1000, so that he could erect a third *Merzbau* in England. In August 1947 an employee of the museum summarized the internal status of the discussion for Alfred Barr: "I spoke to Edgar Kaufmann about this, and he believes his uncle would be willing to extend the scholarship to the $ 3000 only on the recommendation of the Museum that it would be meritorious from the standpoint of the Museum rather than from the wish of Mr. Kaufmann to help Schwitters further. There is a further consideration, which Margaret Miller brings up. Schwitters says 'I have two principle aims, two life works. The second is my *sonata*.' He is anxious to make a recording of his long sound poem which has been published like a musical score. It would require four or five large records, and he estimates the cost at about £ 200. The London Gallery was interested, but has abandoned the project. Schwitters asked if the Museum would be interested in issuing them. Margaret wonders if we (meaning also Oliver Kaufmann as well) would be willing to authorize Schwitters to use part of the original $ 1000 or the $ 3000 if it is forthcoming, to defray the recording expense if

[58] Kurt Schwitters to Oliver Kaufmann, 30 April 1946, Museum of Modern Art, Department of Painting and Sculpture.
[59] Kurt Schwitters to Käthe Steinitz, 17 July 1946, Schwitters-Steinitz Collection, National Gallery of Art Library, Washington.
[60] Museum of Modern Art to Kurt Schwitters, quoted from: John Elderfield, *Kurt Schwitters*, Thames and Hudson, London and New York, 1985, p. 220.

Schwitters would be willing to make a small *Merzbau*. She says the Museum would then be under no obligation to handle the details of the production or distribution of the records. Edgar Kaufmann has seen this letter, and he leaves the matter up to you as to whether or not the proposal should be made to Mr. Oliver Kaufmann concerning the extension of the scholarship on this basis."[61]

Alfred Barr believed raising the stipend to $ 3000 was advisable, but recommended that Schwitters should defray $ 500 of the amount to the recording of his 'Ursonate'.[62] Mr. Sweeney, the Director of the Museum had already informed Edgar Kaufmann in advance: "I think it would be a very interesting enterprise to help Schwitters to reconstruct his *Merzbau*. $ 3000 is quite a bit of money from one viewpoint. Still from another point of view $ 3000 would be the price of one painting. And I think the historical value of the *Merzbau* would be well worth this investment, provided of course your uncle is friendly disposed to Schwitters or is interested in doing something of this sort through the Museum. I think the Museum would be completely justified in encouraging your uncle to assist Schwitters in this direction. In fact, I would be enthusiastic in doing so."[63] Finally the stipend was raised to $ 3000, and Schwitters was to receive a monthly instalment of $ 150.

The magnanimous attitude of the museum induced Schwitters to persuade them to arrange a one-man show of his works. As he had done so often before, he informed Käthe Steinitz about developments: "I wrote for the suggested exhibition to Dr. Sweeney. … He asked me to send photos for a committee. But before these photos and some MERZ drawings arrived, the committee decided: They said, that they would have in 1947 an exhibition of collages, and that the committee would hope that I would participate with my collages, and that he was eagerly looking forward to my work. But because of my exhibition there, there could not be a one-man show. I think it is wrong, because it does not show any development. And my sculptures are unknown in USA. Therefore I wrote now to Mr. Kaufmann and asked him to support my one-man show. … Would you suggest other people? Perhaps the Guggenheim?"[64]

[61] Ione Ulrich to Alfred Barr, 11 August 1947, Museum of Modern Art, Department of Painting and Sculpture.
[62] Alfred Barr to Ione Ulrich, 18 August 1947, Museum of Modern Art, Department of Painting and Sculpture.
[63] James Johnson Sweeney to Edgar Kaufmann, 8 July 1946, Museum of Modern Art, Department of Painting and Sculpture.
[64] Kurt Schwitters to Käthe Steinitz, 17 July 1946, Schwitters-Steinitz Collection, National Gallery of Art Library, Washington.

Käthe Steinitz, 1963

[65] Kurt Schwitters to Edgar Kaufmann, 16 July 1946, Museum of Modern Art, Department of Painting and Sculpture.
[66] Kurt Schwitters to Raoul Hausmann, 15 October 1946, in Ernst Nündel, *op. cit.*, p. 243.
[67] Margaret Miller to Kurt Schwitters, 1 October 1946, Museum of Modern Art, Department of Registration, Collage, Exhibition No. 385, Exhibition File.
[68] Margaret Miller to Kurt Schwitters, 1 October 1946, Museum of Modern Art, Archives of the Department of Drawings.
[69] Kurt Schwitters to Nelly van Doesburg, 21 May 1947, in: Ernst Nündel, *op. cit.*, pp. 275-276.

In his letter to Edgar Kaufmann Schwitters expressed his regret about the museum's refusal to consider a comprehensive exhibition at the present time. He emphasized: "I was very sad, because I can only be shown good in a show of my latest work, the sculptures. Since the loss of the *Merzbau*, which was a big sculpture, in which you could walk as in a cubist picture (5 x 4 x 4.5 meters) I did a lot of small sculptures. ... In any case, I asked Mr. Sweeney to think about whether it would be nice to exhibit with the collage exhibition some of my sculptures. It would make the exhibition richer."[65]

After Schwitters had heard about the collage-exhibition he immediately thought of involving his artist friend Raoul Hausmann in this show. He told Hausmann: "The exhibition in New York has been changed. It is a *general collage exhibition* and not an exclusive exhibition of my works. I will be well represented there ... Don't write to the Museum of Modern Art, but write to me whether you would like to participate. And what you will enter. Then I will write to Margaret Miller (not Sweeney) and tell her, that your work is good and original (not copies) and I will ask her to include some of your works, since we are close friends I will vouch for you. Only collages. There will not be a catalogue."[66] Schwitters' selfless effort resulted in Raoul Hausmann being allowed to enter some of his photomontages in New York.

Margaret Miller was very keen to obtain some of Schwitters' large works for the exhibition and asked the artist to tell her who had such works in their possession.[67] Schwitters named the *Huthbild*, owned by the Giedion-Welcker couple in Switzerland, but the curator did not succeed in borrowing it for the exhibition. So, all Schwitters' loan works were provided either by Schwitters himself or by American collections. From Katherine Dreier alone the museum borrowed 13 works, and another two from Peggy Guggenheim. In November 1946 Schwitters heard that he would be represented at the exhibition with about 20 collages: "Even though we shall probably not be able to hang all of the new ones which you sent, it is always well to have a choice, and I hope that we will be able to sell them for you."[68]

Meanwhile Hans Richter had proposed to Schwitters to make a film about the 'Ursonate'.[69] Schwitters welcomed this idea enthu-

siastically and developed several concepts: "In the meantime, in the leisure time that my teaching job at the New York City College leaves me, I work on the picture side of the Ursonata. After I had finished the largest part, there came another letter from Kurt with a fresh idea: I should get in touch with the Museum of Modern Art in New York. They should pay for the film. He needed the money just as badly as I did. That was a beautiful idea. … It was easy to understand that Kurt, far away in Ambleside, believed the museum would pay five cents for a film about a man whose name they hardly knew, but it was hard to explain this to him. I wrote to him it was a lovely dream. Nobody knew him here and all I could do for him was to invest my professor's salary in the film. With such a request I would only make myself even less popular with the museum than I already was. In spite of this cautious explanation, Kurt was annoyed and insisted. Eventually I replied to him I was not a businessman and I could do no more. In his response he said he was a businessman … and that was it. In order not to give him any further food for discussion I broke off the argument and left the film as it was, an 'unfinished Ursonate'." Unfortunately, not long thereafter a letter arrived from Nelly (van Doesburg) and an urgent one from Hausmann, saying Kurt's health was deteriorating. After this worrying news I wrote to him straightaway and I put a four-leaf clover in the letter with my very best wishes for his recovery. The letter arrived too late. Instead of him his son replied that his father would have needed all the luck (of the clover), but had died the day before.[70]

Survey of Schwitters' Reception in America

When Schwitters died in Ambleside on 8 January 1948, he had never set foot on American soil, despite decades of fruitless attempts. Neither had he managed to have a one-man show of his works there during his lifetime. The opening of his first solo-exhibition finally took place only a few days after his death. As early as January 1947 the New York gallery owner Rose Fried had contacted Schwitters and planned her own exhibition of his works to run parallel to the exhibition of his collages at the museum. In April 1947 Schwitters mentioned to his son he was refining ten of his best pictures for this show.[71] Rose Fried showed 26 of the artist's

[70] Hans Richter, *Begegnungen von Dada bis heute. Briefe, Dokumente, Erinnerungen*, DuMont Schauberg, Cologne 1973, pp. 19-21.
[71] Kurt Schwitters to Ernst and Eve Schwitters, 1 April 1947, in: Ernst Nündel, *op. cit.*, p. 269.

works, eight of which came from private collections and were not for sale.[72] Katherine Dreier, too, made five works from her collection available and wrote an introduction for the benefit of visitors to the exhibition. In her article she pointed out that it had taken more than 20 years before the American public started to show an interest in Schwitters: "I had thought that the response would come as quickly as did that of Klee, not realizing that to the average person Schwitters was far more difficult to understand, because he was purely the painter and there was no approach through the intellect which Klee reached through his whimsical delineation of ideas."[73]

In addition, it seemed that the smallish size of his works made acceptance in America more difficult. Margaret Miller expressed her regret that Katherine Dreier had not shown her large collage *Radiating World* in Rose Frieds Pinacotheca: "For many people associate a certain kind of mastery with large works and a number of people asked me at the time of the show if Schwitters had ever attempted collage on a larger scale. For this reason I have tried repeatedly to obtain the loan of the only other example I know of his large Merz-Bilder, which is owned by his friends, Dr. and Mrs. Giedion."[74] In 1926 Katherine Dreier herself had asked Schwitters for larger works for her exhibition in Brooklyn and, at that time, received the collage *Radiating World*.[75]

Almost 40 years later in 1985 John Russel stated, on the occasion of the Schwitters-Retrospective of the Museum of Modern Art: "He has nothing like the great name that he deserves. This is partly because most of his best works are very small and call for concentration and discernment that not every observer has at his command. 'Little work, little man' is a form of disparagement from which not even Paul Klee has been exempt in this country."[76] Moreover, the fact that Schwitters worked mainly in the medium collage and assemblage, hampered his recognition in America. According to Russel "Americans have trouble believing that someone who did that can be as 'important' as a painter for whom no wall is big enough or a sculptor whose work will make a freight train take fright and go into reverse." All the same Russel counted Schwitters' collages among the 'Treasures of our Century' and urged: "No opportunity of seeing them should be lost."

[72] At the time the collage *Merz #443* (1922) was shown; Dr. Frederic Wertham loaned it to the exhibition. Today it is part of the collection of the Busch-Reisinger Museum in Cambridge (Mass.).
[73] Katherine Dreier, *Kurt Schwitters. The dadas have come to town!*, op. cit..
[74] Margaret Miller to Katherine Dreier, 18 May 1948, Museum of Modern Art, Department of Registration, Collage, Exhibition No. 385, Exhibition File. Katherine Dreier replied on 25 May 1948: "I thought the little exhibition which Rose Fried arranged was really fine, and since her room was so small, a large painting was not so essential. I am happy that it was such a success, and I think increased the interest in Schwitters greatly which will again double after your museum has emphasized his work." Museum of Modern Art, Department of Registration, Collage, Exhibition No. 385, Exhibition File.
[75] Cf. Katherine Dreier to Kurt Schwitters, 5 April 1926, Yale University, Beineke Rare Book and Manuscript Library, New Haven, Connecticut

The influential critic, Clement Greenberg, described Schwitters' 'small collages' in 1948 as "Heroic feats of the art in the 20th century". He added: "Schwitters' signal contribution was his introduction of bright colours in a medium that when originally developed by the classical cubists was confined to a spectrum of black, white, gray, brown and dull yellow."[77] In his appreciation of the artist, however, he made a clear distinction between his early work (1920-28) and his later work (1946-47), in which he could detect little advancement: "As in Giacometti's case, his most recent work shows a great decline, if not a radical change of direction. Though the shapes employed are still more or less rectangular, the composition is no longer built almost exclusively of rectangles on horizontal bases, and the effort toward greater variety of texture and colour grain results in discordances." Schwitters' assemblages, which contained material such as wood and glass, were associated by Greenberg with modern sculpture and he elucidated: "One successful example of this genre, from 1923, demonstrates, as do Arp's bas-reliefs, how contemporary advanced sculpture was able, via collage, to attach itself to painting and take its point of departure from that medium rather than from anything antecedent in its own medium. Without this bridge from painting to sculpture provided by the collage and its derivative bas-relief, Giacometti, for instance, would have been unable to embark on this revolutionary path."[78]

Whereas Clement Greenberg made the connection between the artist and Giacometti, younger critics soon cast their eyes forward, towards the next generation: "Schwitters seems to have prepared the way for every artist from Joseph Cornell to Robert Motherwell and on to Jasper Johns", concluded William Wilson in the *Los Angeles Times* in 1985.[79] On the other hand Greenberg had argued in 1948: "Schwitters was one of those artists, who, because they go very far ahead along a narrow path, tend to be overlooked for a time." Altogether, Schwitters' recognition in America seems to be marked by contradictions.

The success of the first solo-exhibition already led to a diversity of opinions. Hans Richter, for instance, commented: "It was a wonderful exhibition of his collages. Nobody came, neither critics, nor museum officials, nor art dealers, nor visitors. It was a

[76] John Russel, 'Kurt Schwitters', in: *The New York Times*, 7 June 1985.
[77] Clement Greenberg, 'Kurt Schwitters', in: *The Nation*, 7 February 1948. Schwitters' realistic works, as well as his abstract works from the thirties up to the end of the Second World War, were not shown at this exhibition.
[78] Clement Greenberg, *op. cit.*
[79] William Wilson, 'Kurt Schwitters', in: *The Los Angeles Times*, 23 June 1985. He continued: "*Merz-picture with Rainbow* of 1939 seems to set the format for Johns' *According to What* and incidentally, here is the little *For Kate* (1947) to cue in something called Pop Art 15 years after Schwitters' death in 1948."
[80] Hans Richter, *Begegnungen von Dada bis heute*, *op. cit.*, p. 20.

complete fiasco."[80] Käthe Steinitz, on the other hand, remarked in a letter to Ernst Schwitters: "Have you read the excellent review in *The Nation* about the exhibition in Miss Fried's Pinacotheca, New York? Schwitters may not be *popular in a wide circle*, but found the greatest and most exquisite recognition in a small circle of connoisseurs, so to speak. A friend of mine, John Begg, sculptor, typographer and production manager with Oxford University Press, acquired a Merz-drawing at this exhibition and paid a good price, although I do not know how much. Recently Miss Fried turned up here, I believe she still frisks about in L.A. … She says, she would very much like to have more of Schwitters' works for other exhibitions."[81]

In 1952 the artist was given another one-man show in Sidney Janis' New York gallery. Stuart Preston, who reviewed this show for *The New York Times*, praised, like Clement Greenberg did earlier, the artist's early collages: "But later on, when history's mood had changed, similar works, for all their deftness are less striking. Dada is nothing outside of its own period and Schwitters' power of invention was too cerebral and literary to make much headway in painting and sculpture as such."[82] Preston's opinion, that Schwitters' art was too much cerebral, is directly opposed to that of Katherine Dreier, who had actually defended the opinion that the artist's work could not be approached through reason.

In May 1973 Vivien Raynor commented on another Schwitters-exhibition and was the first to draw attention to the artist's humour: "An earlier visitor to the show, doubtless in response to the Dada jokiness of it all, had hung a New York subway token on a nail projecting from *Merzbild 13 A. Der kleine Merzel* (1919). Some spectators, convulsed with laughter, drew this to the attention of a gallery attendant. He was for leaving it there, it being, as he said, *pure* Schwitters. … Hard to tell how the artist would have reacted to the token. But there is a chance he might have responded to the spirit behind New York subway art. Even though no collage is involved, he surely would have appreciated such a Merzbahn of defacement."[83] Raynor continued: "In all other respects, the Merz-Estate has for some time seemed very carefully 'protected'. Many of the 'shouts' of revolutionary jubilation come exquisitely mounted in glassed-in boxes. One was especially memorable for

[81] Käthe Steinitz to Ernst Schwitters, 30 August 1948, Schwitters-Steinitz Collection, National Gallery of Art Library, Washington.

[82] Stuart Preston, 'Sidney Janis Gallery', in: *The New York Times*, 19 October 1952.

[83] Vivian Raynor, 'Kurt Schwitters at Marlborough', in: *Art in America*, May-June 1973, pp. 103-104.

[84] Herbert Read, Catalogue preface, in: *Kurt Schwitters*, the Modern Art Gallery, London, Haymarket, December 1944. The limited possibilities Schwitters had to develop freely without financial worries, are elucidated by a comparison with Walter Gropius. The former director of the Bauhaus had migrated to the USA at an early stage and wrote to Kurt Schwitters in 1937: "Thank you so much for your congratulations, which are appropriate indeed, since I have been fortunate here, physically and mentally, and I hope I will eventually take root here, so that I will not have to move on to China, as you presume. I have got the job of professor of Architecture and, together with the dean, who stands by me

its aluminium-edged container and broad expanse of terre verte velvet mount." Schwitters' collages and assemblages, which the artist found very hard to sell, had in the meantime become desirable museum objects, that apparently demanded professional measures for their conservation.

As early as 1944 the English art historian Herbert Read had characterized Schwitters as being 'too modest': "He has not been boosted by critics and art dealers to the same extent as some of his contemporaries. He is nevertheless one of the most genuine artists in the modern movement."[84] Even without formal recognition and notable financial success Schwitters himself had always been convinced of the importance of his art and as early as 1931 he declared with prophetic vision: "I know that I am an important factor in the development of art and shall forever remain so. I say this with great emphasis, so that one can not say, at a later date: 'The poor fellow had no inkling of how important he was'. No, I am no fool, nor am I timid. I know full well that the time will come for me and all other important personalities of the abstract movement, when we will influence an entire generation. However, I fear that I shall not experience this."[85]

through thick and thin, I am trying to reorganize the entire college following my old principle, but adapted to America. I also have the possibility of taking on actual construction and therefore I have asked Marcel Breuer to come over to be my partner. I also succeeded in getting Moholy appointed director of a newly established college in Chicago. Quite soon, in October, he will open 'The New Bauhaus, Chicago' ... All the friends I mentioned and, in addition, Schawinsky and Herbert Bayer were here in July and August as our guests. ... In the next few days I will see several of our friends again in New York. ... Distances are no longer of any consequence ..." Walter Gropius to Kurt Schwitters, 17 September 1937, Houghton Library, Harvard University, Cambridge (Mass.), bms Germ 208 (1521) Schwitters-Gropius Correspondence.
[85] Kurt Schwitters, 'I and my purpose', *Merz*, no. 21, 1931, quoted by Ernst Schwitters in the introduction to the catalogue of Kurt Schwitters' one-man show at the Marlborough Gallery, London, March-April, 1963.

Absences/Presences

Kurt Schwitters' Late Collages

Dorothea Dietrich

The invention of collage in 1912 by Picasso and Braque proved to be one of the most fertile and significant innovations in modern art. Composing works of art with materials appropriated from everyday life rather than pencil and brush, Picasso and Braque put into question the most fundamental assumptions about art, authorship, and originality, the materials of works of art, frame and reference, and a host of other ideas held dear by critics and public alike. Cubist collage constitutes a new approach to representation in which the traditional function of painting as transparent window has been replaced by a witty exploration of the status of representation itself and 'the play of paradox, conflicting interpretations, and the collision of multiple (high and low, pictorial and verbal) cultural codes.'[1] Opening the field of representation to formal and conceptual game playing, collage in the hands of Picasso, Braque, and Juan Gris has replaced the notion of painting as *tableau* with the notion of painting as a *table de jeu*.[2]

For Rosalind Krauss, the cubist collagist's game playing can best be grasped with the help of Saussurian linguistics. As each collage fragment can simultaneously fulfill several functions within the composition (a rectangular piece of tissue paper may signify 'transparency' as well as 'edge' or 'plane'), its meaning is never absolute. The signifier in this instance is a material constituent (tissue paper) and the signified an immaterial idea or concept (transparency); as a sign, it functions like any sign as a substitute for an absent referent. Krauss argues that cubist collage 'inaugurates a systematic play of difference' and represents 'the first instance within the pictorial arts of anything like a systematic exploration of representability entailed by the sign.'[3]

[1] Christine Poggi, *In Defiance of Painting. Cubism, Futurism, and the Invention of Collage*, Yale University Press, New Haven 1992, p. 87.
[2] Poggi, *In Defiance of Painting*, op. cit., Ch. 3, 'Frames of Reference: *Table* and *Tableau* in Picasso's Collages and Constructions', pp. 59-88.
[3] Rosalind Krauss, 'In the Name of Picasso', *October* No. 16 (Spring 1981), p. 16. For a related interpretation of collage, see also Yve-Alain Bois, 'Kahnweiler's Lesson', *Representations*, No. 18 (Spring 1987), pp. 33-68.

4 Kurt Schwitters, 'Merz. Für den Ararat geschrieben' (1920), in: Friedhelm Lach (ed.), *Kurt Schwitters. Das literarische Werk*, DuMont, Cologne 1973-81, vol. 5, p. 77. English transl. by Ralph Mannheim, 406. See also *Der Ararat. Glossen, Skizzen und Notizen zur Neuen Kunst*, 2, no. 1 (Munich, January 1921). 'Merz will Befreiung von jeder Fessel (...) Merz bedeutet auch Toleranz in bezug auf irgendwelche Beschränkung aus künstlerischen Gründen. Es muß jedem Künstler gestattet sein, ein Bild etwa nur aus Löschblättern zusammenzusetzen, wenn er nur bilden kann.'
5 'Kurt Schwitters' (1930), in: Lach (ed.), *Kurt Schwitters. Das literarische Werk*, vol. 5, p. 335. Originally published in: Heinz and Bodo Rasch (ed.), *Gefesselter Blick. 25 kurze Monografien und Beiträge über neue Werbegestaltung*, Wissenschaftlicher Verlag Dr. Zaugg, Stuttgart 1930, pp. 88-89. "Im Kriege da hat es furchtbar gegoren. Was ich von der Akademie mitgebracht habe, konnte ich nicht gebrauchen, das brauchbare Neue was noch im Wachsen. (...) Und plötzlich war die glorreiche

Schwitters turned his attention to collage in 1918/19 several years after the cubists; until then he had been a fairly traditional painter who was beginning to receive some favourable reviews in local papers for his broadly painted naturalistic portraits, still lifes, and landscapes. When he did turn to collage, Schwitters did so because he was searching for means with which to express the fundamental social and political transformation the war and the birth of the Weimar Republic had brought about. Collage, as a language of fragmentation, embodied the break with tradition; as a non-hierarchical mode of representation, it expressed social values associated with a democratic form of government. Said he in 1920: "Merz [the term he used for all his collage work] stands for the freedom from all fetters. (...) Merz also means tolerance towards any artistically motivated limitation. Every artist must be allowed to mold a picture out of nothing but blotting paper, for example, provided he is capable of molding a picture."[4] In his often-quoted autobiographical essay of 1930, Schwitters linked more firmly his adoption of collage in the immediate post-World War I period to the political events of the day: In the war, things were in terrible turmoil. What I had learned at the academy was of no use to me and the useful new ideas were still unready. (...) Then suddenly the glorious revolution was upon us. (...) I felt myself freed and had to shout my jubilation out to the world. Out of parsimony I took what I could find to do this, because we were now an impoverished country. One can even shout with refuse, and this is what I did, nailing and gluing it together. I called it 'Merz;' it was a prayer about the victorious end of the war, victorious as once again peace had won in the end; everything had broken down in any case and new things had to be made out of the fragments: and this is Merz.[5]

For the cubist artists, collage provided the tool with which to explore the condition of representation and the changes in perception initiated by modern science and physics as well as the advances of capitalism and consumer culture[6]; for Schwitters, collage became first the instrument with which to make visible his rejection of bourgeois culture and which afforded him an experimental engagement with the new; later, when living in exile during and after World War II, collage provided the means with

which to explore the conditions of uprootedness. He, too, would ultimately resort to the metaphor of game playing: "Wir spielen, bis uns der Tod abholt" [We play until death picks us up], but that was only after World War II. It was only then that he began to more systematically explore the critical properties of collage as a play with absence and presence that forms the backbone of cubist collage.

Schwitters' early collages tend to be small and tightly constructed, their strict organization indebted to the cubist grid.[7] Most typically, he would cover the ground completely with the collage elements and arrange them for utmost aesthetic effect, carefully balancing tonal and textural values, transparencies and opaqueness, at times engaging in witty verbal or visual plays with the interplay of typographic and pictorial fragments. The rich accumulation of diverse materials characteristic of his earliest collages of the immediate postwar period gave way in the early 1920s under the influence of De Stijl and constructivist artists to more simplified compositions and greater clarity of form. During the 1930s, particularly during his Norway period when he increasingly turned his attention to organic materials, Schwitters loosened the grid structure to express ideas of growth and organic flux. In his late collages produced during his time in England, Schwitters turned his attention once more to urban materials. In that, the late collages are reminiscent of his earliest, but are larger and more messy in comparison, with a diversity of materials affixed helter-skelter to the supporting ground, the pleasures of visual refinement derived from meticulous construction evidently no longer a goal. During this last period of his life, Schwitters also extended his interest in collage with renewed vigour to the production of assemblage paintings, sculpture, and the building of a new *Merzbau*.

Mz. 231. Miss Blanche, 1923 is a typical work of the early period. It shows the influence of his friends Theo van Doesburg and Vilmos Huszár with whom he had recently completed his Holland Dada tour and indeed several of the paper fragments bear witness to his Holland trip. Like his De Stijl colleagues, Schwitters arranged the collage elements in a tightly constructed grid pattern and, to reinforce the geometry of the design, he cut the papers with scissors to

Revolution da. (…) Ich fühlte mich frei und mußte meinen Jubel hinausschreien in die Welt. Aus Sparsamkeit nahm ich dazu, was ich fand, denn wir waren ein verarmtes Land. Man kann auch mit Müllabfällen schreien, und das tat ich, indem ich sie zusammenleimte und -nagelte. Ich nannte es Merz, es war aber mein Gebet über den siegreichen Ausgang des Krieges, denn noch einmal hatte der Frieden wieder gesiegt. Kaputt war sowieso alles, und es galt aus den Scherben Neues zu bauen. Das aber ist Merz."

[6] See, for example, John Berger's account of Cubism in his *The Success and Failure of Picasso*, Pantheon, New York 1989 (1965[1]).

[7] John Elderfield, *Kurt Schwitters*, Thames & Hudson, London and New York 1985, pp. 82-84.

Kurt Schwitters
Miss Blanche, 1923
15,9 x 12,7 cm
Collage,
private collection

give them sharp edges and clear rectilinear form. He conjoined the papers in a carefully manipulated pattern of overlapping and adjoining shapes of white and ochre. While paying homage to De Stijl, *Mz. 231. Miss Blanche* also visualizes Schwitters' reflections on the limitations of neoplasticist doctrine: it introduces decorative elements and with them themes of the exotic and desire. The decorative, so alien to De Stijl, is conjured up on several planes: in the subtle colour relationships of creamy white and delicately modulated yellowed beige papers exquisitely layered to reveal and cover up, and the elegant use of typography. *Mz. 231* returns to the theme of women and desire Schwitters had addressed in of some of his earlier collages, such as *Mz. 180. Figurine,* 1921 and *Mz. 158. Das Kotsbild* [Vomit Picture], 1920, but without the derision of women evident in the earlier work. Miss Blanche is 'fine/superfine,' the exotic other, Egyptian, obtainable, and linked to fantasies of distant lands as indicated by the image of the pyramids and the sphinx below. Miss Blanche, like the cigarette her name advertises, is to be consumed as a colonial body ripe for conquest. Enacting operations of framing, distancing, and revealing, the collaged papers function not only as signifiers of space and ground, but also of desire. In spite of his assurances that collage made visible his break with tradition, this collage as so many others from his early period, makes clear that Schwitters conceived of collage above all as an enrichment of his pictorial language, an augmentation rather than rejection: *Miss Blanche* is thoroughly indebted to the orientalist tradition in Western painting.

The collage *47.15 pine trees c 26,* 1946, looks sloppy in comparison. It has little of the tightness and preciousness that characterized his collages from the early 1920s. Here, uneven vertical strips of cut and torn coloured and imprinted papers are loosely arranged on a ground of corrugated cardboard visible throughout the entire composition. The colour scheme has nothing of the subtleties of the earlier collage: battleship grey predominates, augmented by black and blue, and set off with dull whites and muddied yellow. The strips of paper are built up haphazardly, some bear traces of imprinted papers that had previously stuck to them, others are painted with a few bold strokes of the brush, others still carry fragmented photographic reproductions; all seem almost

squeezed into, rather than artfully arranged on top of the vertical ribs of the corrugated cardboard. Neither desire nor the decorative figure in this collage are absent, of course, absent are also the pine trees. Although the title evokes a pastoral scene, the materials carry with them connotations of machine production; only the sparse pencil marks in the centre may be vaguely reminiscent of pine needles, but function above all as the dialectical opposite of the machine produced-patterns of black and white.

No wonder critics have derided Schwitters' late work as lacking refinement and control. The artist seems to have given up his dominion over his collage materials, and the aesthetic subtleties of the early work have given way to coarseness and grittiness. Critics have attributed this change in Schwitters' approach to collage to his personal history, his experience of uprootedness, life in exile, and personal tragedy: "Schwitters' work in England is (...) overshadowed by resignation and the tragedy of an uprooted life. His art has lost the certainty of aim, and therewith its steady orientation. (...) His instrument no longer resounds with the old purity, and all the sounds refer to the player."[8]

In a similar vein, Schwitters' biographer, Ernst Nündel, saw the late collage *Ein fertiggemachter Poet* [A ready-made Poet], 1947, as an apt summation of his life in exile.[9] In this work Schwitters used paper fragments and paint to cover a portrait of the poet Shelley, revealing only his closed mouth, neck, hand, and pen. Robbed of his identity and reduced to a silenced presence, Shelley (who died abroad lonely and forgotten) becomes the dispossessed poet and Schwitters' stand-in. The title further enhances the allusions and cross references suggested by the image: 'fertig gemacht' ('ready-made,' as in the use of a reproduction) evokes the process of collage itself; but it also suggests a psychological or physical state, as in 'being at the end of one's rope' or 'knocked out.' Both point to Schwitters the artist, as the witty player with process and meaning and as the resigned individual living in exile, temporally and physically cut off from the lively, challenging and reciprocal relationships that characterized the pre-war international avant-garde on which his work depended. John Elderfield offers a more appreciative view of the inventiveness and experimentation of Schwitters' late work: "But what takes place is not so much a decline as a

[8] Werner Schmalenbach, *Kurt Schwitters*, Harry Abrams, New York 1967, pp. 162 and 167. Schmalenbach has since then changed his position in favour of a more positive evaluation. Cf. Seibu Museum of Art, Tokyo, *Kurt Schwitters*, exh. cat., 1983, p. 147.
[9] Ernst Nündel, *Kurt Schwitters in Selbstzeugnissen und Bilddokumenten*, Rowohlt, Reinbek bei Hamburg 1981, p. 114.

Kurt Schwitters
Green and Red, 1947
33,5 x 29 cm
Collage,
private collection

reassessment. In an important sense, the late assemblages are the most daring of Schwitters' work."[10] But Elderfield also carries over expectations shaped by Schwitters' early work and uneasily notes the dissolution of order and structure of what he calls 'the resistant Cubist plane or grid' underlying the early work: "The late works seem at times unbearably casual, uncomfortable in Schwitters' refusal to be bound by the structures he had depended upon for so long, although these structures would have guaranteed him (as they had done in the past) more coherent and ordered results. Here again we may be tempted to see the uncertainty and disorientation of Schwitters' personal life reflected in the changes in his art."[11]

Loss of 'certainty of aim' and of 'purity,' 'refusal to be bound to old structures,' 'unbearably casual,' Schwitters' work, so we must conclude from these accounts, was contaminated by exile. Schwitters' artistic will was slackening under the impact of personal tragedy. But what about his tremendous productivity (1946 and 1947 were the most productive years of Schwitters' entire career), the evident delight in experimentation and exploration of new pictorial materials, his earlier reports from the internment camp on the Isle of Man in which he described his life in a lively community of cultured expatriates, his new connections and friends in London and later in the Lake District? And what are we to make of the more assured size of the late collages that has replaced the precious scale of the early works? Schwitters indeed produced his late works under the extreme conditions of personal trauma and ill health, but the works from this period show a vigour and inventiveness largely absent from the earlier works. Exile and trauma seem to have freed Schwitters from his attachment to the decorative; he no longer domesticates his materials but gives them full rein to display their different registers so that looseness and grit become values in their own right.

Schwitters' late work is characterized by a remarkable emphasis on oscillation: physically, in the unstable surfaces in which layers of collage blend into loosely painted fields of tufted colour; conceptually, in the question of the supremacy of art over mass culture, evident in his placements of fragments of photographic illustrations or line drawings gleaned from the contemporary mass

[10] Elderfield, *Kurt Schwitters*, op. cit., p. 213.
[11] *Ibid.*, p. 213.

media next to reproductions of the works of the Old Masters; psychologically, in the overcoming of distance, as when postage stamps serve as substitutes for friends in far-away places and are conjoined with scraps of paper bearing Schwitters' current address. In the late work we witness a radicalization of his working method and an evident disregard for norms; technique and historical imagination now coincide to comment on the condition of exile.

Marginality was of course always the operative in Schwitters' work. Schwitters lived in Hanover, rather than Berlin, the centre of the avant-garde in the Weimar years. Marginality had flavoured the development of his Merz (i. e. collage) art with its specific combination of radical innovation and insistence that art should not fall prey to topicality. Yet, after 1940, and especially after 1945, a noticeable shift in his position on the margin had taken place.[12] It was only in England that Schwitters replaced the traditional bonds of family, of filiation, with the new bonds of affiliation – a situation sociologists describe as a typical manifestation of displacement that is the formative experience of the modern. In this last phase of his life, Schwitters was an outsider while at the same time connected to his new environs through his English companion, Wantee.

Green and Red, 1947 speaks eloquently of Schwitters' changed circumstances, but more importantly, it demonstrates how Schwitters was now able to take the conditions and emotions associated with exile as the basis of successful pictorial innovation. The collage is composed of a few pieces of loosely arranged pieces of torn and cut papers, some a dark ochre, others off-white, two blue and one red, all laid down on greyish corrugated cardboard which provides a prominent vertical pattern and regular rhythm. The slightly askew placement of the paper fragments, however, which all seem to tumble out of the frame towards the lower right hand corner disturb the rigid verticality and initiate a visual oscillation between verticality and horizontality. Most striking is the absence of decorative elements, an exception perhaps the epistolary flourish 'Par avion' on a large off-white paper scrap just above center. The small blue paper fragment in the lower left, however, clearly indicates that the decorative tradition is now defunct: it bears the

[12] To escape Nazi persecution, Schwitters together with his son Ernst (who had left two weeks earlier) had fled Germany to Norway in January 1937, where they settled in Lysaker, near Oslo. Father and son escaped to England when the Nazis invaded Norway in 1940. There Schwitters was placed in internment camps until December 1941, when he and Ernst settled together in London. During this time, and particularly in 1944, Schwitters' life was marked by several personal tragedies: in that year, a heart attack left him partially paralyzed; he learned of his wife's death from cancer while attending the opening of his exhibition at the Modern Art Gallery in London in December (Helma did not follow Schwitters into exile but had stayed behind in Hanover to take care of family matters). During this time he also found out that the *Merzbau*, which he considered his most important work, had been destroyed in a bombing raid on the city of Hanover. Schwitters himself suffered not only the partial paralysis, but several other severe bouts

barely legible imprint of a line drawing depicting a sideboard with a display of several bottles and plates. Like *Pine trees*, this collage is stark in its simplicity and even bolder in its reductiveness. Yet, while simple and stark, Schwitters engages in *Green and Red* in a sophisticated play with absences. In this collage, he shows himself heir to cubist linguistic game playing. He is closer here to his artistic forebears than in his early work and truer to the spirit of cubism than Picasso himself in his own later development.

A comparison with Picasso's well known cover collage for *Minotaure*, no. 1, 1933 will show how far Picasso in his later collages had digressed from the theoretical premises that marked his cubist collage work; it will also reveal how Schwitters managed to infuse collage with new vigour. Picasso, too, used corrugated cardboard as the background material for his collage turned so that its ribbed lines run horizontally from left to right. On top of this supporting ground Picasso affixed several decorative fragments: two pieces of cream-coloured ribbon, a paper doily with an attractive lacy edge, two pieces of crumpled and patterned aluminum foil above and below, a length of wallpaper border with a leaf design highlighted with gold and gouache directly behind the figure of the minotaur, and three leaves to the right, allusively mirroring the oversize oyster shucker in the minotaur's right hand, all arranged to decoratively frame the central image of the minotaur whose bulging muscles and bovine face embody masculine energy and lust. The decorative collage elements not only serve as adornment of the phallic minotaur, but also as signifiers of his sexual desire.

There is no central figure in Schwitters' collage, no bullish stand-in. The central supporting axis is pushed off to the right as a thin band which slants towards the upper right and is barely capable of anchoring the flutter of torn papers. Where Picasso amassed signifiers of the decorative, Schwitters alluded to the decorative as a broken tradition, and where Picasso affirmed the language of art and the presence of the artist with the assertively drawn figure of the minotaur as well as multiple references to the iconic tradition of oil painting (the wooden support, allusion to frame, title), Schwitters only notes absence. Picasso's collage presents itself as what Mikhail Bakhtin has termed a self-sufficient,

with illness that left him profoundly weakened until his death in January 1948. At the end of the war, Ernst Schwitters moved back to Norway and became a Norwegian citizen, while Schwitters moved to the Lake District with his new companion, Edith Thomas ('Wantee'). While Schwitters had never visited England before the war and spoke the language only badly, he as so many other German emigrants nevertheless refused to speak his native language and applied for British citizenship as soon as was possible (which was granted to him the day after his death).

closed authorial monologue. Schwitters' collage, in turn, questions the possibility of representation by referring to the very problem of language itself.

Bakhtin observed that a unitary language gives expression to forces working toward concrete verbal and ideological unification and centralization, which develop in vital connection with the processes of sociopolitical and cultural centralization.[13] As a collage of independent and only loosely attached parts, Picasso's *Minotaure* works against the forces of unification. Indeed, the thumbtacks underscore representation as artistic construct. Picasso's evocation of the romantic notion of the artist as creator, however, his broadcasting of his skills as a draftsman within a collage of ready-made materials, his various references to the iconic tradition of painting in the centralized placement of forms affirm the rule of traditional aesthetics. Ideologically, this work is firmly embedded in a high-art tradition, even if (or especially as) it caters to the Surrealist fascination with sexual taboos. Politically, it reaffirms gender relations as a particular manifestation of male dominance. Picasso toys with the deconstruction of norms by referring back to his cubist accomplishments without, however, attempting the paradigm shift that he achieved with his earlier work: the artist's stand-in, the conquering minotaur, sits firmly on top.

Pablo Picasso
Design for Minotaure, 1933
Museum of Modern Art,
New York

Where Picasso placed an iconic representation of the artist, Schwitters placed nothing or rather, a signifier of nothingness. The centre of Schwitters' collage is marked with the outer edge of the pale blue cigarette paper, noteworthy for its lack of inscription. The actual focal point is slightly to the left of centre and is formed by the official looking two words 'Sprache/Language' which are imprinted on a smallish piece of ochre paper bounded by sharp edges on two sides, and softly torn edges on the other two. Its placement is crucial because its slight distance from the actual centre of the composition draws attention to 'centre' as a critical concept. Schwitters debunks the notion of a single authority with the introduction of heteroglossia.

The two words 'Sprache/Language' are like a mathematical division separated by a horizontal line so that the viewer's eye moves back and forth between them. As the two words describe the same concept, albeit in German and English, 'Sprache' and

[13] Mikhail M. Bakhtin, 'Discourse in the Novel', in his *The Dialogic Imagination*, University of Texas Press, Austin and London 1981, p. 273, transl. by Caryl Emerson and Michael Holquist.

'Language' are placed in a dialectical relationship and connote the absence of a unifying tradition. Language, any language, is revealed as a form of translation, of representation, rather than absolute truth. Schwitters expands his play with the concept of language with the text fragments above and below. 'Par avion' introduces French into the network of languages; as handwritten text, it contrasts the personal with the official, whereas the text beneath, 'WATT's the use of living,' conjures up the technological world of machines. Both text fragments add visual and conceptual oscillation to the composition. As a question about the meaning of life uttered by an artist living under trying conditions in exile, 'WATT's the use of living' undoubtedly also suggests a reading of these different textual elements in terms of personal biography. The personal is an important aspect of this work but certainly not the only one. The success of this collage lies not in the manifestation of personal trauma, but rather in Schwitters' ability to marshal the language of collage to make manifest the condition of exile. As Brecht observed in his *Flüchtlingsgespräche*, emigration provides the best lesson in dialectics.

There is a most likely unintended additional element in Schwitters' play with the linguistic sign. The coupled 'Sprache/Language' with its horizontal separation line and the small 's' on the blue paper next to it is printed like the Saussurian shorthand for the relationship between signifier, signified and sign. Be it as it may, Schwitters clearly engages here the linguistic understanding of the operation of the sign and fully exploits its diacritical nature. The sign according to Saussurian linguistics is never absolute but rather must be understood as a term whose meaning is derived as a choice made from different possibilities. Meaning, we remember, is determined by that which is not chosen, so that the notion of absence becomes therefore one of the preconditions of the operation of the sign. Referring to different national languages and contrasting public and private speech, Schwitters points to an absent centre and loss of origin as the determining characteristics of an emigrant's life.

His success in translating the idea of absent origin commonly associated with emigration to the actual operations of the collage is evident in other aspects of this work as well, particularly in his treatment of the corrugated cardboard as the supporting ground.

Significantly, as in *47.15 pine trees*, and other late collages, Schwitters liberates the ground from its supporting role and emancipates it as a full partner in pictorial discourse. This is especially visible at the right hand margin where the ribs of the corrugated cardboard echo the vertical axis of the frame-like thin strip of superimposed paper, but also throughout the composition when the corrugated cardboard is given centre stage. The ground, as formerly in cubist collages, effects a continual transposition between negative and positive space, and as Rosalind Krauss has pointed out, this 'formal resource derives from collage's command of the structure of signification: no positive sign without the eclipse or negation of its material referent.'[14]

Not the least, the title itself, *Green and Red*, draws attention to absence and amplifies perceptual oscillation. 'Green' signifies natural abundance, but there is no green in this collage nor are there references to the organic, except in the phrase 'WATT's the use of living' which defines life as endangered. As a colour green is the opposite of red and thus implies a dialectical relationship between the two, conjuring up red's absent partner much like the 'Par avion' and the various scraps from envelopes invoke Schwitters' absent correspondent, and the fragment of a piece of furniture the lost decorative tradition.

Used to thinking of Schwitters as the protagonist of his late collages, the comparison between Picasso's *Minotaure* collage and Schwitters' *Green and Red* brings out the unexpected. Picasso placed himself at the centre of his collage, reaffirming authorship and masculine power, whereas Schwitters removed himself from the centre of his composition and replaced his authorial control with a reference to language: Inscription replaces representation. The removal of the author implies, so Roland Barthes has argued, a radically different temporality and utterly transforms the text. Without the author as progenitor, there is no 'before' and 'after;' 'there is no other time than that of the enunciation and every text is eternally written *here and now*. The fact is (...) that *writing* can no longer designate an operation of recording, notation, representation, 'depiction;' (...) rather, it designates exactly what linguists (...) call a performative (...) in which the enunciation has no other content (...) than the act by which it is uttered.' Without the

[14] Rosalind Krauss, 'In the Name of Picasso', *op. cit.*, p. 16.

author, there is only 'a pure gesture of inscription' which 'traces a field without origin – or which, at least, has no other origin than language itself, language that ceaselessly calls into question all origins.'[15]

The organic is associated with origin and not surprisingly it figures in Schwitters' late collages as in *Green and Red* and *47.15 pine trees* mostly as absence. This is significant, because the organic was always one of Schwitters' key concerns and he never lost sight of its utopian potential.[16] In the last months of his life when he began anew work on a *Merzbau*, the Merzbarn, Schwitters initiated once again a separation between the various aspects of his work. Collage in the Merzbarn, that is, collage as assemblage, embraces the organic, treats in fact the ground as a decidedly organic matrix in which pebbles, branches, and other materials are embedded as in a fertile ground. The individual collages and assemblage paintings, however, consistently point to the organic as a broken tradition. In numerous late works, Schwitters evokes the organic by means of quotation, particularly of his stippled brushwork of his highly organicist Norway paintings. In *Oval Painting*, 1947, for example, the stippled brushmarks which he employed in his Norwegian paintings are here singled out and enclosed by a painted oval frame placed within a rectangular canvas; they are thus taken out of an organic flow and function as a transportable fragment, as quotation. In *Invisible Ink* and *Examiner 2861*, both 1947, the relationship between frame and composition is reversed as Schwitters assigned to the organic (again symbolized by the pronounced brushmarks) the function of a frame to enclose rectangular collages made with fragments of urban life (transportation tickets, newspaper clippings, and the like). In his late works, Schwitters monumentalizes and objectifies his own collage style and boldly mingles the signifiers of the pastoral and organic with the signifiers of the urban and technological. All are equally disembodied, uprooted signs of a lost tradition.

Origin is also called into question in Schwitters' use of mass cultural materials, particularly photographic reproductions. Unlike the Berlin Dadaists Schwitters had rarely used photographs or mass media reproductions as collage material; more commonly, Schwitters would select his materials not as a shortcut to repre-

[15] Roland Barthes, 'The Death of the Author', in: *Image, Music, Text*, Hill and Wang, New York 1977, pp. 145-146, transl. by Stephen Heath.
[16] For a discussion of the organic in Schwitters' work, see John Elderfield, *op. cit.*, and Dorothea Dietrich, 'Merz and the Longing for Wholeness', in: Charlotte Stokes and Stephen C. Foster (eds.), *Dada Cologne Hanover*, G. K. Hall, New York 1997, vol. 3 of *Crisis in the Arts. The History of Dada*, pp. 109-35.

sentation but for properties of colour, texture, or design, often favouring the worn over the shiny and new, and sometimes exploring the text fragments on newsprint or wrapping paper for their possible anecdotal properties. In England, however, there is a notable shift in emphasis: after his frequent use of organic materials in Norway, photographic reproductions in their various incarnations now begin to play a major role. Schwitters culled them from the contemporary media and usually included them only as fragments.

(Counterfoil), ca. 1942-43, is a densely constructed collage of photographic reproductions which form a rich accumulation of diverse images, ranging from fragments of city views, landscapes, reproductions of old master paintings, contemporary advertisements featuring mostly glamorous women, snippets of advertising copy, as well as some ticket stubs, envelopes, and other snippets of imprinted papers. The supporting ground is not visible in this collage, but the manifold images of vastly different scale and the bold angles of several paper fragments create a lively, constantly fluctuating surface which Schwitters further activates by veiling some areas with thinly applied pigment. Other works, like *c 63. old picture*, 1946, employ photographic reproductions more sparingly, but similarly obfuscate the separation between figure and ground.

In these collages with photographic reproductions, there is often no ground visible, but neither is there a continuous surface; instead, the image constitutes itself out of a series of distinct segmentations, each of which possesses sufficient signal power to be noticed. The entire image can thus be understood as having been composed as a series of individual 'pregnant moments' which are uneasily suspended between different spatial registers. Lessing defined the pregnant moment as the summation of perfect instants which the painter or sculptor had at his disposal to tell a story in the arrested form of pictorial or sculptural representation. Barthes considers Brecht's theater and Eisenstein's cinema as series of pregnant moments and poignantly defines this crucial instance as "this presence of all the absences (memories, lessons, promises) to whose rhythm History becomes both intelligible and desirable."[17]

Schwitters' collages usually do not carry a message with the hieroglyphic clarity of a Brecht or Eisenstein montage; because of their constant visual and conceptual oscillation, they operate in a less defined manner. Yet, in Schwitters' late collages, history becomes intelligible. It is history as experienced by the stranger, the figure the sociologist Georg Simmel defined as 'the man who comes today and stays tomorrow.'[18] Simmel describes the special position of the stranger in terms of spatial relations: 'In the case of the stranger, the union of closeness and remoteness involved in every human relationship is patterned in a way that may be succinctly formulated as follows: the distance within this relation indicates that one who is close by is remote, but his strangeness indicates that one who is remote is near. That state of being a stranger is of course a completely positive relation; it is a specific form of interaction.'[19]

Schwitters in exile recognized that his position as a stranger in his newly adopted land afforded him an unusual degree of freedom. In the best of his late collages, he was able to translate the experiences strangeness and familiarity, absence and presence, indifference and involvement into vehicles for the apprehension of truth: the fact that marginality had become the normative experience of postwar society.

[17] Roland Barthes, 'Diderot, Brecht, Eisenstein', in: *Image, Music, Text*, op. cit., p. 73.
[18] Georg Simmel, 'The Stranger' (1908), in: Donald N. Levine (ed.), *Georg Simmel. On Individuality and Social Forms*, The University of Chicago Press, Chicago and London 1971, p. 143.
[19] *Ibid.*, p. 143.

Schwitters picks flowers for 'the paradise of colours'
1920s
Photo: Kate Steinitz

Aq. 36. Das ist das
Biest, das manchmal
niest, 1918
20,7 x 17,2 cm

Z 71, Der Einsame (1)
1918
16,1 x 10,6 cm

Z 41, Der Einsame (2)
1918
15,6 x 10,7 cm

75

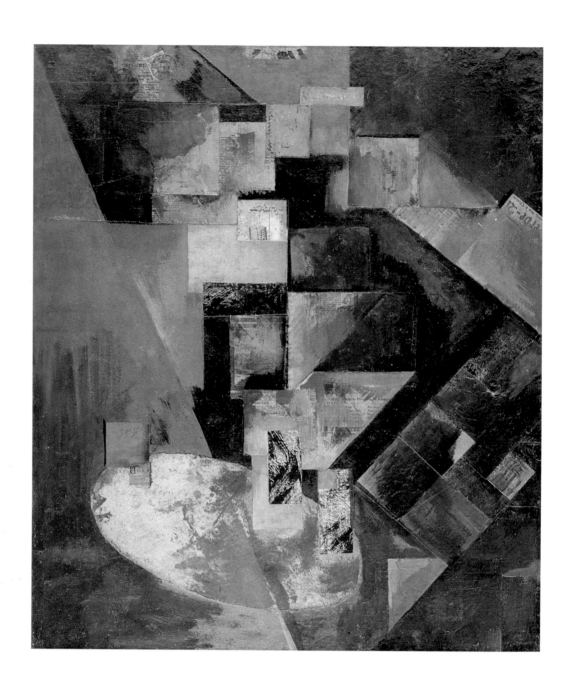

Merzbild 1 B
Bild mit rotem Kreuz
1919
64,5 x 54 cm

76

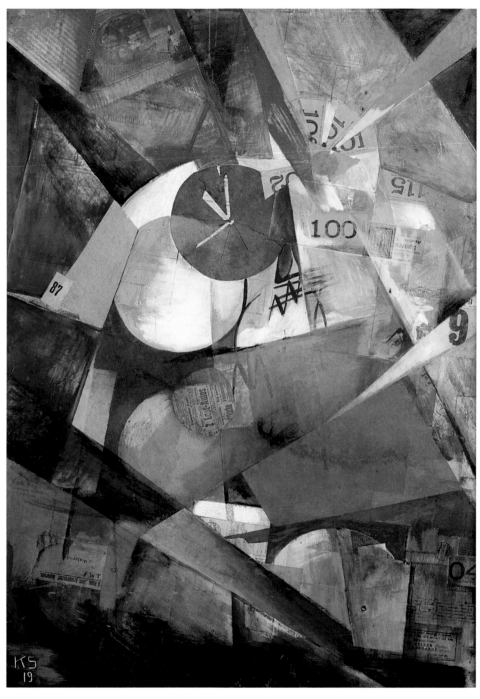

Merzbild 9 B
Das große Ich-Bild
1919
96,8 x 70 cm

77

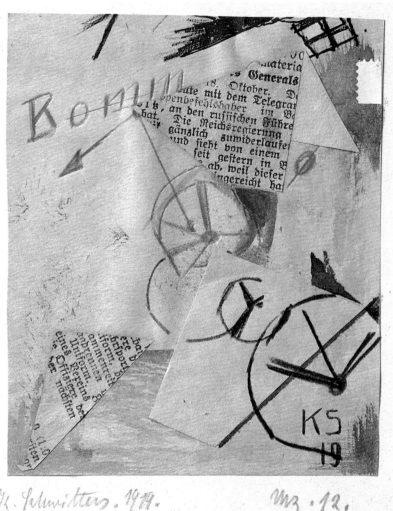

Mz. Bommbild

1919

12 x 9,8 cm

Windmühle
1919
15 x 12 cm

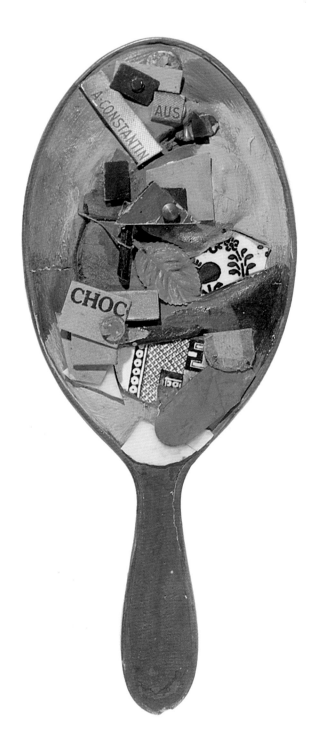

Miroir-Collage
1920-22
28,5 x 11 cm

80

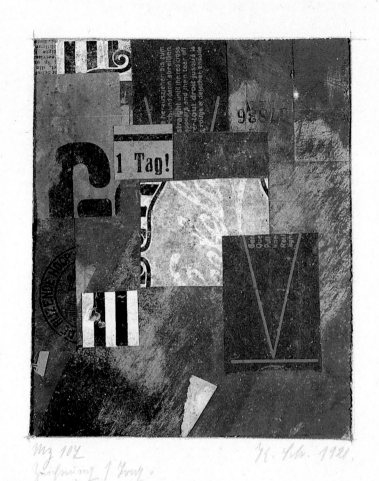

Merzzeichnung 107
1921
17,3 x 14 cm

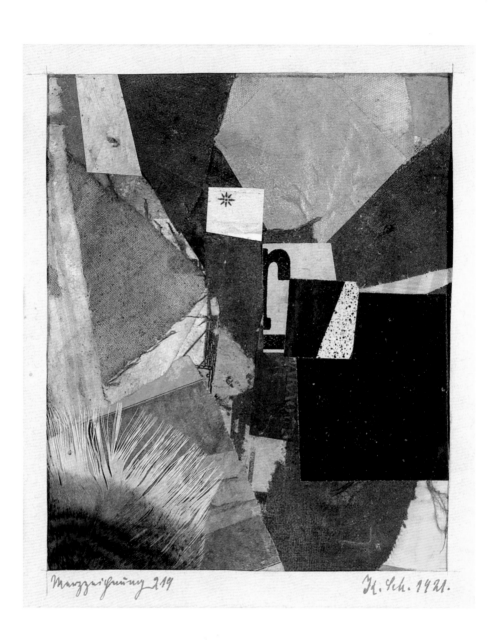

Merzzeichnung 219
1921
17,3 x 14 cm

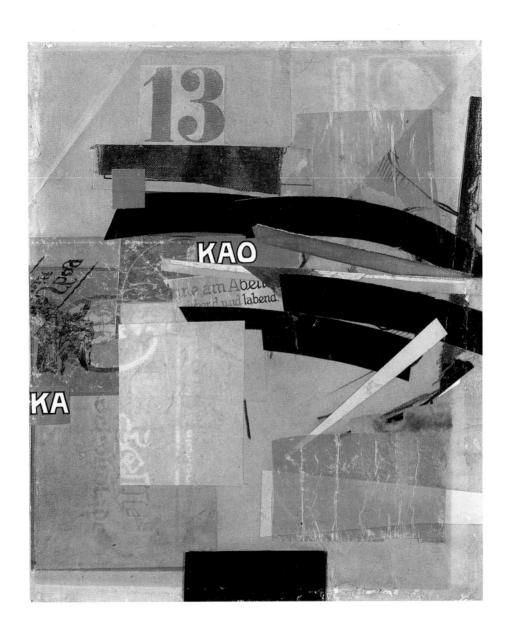

Ohne Titel
ca. 1922
29,4 x 24 cm

83

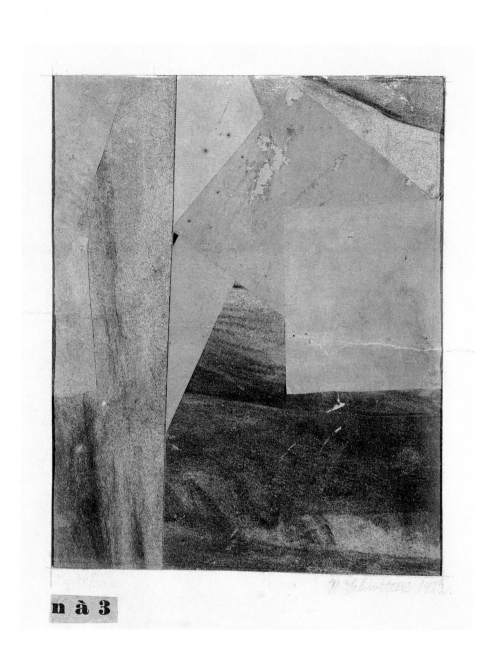

n à 3 (Mz 367)
1922
32,4 x 24,7 cm

84

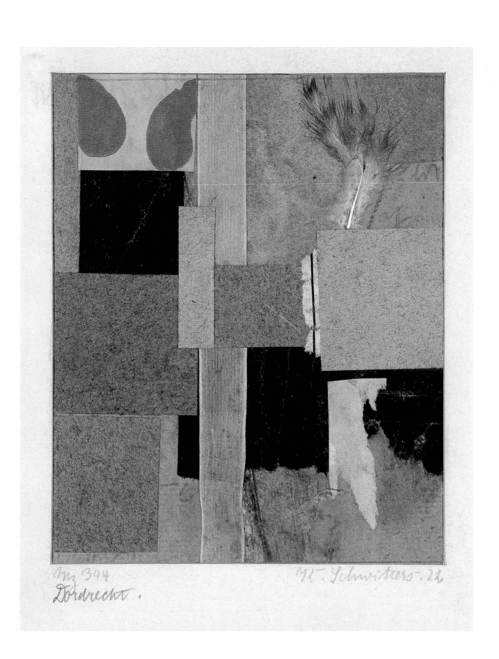

Dordrecht (Mz 344)
1922
20,5 x 17,5 cm

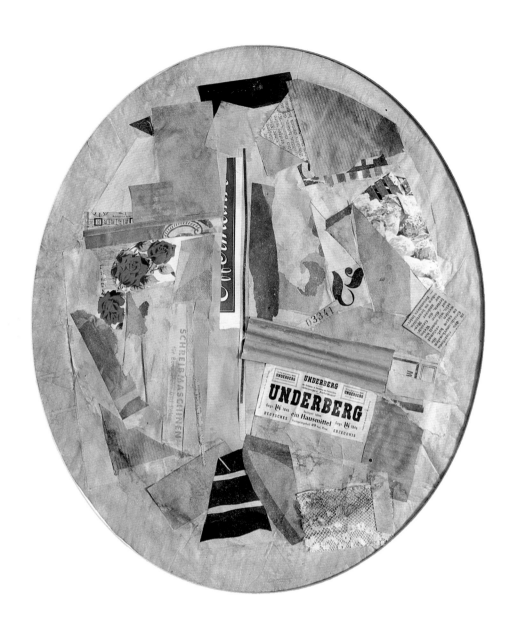

Oval (Underberg)
1926
37 x 31,9 cm

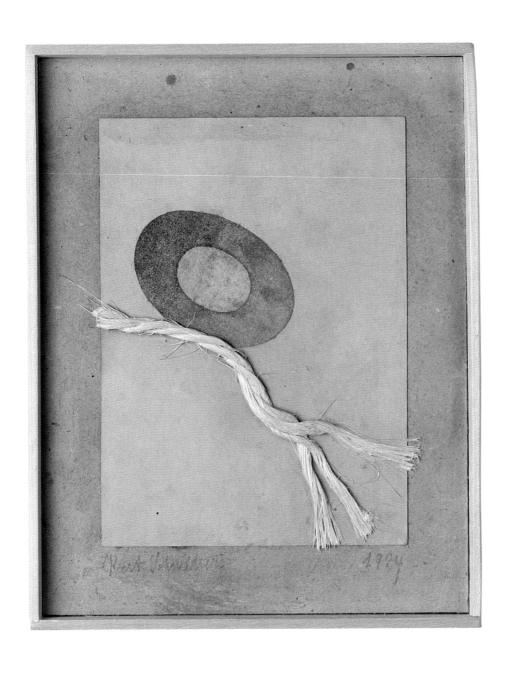

Hommage à Jean Arp
1924
20 x 14,5 cm

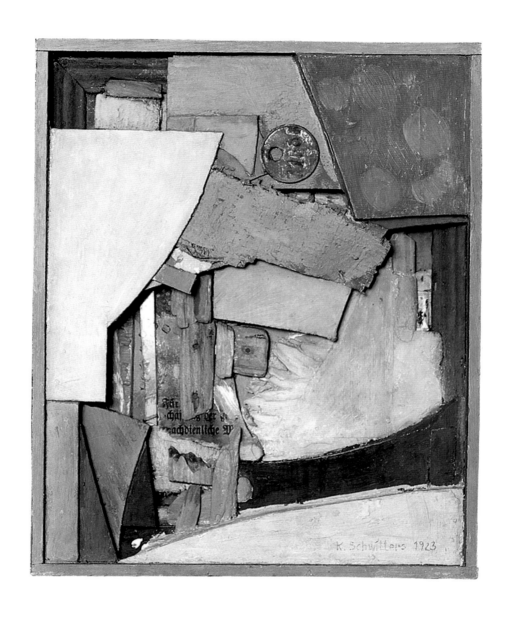

Relief
1923
35,5 x 30 cm

88

Eve Blossom Has Wheels

Kurt Schwitters

Merz Poem 1

O thou, beloved of my twenty-seven senses,
I love thine!
Thou thee thee thine, I thine, thou mine, we?
That (by the way) is beside the point!
Who art thou, uncounted woman,
Thou art, art thou?
People say, thou werst,
Let them say, they don't know what they are talking about.
Thou wearest thine hat on thy feet, and wanderest on thine hands,
On thine hands thou wanderest
Hallo, thy red dress, sawn into white folds,
Red I love eve Blossom, red I love thine,
Thou thee thee thine, I thine, thou mine, we?
That (by the way) belongs to the cold glow!
eve Blossom, red eve Blossom what do people say?
PRIZE QUESTION: 1. eve Blossom is red,
2. eve Blossom has wheels,
3. what colour are the wheels?
Blue is the colour of your yellow hair,
Red is the whirl of your green wheels,
Thou simple maiden in everyday dress,
Thou small green animal,
I love thine!
Thou thee thee thine, I thine, thou mine, we?
That (by the way) belongs to the glowing brazier!
eve Blossom,
eve,
E-V-E,

E easy, V victory, E easy,
I trickle your name.
Your name drops like soft tallow.
Do you know it, eve,
Do you already know it?
One can also read you from the back
And you, you most glorious of all,
You are from the back as from the front,
E-V-E-.
Easy victory.
Tallow trickles to strike over my back!
eve Blossom,
Thou drippy animal,
I
Love
Thine!
I love you!!!!
(ca. 1919)

Merz Painting

Kurt Schwitters

Merz paintings are abstract works of art. The word 'Merz' essentially means the totality of all imaginable materials that can be used for artistic purposes and technically the principle that all of these individual materials have equal value. Merz art makes use not just of paint and canvas, brush and palette, but all the materials visible to the eye and all tools needed. It does not matter whether the materials used were originally made for any particular purpose or not. The wheel off a pram, wire mesh, string and cotton balls – these are factors of equal value to paints. The artist creates by choosing, distributing and reshaping the materials.

Reformulation of the materials can be achieved through their distribution on the picture surface. This is aided by division, twisting, covering or painting over them. In Merz art, the crate cover, the playing card, the newspaper clipping become surfaces; strings, brushstrokes or pencil strokes become lines; a top layer of paint or stuck-on sandwich wrap become glazing; cotton balls are used for softness.

Merz art strives for immediate expression by shortening the path from intuition to visual manifestation of the artwork.

For those honestly prepared to follow me, these words should make it easier to empathize with my art. Not very many will want to. They will receive my new work as they always have when something new presents itself: with indignation and screams of scorn. (1919)

Autobiography of Kurt Schwitters

June 6, 1926

Sent to Hans Hildebrandt probably in response to a request for biographical material.

The facts of one's life are not especially interesting to write about: one can't lie, one hasn't experienced anything significant, and yet one lives. Exept for a fortuneteller, isn't it entirely unimportant then I was born? But I'm not one of those prophets and I don't believe one can grasp the nature of a person from the lines of his hand, the minute of his birth, the events of his life. He is bound to turn out differently than predicted. For example, didn't they prophesy to my mother when I was three years old that I would die soon, while still a child. Now, I'm thirty-nine years old and still living. Indeed, I get one year older every year and I predict that every person will get one year older every year as well, if he doesn't die. For the other prophets, I'll offer the information that I was born on June 20, 1887, unfortunately, somewhat too early since I no longer see my God-like qualities. But all of us are born too early. One can come back again later and then enjoy one's fame. Since only fools are modest, I am, for example, absolutely convinced that I once lived as Rembrandt van Rijn. And I whole-heartedly enjoy the enthusiastic admiration I receive in that guise. By the way, I originally wanted to be a coachman so I could take my mother for outings. Then I had the intention of studying Physics because I have even less talent for that than painting. But I decided for Art and studied at the Hanover School of Applied Arts, for which reason it will become famous and will have a plaque reading 'Here slept, etc.'. Then as I recall, I was the model student for five years at the Academy in Dresden. Also worth a plaque. I studied portrait painting with Bantzer.

As a result, Herr Professor Bantzer became Director of the Academy in Kassel. In between I compromised the Berlin Acade-

my by trying to be accepted as a student there. After four weeks I was dismissed on the grounds that I was a lazy good-for-nothing. I share this fate with Menzel. Thereafter, I joined Kühl's Master Class in Dresden. There, in his studio, Herr Privy Councillor Professor Gotthard Kühl personally sat on my palette and then no longer wished to instruct me. This incident, however, inclined me to abstract art. The palette broke in half. Then I went to Professor Hegenbarth to paint animals and to learn colour. Then the war came. I married and still live in happy matrimony with Helma, born Fischer. My father-in-law is Professor of the Hanover streetcar system. Perhaps you can draw some conclusions about my art from this, if only false conclusions. In the war, I preserved the Fatherland and the history of art by bravery on the home front. I was only a soldier for three months and in an office at that. Then I had myself discharged to practice the following occupation: I drew the moving parts of Hill-clutches at the Wülfel Iron Works. Here, a plaque is also in order. Just as soon as the great and glorious Revolution broke out, I gave notice and now live entirely for art. For a while, I tried to create new forms of art from the remains of the old culture. From this *Merz* painting emerged, painting that happily used every material – Pelikan colors or the rubbish from the rubbish heap. So I experienced the Revolution in the most delightful way and pass for a Dadaist, without being one. As a result, I could introduce Dadaism into Holland with complete impartiality. In Holland, I became familiar with architecture for the first time. Even though I studied architecture for two semesters during the war. Now I have an architectural publishing house, the Aposs Verlag, that has already brought out a 32-page volume on urban building by Ludwig Hilberseimer that you simply must read.

Also, you certainly should have read my magazine, MERZ Number 4. My extraordinary gift for poetry that I discovered in the Revolution also deserves mention. At that time, I composed the well-known poem to 'Anna Blume'. A particularly worthwhile sentence of mine is 'Das Weib entzückt durch seine Beine, ich bin ein Mann, ich habe keine!' Even better are my sound poems: 'Fümmsböwötääzääuu, pögiff, kwiiee. Dedes nn nn rrrr, ii ee, mpifftillfftoo tilll. Jüü kaaß. Rinnzekete bee bee nnz krr müü ziiuu ennze ziiuu rinnzkrrmüü; rakete bee bee. Pumpfftilfftoo?

Ziiuu ennze ziiuu nnz krr müü, ziiuu ennze ziiuu rinnzkrrmüü; kakete bee bee, rakete bee zee. – Fümms bö wö tää zää uu, Uu zee tee wee bee fümmmmms!' if you want to know more, the Sonata is about to be printed. So now at least you have an approximate idea.

Respectfully,

Kurt Schwitters.

Hanover. Waldhausenstr. 5 II (1926)

My New Hat

Kurt Schwitters

Shouldn't think that I never had a hat before; had the nicest hats you can imagine. At home I had a hat that I inherited from my papa. It was a very fine Italian hat, but very worn. There was a hole in the front, where you tip it, and it was brown. Over time, this hole became very – and I mean very – big. So big that I could no longer stand the draught in good health. That was in May. I got jaundice and think there is a causal relationship with that hole. May has always been my unlucky month. I was born in May, too, my first unlucky experience. Once I recovered, I lost my hat, and when I went to Vienna, I went without a hat and lived without a hat. The same from Vienna to Germany. There I bought a very fine hair hat and rode with it to Budapest, and when I stepped out of the train, my hat flew off into the Danube. I came to Germany for a second time without a hat. Then I bought one in Dresden, a very fine velvet hat, and I rode with it to Paris. At Gare de L'Est, a train smashed my new velvet hat. That was in May, too.

Then I bought a very elegant hat in Paris, and it was stolen from me in a café in Weimar. I bought another one in Dessau, and a friend of mine wanted to get out in Karlsruhe, and I didn't, and finally the hat ended up staying behind in the coupé. Then I bought a very, very good one in Stuttgart, and I still have it, and treasure it. It is a pointy hat with a decorative Gamsenbart tuft of chamois on top. So yesterday I was walking around the corner, and the wind blew my hat from my head to the top of a new house. That's it. And then the house collapsed, nothing left, and my Gamsenbart hat came back and put itself right back on top of my head. It's true. (1926)

Kurt Schwitters **Truth**

There are few concepts about which so many rumours circulate than about truth. People tell others 'the truth' when they get rough with them. Many people associate the concept of nobleness with truth. The opposite of truth is supposed to be the untruth that people say when they lie, even if these lies go directly up to heaven. Truth claims to be eternal and godly. I will tell you the truth, my friends: "Truth is a liquid."

You think of wine. In wine, there is truth. Since there is only liquid in wine, no matter how you look at it, it must be a liquid. I am of the opinion that truth is a liquid closer to petroleum. I can back this up with proof.

A competent person I know recently said to me, "I have always wished I could drill into people to drill for truth." He said it literally that way, and that is why I believe him that such an experiment would work, if the government would allow vivisection of people for the purpose of raising the truth.

This truth would then spontaneously flow from the drilled hole, further proof that truth is a liquid.

Now I have asked myself, if truth is in people, why does it not flow out of the many holes already present, making it unnecessary to drill for it? First there are the vast number of pores; you would not need to drill them. In this way, truth is the same as petroleum, which could also flow out of the many holes already present such as water pipes or sewers, but which does not. No, petroleum and truth choose to be drilled.

Now, it could just happen some time that truth could flow freely out of an opening that is already there, just as petroleum could accidentally flow out of water pipes. The mouth could emit

the truth, for example. But what does the mouth do? It eats and eats, and when it finally does give out something, it is usually just, or sometimes unjust, to conceal the truth from being told. Or the ears. At least they conduct the truth out once it has got in, because if you tell someone the truth, they see to it that it goes in one ear and out the other. The eyes however cleverly see around the truth, even when there is such a thick coating of truth on things. (1925-40)

Kurt Schwitters **What a b what a b what a beauty**

What a b what a b what a beauty
What a b what a b what a a
What a beauty beauty be
What a beauty beauty be
What a beauty beauty beauty be be be
What a be what a b what a beauty
What a b what a b what a a
What a be be be be be
What a be be be be be
What a be be be be be be be a beauty be be be
What a beauty.

(1944)

She Dolls with Dollies

Kurt Schwitters

The dollies doll with little dollies,
The little dollies doll with tiny dollies,
The tiny dollies doll with dolly dolls,
The dolly dolls doll with little dolly dolls,
The little dolly dolls doll with tiny dolly dolls,
The tiny dolly dolls doll,
But no one dollies with she.
O thou my darling dolly,
I get to feel so jolly
When I do press my muzzle
Against your guzz – and guzzle.
Dolly jolly
Jolly dolly
Dolly guzzy.
Guzzly dolly dolly lady
First they muzzle then they guzzle.

(1944)

When I was born, 20.6.87, I was influenced by Picasso to cry. When I could walk and speak I still stood under Picasso's influence and said to my mother: 'Tom' or 'Happening' meaning the entrances of the canal under the street. My lyrical time was when I lived in the Violet Street. I never saw a violet. That was my influenced by Matisse because when he painted rose I did not paint violet. As a boy of ten I stood under Mondrian's influence and built little houses with little bricks. Afterwards I stood under the influence of the Surrealists, because when they painted natural things with their phantasy, I refused to tear out the wings of the flies for throwing them in the air. I never stood under influence of the Dadaism because whereas the Dadaist created Spiegeldadaismus on the Zurich Lake, I created MERZ on the Leineriver, under the influence of Rembrandt. Time went on, and when Hans Arp made concrete Art, I stayed Abstract. Now I do concrete Art, and Marcel Duchamp went over to the Surrealist. I became an admirer of Chirico, when Chirico went to the Classics, and at all I have much fun about Art. Life and history of Art is as simple as the human spirit, for example Philosophy. I think I shall create now the Phylism, or the Ptolism, because Sophism does already exist. I have to combine it, and call it *Philphorism*. The Philphorism goes out from the Anatomy of the Spirit, without being Spiritism.

One needs a medium. The best is, one is his own medium. But don't be serious because seriousness belongs to a passed time. This medium, called you yourself will tell you to take absolutely the wrong material. That is very good, because only the wrong material used in the wrong way, will give the right picture, when you look at it from the right angle. Or the wrong angle. That leads

us to the new ism: Anglism. The first art starting from England, except the former shapes of art. That is my confession I have to make MERZ. (1940-46)

Kurt Schwitters **The Origin of Merz**

I had a so-called friend, he was a doctor, his name was Schen-
zinger. I was to paint his portrait. He was constantly occupied,
constantly working, and so he wanted to play piano at the sitting.
He said that I'd be better able to capture his character if he were
moving a little.

Next to me lay a beer-mat.

I ardently set about trying to interpret his character from his
movements and have it crystallize in the painting. He played the
'Mondscheinsonate', final movement.

Next to me lay the beer-mat.

I thought, "Everything can be characteristic of everything else.
It all comes down to this. If it is not characteristic, then it's just bad
luck." And I tried to find out if his, Schenzinger's, movements
were characteristic of the Mondscheinsonate.

Next to me lay the beer-mat.

Such a beer-mat, for example, is characteristic for a beer glass
with beer and a beer-drinker, not for Dr Justus Bier, the tailor from
Riemen.

And the round shape …

Suddenly I had a brilliant, perhaps not so brilliant, in any case
an inspiration. I stood up, smeared the reverse of the beer-mat
with not paste but red paint and used that to stick it on the cheek
of the profile portrait I had painted. It reached from ear to nose,
in so far as one can speak of the nose and the ear of an oil paint-
ing.

Dr Schenzinger suddenly stood up. The Mondscheinsonate fell
silent.

"What have you done?" Schenzinger asked suddenly.

"What have I done?" I answered, my voice quivering. "What I've done, I've done", I said firmly.

"You stuck a beer-mat on my cheek!" Dr Schenzinger said angrily.

"I nonchalantly stuck the beer-mat on the painting's cheek, in so far as one can speak of the cheek of a painting, this painting that is to characterize you", I said wearily.

"Take it off!" Dr Schenzinger commanded.

"I'm happy it's on there!"

"Take the beer-mat off."

"I won't do it!"

"Then I'll take it off!"

"Don't do that! You'll destroy the unity of the work."

"The beer-mat is an insult to me."

"The beer-mat characterizes you somehow."

"How can I be characterized by a beer-mat?"

"I can't say exactly how, but it does, I feel it."

"Because it's round?"

"And somewhat fuzzy. Perhaps."

"And made of pulp?"

"Because you are not made of pulp."

Then he tried to be cunning and said, "And perhaps it expresses the Mondscheinsonate too?"

"The Mondscheinsonate? The Mondscheinsonate by Dr Mondschein?"

I happen to know Dr Mondschein, he was a dentist originally and used the slogan: "Mondschein – schont mein." [Mondschein – takes care of mine].

"O.K., maybe he had written it originally, in any case, he gave the brilliant tip to Beethoven. Where do you stand on the question of whether the beer-mat expresses Beethoven?"

"Sir," I said, "Do you think that you yourself express Beethoven? And that picture is supposed to be a portrait of your nature."

At that, Mr Schenzinger left and closed the door behind him.

We haven't been friends since then, especially since I exhibited the painting with the beer-mat on the oil-painting-cheek as the Portrait of Dr Schenzinger.

I painted a portrait of Frau Luise Spengemann in the same

period; it was early 1919. Here I tried a composition of small objects that lay around the room and tried to use them to characterize her nature. The character was to be founded on the choice and distribution of colour values. And it succeeded beyond expectations. Luise Spengemann said, "That's me, it couldn't be anyone else."

Now I pondered my experiences. I had attempted to characterize Dr Schenzinger by using a single beer-mat in conjunction with a copy of his features. The result being that what seemed to me to be a characterization was an insult to him. With Frau Luise Spengemann, I undertook a composition of every part of the picture, without just including an object that could be considered as alien to a painting. That painting struck a chord with her, Frau Spengemann, her nature, her character.

What was relevant was the composition. Next I attempted to compose an object which could be described as refuse, because it had been discarded, and soon found out that a convincing total general expression lay in composition. Perhaps it was exaggerated that Frau Luise Spengemann believed she recognized herself in the composition of her picture, and it was perhaps, let us say pretty definitely wrong for me to try to characterize her in a composition. Compositions can only give a general expression, an expression that perhaps resembles a person, akin to the way a cloud can resemble a lion. And yet the cloud is merely fog. For people who are sensitive to it, a composition can communicate an expression, and a composition of colour values in painting can achieve it just as surely as a composition of tones can in music.

Beethoven goes even further: besides expression, he clearly gives the impression of a thunderstorm. I think: woods. (1942-47)

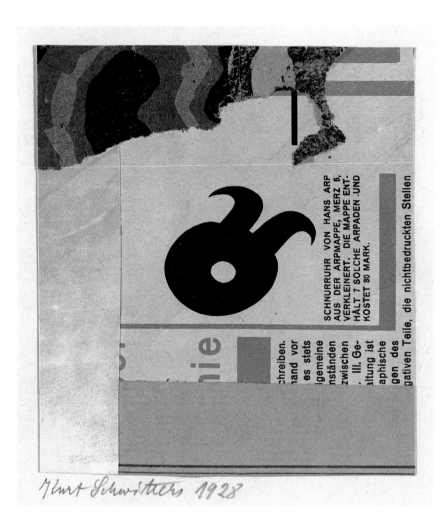

Ohne Titel
(Schnurruhr von
Hans Arp), 1928
12,8 x 10,1 cm

105

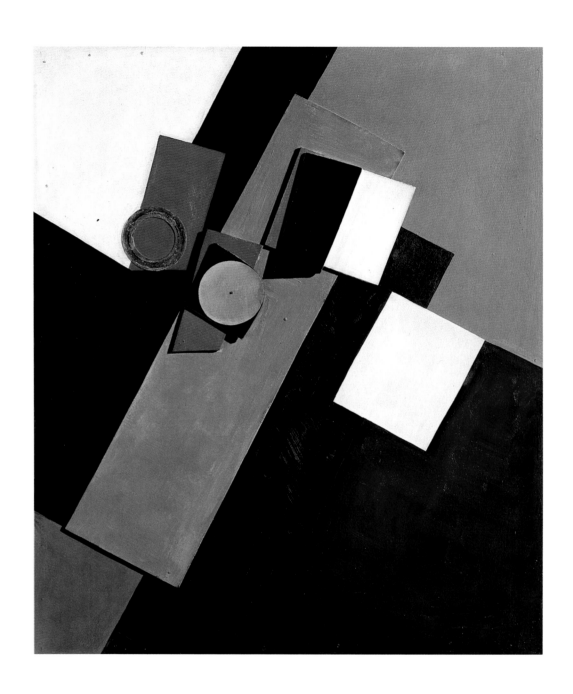

Merzbild mit grünem
Ring
1926
60 x 51 cm

106

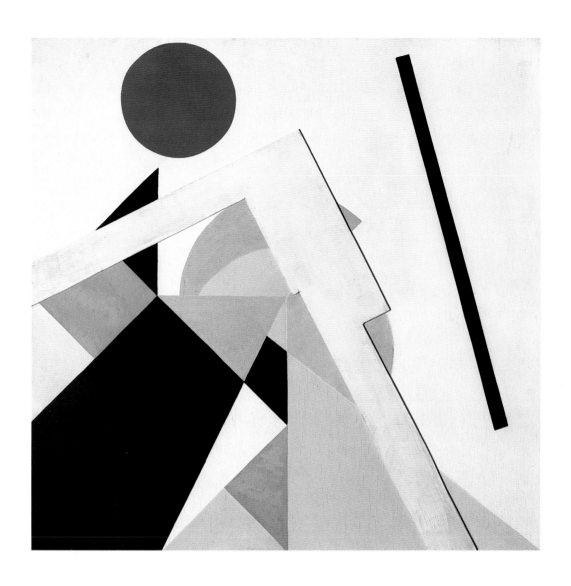

Picture from 8 sides
1930
91 x 90 cm

107

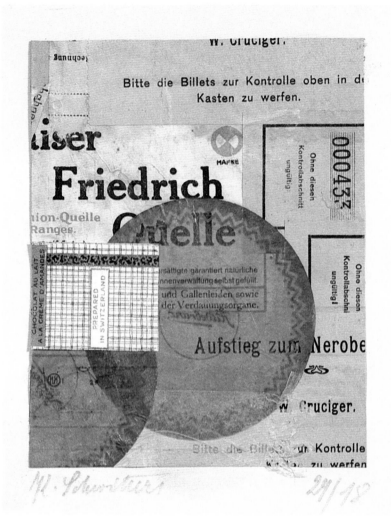

Merz 24.18 Kaiser
Friedrich Quelle
1924
11,6 x 9,2 cm

Kurt Schwitters

A4616/55/27 10:13½ 1927

Ohne Titel
ca. 1930
13,4 x 10,2 cm

109

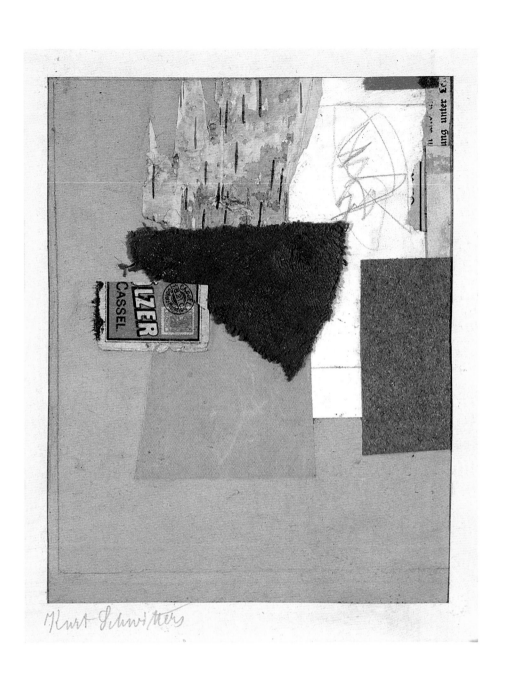

LZER CASSEL
1924-26
23,6 x 18,2 cm

111

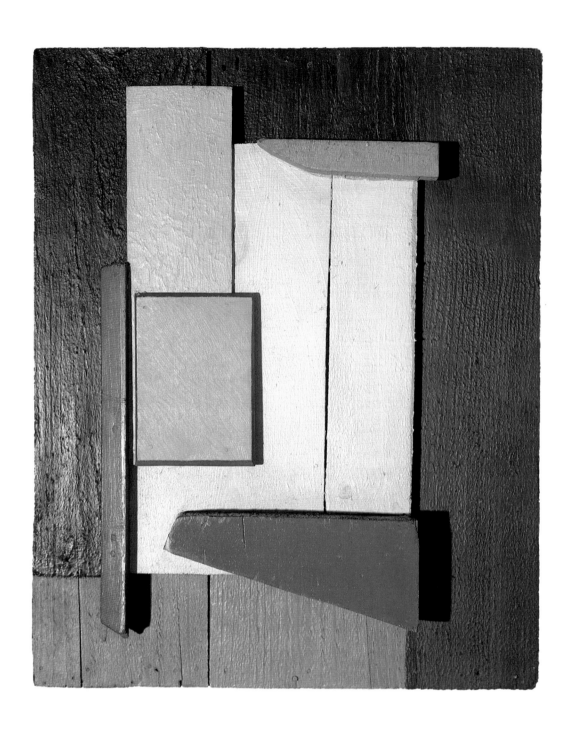

Blau
ca. 1923-26
53 x 42,5 cm

112

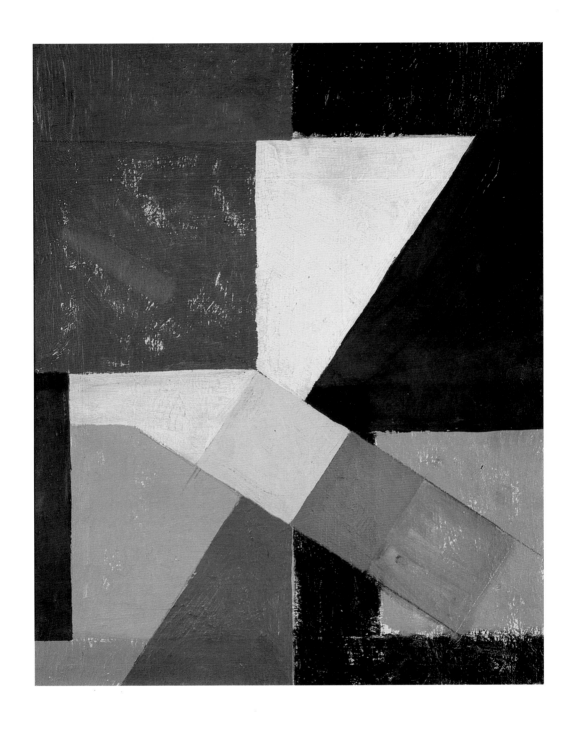

Abstrakte
Komposition
1923-25
76,2 x 50,8 cm

113

Mauxio
1930
12,6 x 9,6 cm

Februar
1929
21,9 x 16,7 cm

115

Geklebt in Zürich
für Rudolf Jahns
1929
21,3 x 16,6 cm

Konstruktives Bild
(Merz 1926, Nr. 8)
1926
80 x 65,5 cm

117

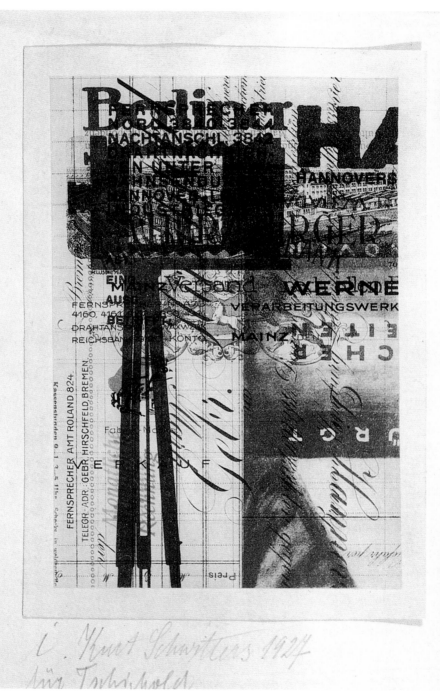

i-Zeichnung
(für Tschichold)
1927
15 x 11 cm

Ohne Titel
(i-Zeichnung ›Pferd‹)
1928
17,8 x 13,7 cm

119

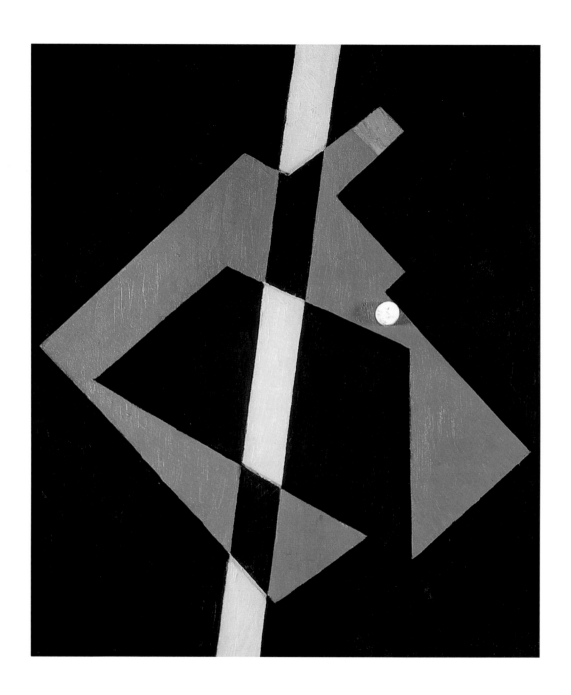

Das ist der Frühling
für Hans Arp
1930
61,5 x 51 cm

120

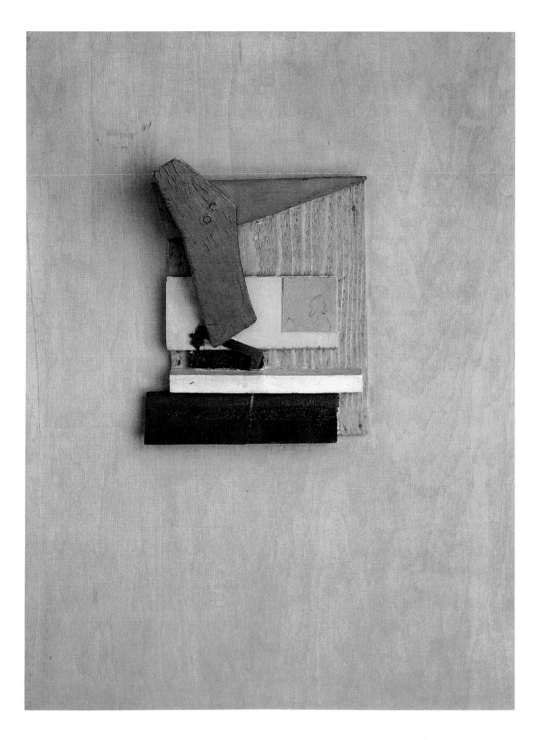

Plastische Merz-
zeichnung, 1931
48 x 34,8 cm

121

Camel
1936
17,8 x 14,6 cm

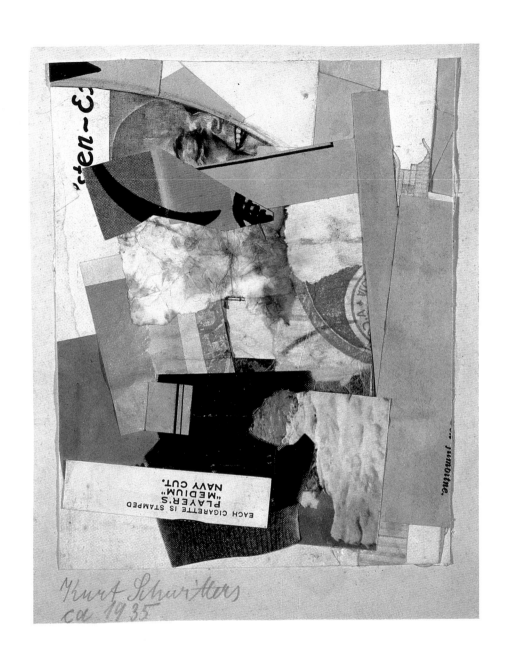

Players Medium
Navy Cut
1935
15,2 x 12,1 cm

Helden des Alltags
1930
34,2 x 27,6 cm

(ANS)
1938
24,5 x 19,5 cm

125

Bild abstrakt Molde
1939
66 x 54 cm

Komposition Nr. 114 U
1938
59,5 x 49,7 cm

127

Hjertøya
1937-38
50 x 71 cm

Gamle Fru Hol
1937-38
52 x 66 cm

129

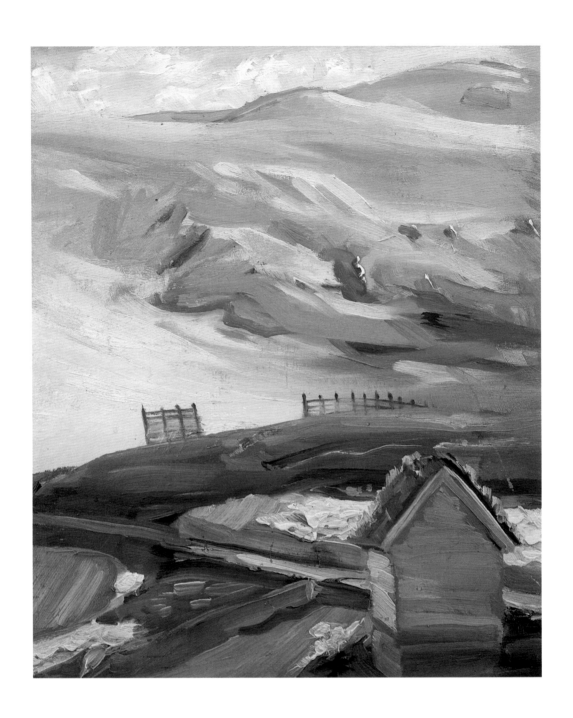

Vinterstemnig
Djupvassbotn
1937-38
62 x 50 cm

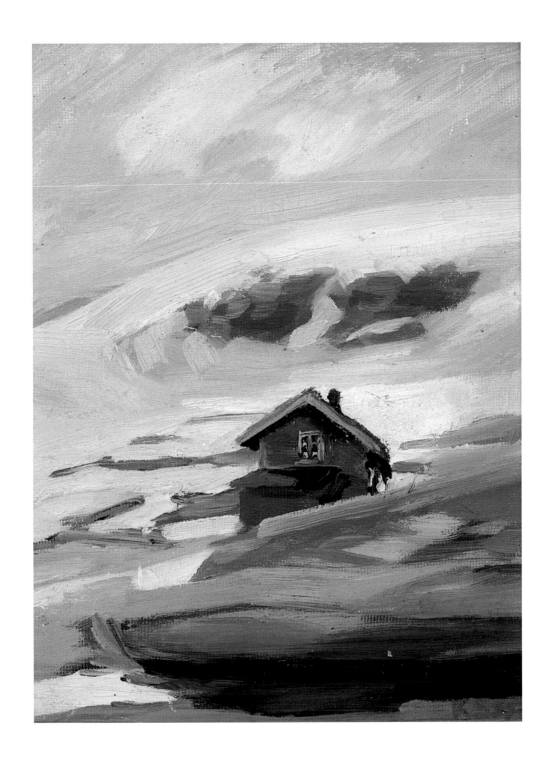

Djupvasshyta, 1937
31 x 23 cm

Snake
1937
22,3 x 14,5 cm

Die Frühlingstür
1938
87,8 x 72 cm

133

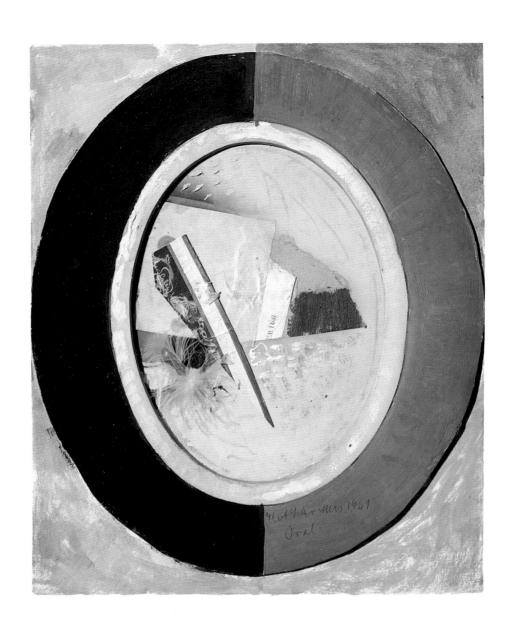

Oval
1941
32,7 x 27 cm

134

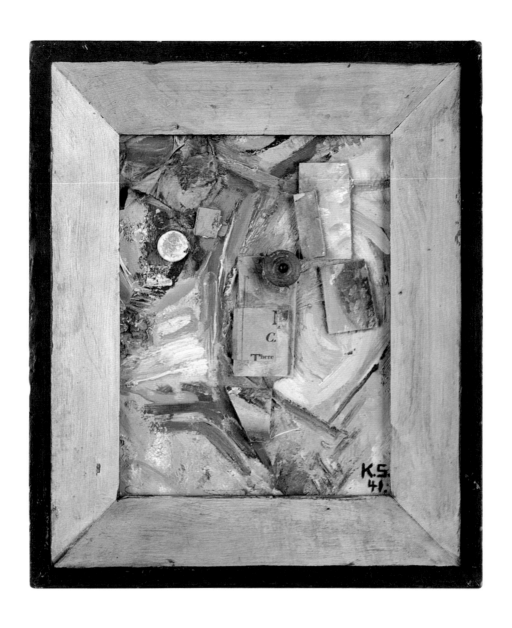

(There)
1941
21,2 x 16,6 cm

135

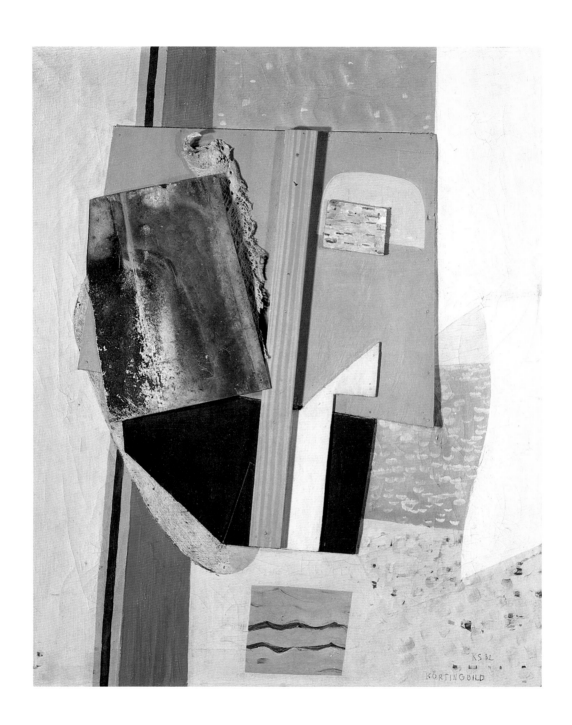

Kortingbild
1932
73 x 60 cm

136

I Merzed with Schwitters

Georg Muche

I met Kurt Schwitters in 1919. We met at the 'Sturm' in Berlin. When the exhibition ended at about six o'clock, we went across the street to Café Josty on Potsdamer Platz. We sat down at one of the round marble-top tables on arched iron legs, ordered our coffee, and Schwitters asked me straight away if I would like to merz with him.

At first, I did not know what he meant. I thought I had misheard him. He took a blank postcard out of his breast-pocket and placed it on the marble table-top. He took some scraps of paper out of his other breast-pocket. He found a green streetcar ticket and ripped it up. Then he took one of the pieces of paper printed with numbers and letters and put it on the postcard. Then he asked me to merz further, and offered me a choice from his small pile of trash on the marble tabletop.

I was convinced that this imaginative person was teetering on the edge of reason. I thought it best to treat him with caution. Meanwhile, Schwitters had realized that he could have merzed the bit of ticket on the bottom part of the card. That artistic result would have been different than the one he had achieved now by putting the paper in the middle of the card on the centre line.

I reached in my bag and found matches. They were red with a yellow tip. I said to Schwitters, "You see, sir, I could merz by just taking any old match and putting it in the upper left-hand corner. But, I'm not going to." I took a match, lit it and let it burn down half-way. Now it was made of red wood, a strip of black coal and a black ash tip. "Now, I will merz with this match. In a way, it is a match and in a way, it was a match – but we cannot merz with the past – at least as far as I know." Schwitters replied, "I will merz in

the same vein as you." He took the cigarette out of my mouth and sprinkled ashes on the postcard. We were all merzed out. (ca. 1955)

Franz Müllers Drahtfrühling

Hans Arp

Memories of Kurt Schwitters

Whatever became of Kurt Schwitters' novel Franz *Müllers Draht-frühling* [Franz Müller's Wire Spring] several chapters of which we composed together? Is it buried under the bombed ruins of his house on Waldhausenstraße in Hanover? For hours, Schwitters and I sat together and spun dialogue, in rhapsody.

He took these writings and channelled them into his novel. Every time we got together in Hanover, in Wyk auf Föhr, in Berlin, we wrote together. If I am not mistaken, a few chapters of *FraMü-Drah* were published in *Sturm*.

I know for certain that short ad lib stories of ours which could not be merzed into *Franz Müllers Drahtfrühling* did appear in *Sturm* and that a Hanover newspaper published our poem 'Die Piepmänner und das Schwein' [The Chirping Men and the Pig].

When writing at Schwitters' house, we were often interrupted by Schwitters' calls and questions to his wife Helma:

K. Schw.: "Helmchen! I'm feeling faint. Don't you have a little b-itty piece of chocolate for me?

Helmchen! Don't forget that Hännchen (Hannah Hoech) is coming from Berlin this afternoon!"

H. Sch.: "But Kurt, honey, where is she going to sleep?"

K. Schw.: "In my bed, of course!"

H. Schw.: "Kurt, you know that isn't possible!"

K. Schw.: "Why not?"

H. Schw.: "You spilled your paste-pot when you were working in bed, don't you remember?"

The Greek gods had nectar and ambrosia; Kurt Schwitters' nectar and ambrosia was paste.

Schwitters often teased me, holding his paste-pot under my

nose, with its sour scent, saying "Would you like to taste it?" Schwitters literally relished paste, and with it he brought his wonders, his pasted pictures, into being. Whatever fell and broke into pieces, Schwitters magically brought back to life. I ran into him once when one of his Merz pictures came back damaged from an exhibition. A big piece of glass which Schwitters had attached to it in a very complicated way had broken. It could not be removed without damaging the picture.

"What are you going to do now?" I asked Schwitters. "Raise the price", was his answer. He turned the picture over, on the reverse of which a price of RM 250 was written in big blue numbers, and changed the price to 300.

We sat together again, writing *Franz Müllers Drahtfrühling*:

H. A.: "The nightingales have had enough of your hymnal *Karagösen*. Play violin on parrots, but avoid the women red hood and snow widow."

K. Schw.: "Should I pe-trify something for you? Or would you like to play cry together?"

H. A.: "Should we wash our tears or drown them?"

K. Schw.: "You are a sipsnipper. Since when do your diamonds bark?"

H. A.: "The weather is getting hard. A fruit cries out loud and gives birth to a fish."

K. Schw.: "I'll p-ut it in the sea, or should I st-ab you with it?"

And Schwitters stenographed and channelled it into Franz Müller. We usually wrote in his 'good r-oom'. His work room was one floor down. I will never forget this floor of the Schwitters household because once, at this very place, after Schwitters had drawn a great breath though his teeth, suddenly took out his dentures, thrust them into my hand and said: "Hold these for a moment, it's pinching me, let me get my file." Then we went down to his work room, in the horribly beautiful Merz grotto, where broken wheels paired with matchboxes, wire lattices with brushes without bristles, rusted wheels with curious Merz cucumbers, pulp boxes full of poster shreds with hand mirrors, arching up to the ceiling. How often did we 'p-lay' in this room! Schwitters called playing, considering the sweat, working. There we glued together our paper pictures, and as I tossed away one of my glued-

together works one morning, Schwitters asked, "You don't like it? Can I have it?" – "What do you want with this failed piece of toast?" Schwitters took a good look at it and said, "I'll put what's on top on the bottom, I'll stick a little Merz nose in this corner and I'll sign the bottom Kurt Schwitters." And, yes indeed, this collage became a wonderful picture by Kurt Schwitters. Schwitters was a wizard, just as Hokusai was a wizard, as he tossed a handfull of indigo on a temple door and a wondrous blossoming came from it. In my opinion, Schwitters is one of the greatest German visual artists.

In the top of an old fir at the beach at Von Wyk auf Föhr, I heard Schwitters practice his 'Lautsonate' every morning.

He hissed, howled, chirped, fluted, cooed, spelled.

He succeed in making *über* human, seductive, siren-like sounds, about which one could develop an entire theory about, similar to the Cacophony of the Dead.

Yet I should not fail to mention that the muse for this 'Lautsonate' was Raoul Hausmann, who performed tonal poems and tonal sonata in several German cities with Schwitters. (1956)

Rudolf Jahns

Notes About his First Encounter
with the *Merzbau*

In 1927, our friendship with Kurt Schwitters (and Helma, his beautiful, devoted wife) led to the establishment of the group 'Die Abstrakten Hannover' [The Hanover Abstractionists], the International Association of Expressionists, Cubists, Futurists and Constructivists Association of Central Berlin. The founding and also active members were Kurt Schwitters, Friedel Vordemberge-Gildewart, Karl Buchheister, Hans Nitschke and myself. The official founding date of the group, as evidenced by the invitation dated 5-3-27, was 13-[sic]3-27, my birthday and the birthday of this group. We met at Kurt Schwitters' flat at Waldhausenstr. no. 5. I remember the exact circumstances. It was still cold and the iron furnace was blasting tremendous heat. Kurt Schwitters had just come up from the basement where they kept guinea pigs, and brought up a dead animal that he threw in the furnace after saying a few consecratory words. Later we were to go down to the basement to see the guinea-pig-breeding operation.

Needless to say, we (my wife and I) also had to see the *Column* on the ground floor. The way there along the narrow corridor took us past all kinds of interesting things. For instance, I remember a box, the longest front side of which (about 50 cm) was closed halfway by a board and halfway by wire netting. Inside on a bed of hay were two strange-looking creatures with large, smudged white bodies and heads. Each had only one big, s-shaped bent black leg. There was a mysterious semi-darkness in the box that made these creatures seem more of an idea than something recognizable. They were two porcelain insulators like the ones you see on telegraph poles along the railway. – Odd displacement of these technical objects. They had become completely transformed. You

walked through a narrow door to enter the *Column*, which had developed into more of a cave. The plaster designs went over into the door-openings. I did not see the beginning of this 'Kathedrale des erotischen Elends' [Cathedral of Erotic Misery] as Kate T. Steinlitz described it in her book *Kurt Schwitters* published by Verlag der Arche in Zürich. Once we had finished our meeting about founding the 'Abstrakten', Schwitters asked me to go into the 'grotto' alone and, once it had had its effect on me, to tell my thoughts to a beech tree in the middle of the structure on a small table (made of wood or plaster or plastered wood – I don't remember exactly anymore). I entered the structure, which, with its twists and turns, resembled at once a snail-shell and a cavern. The path to the centre was very narrow, because new structures and constructions and already Merz reliefs and recesses kept emerging from the side walls into the as yet empty space.

A bottle full of Schwitters' urine with immortals floating in it was hanging at the immediate left of the entrance. Then there were recesses of various types and sizes with entrances that were not always at the same level. If you walked round, you finally ended up in the centre, where there was a seat and where I sat down. A strange feeling came over me, as if I had been carried away to another place. This space had its own very special life.

Footsteps made barely any sound here; absolute silence reined. Just the shape of the grotto encircled me and allowed me to find words related to the absolute in art.

I saw the grotto once again soon thereafter. It had already been changed. Many of the recesses were nailed shut and the overall impression was more closed. I never experienced the final state that Kate Steinitz described.

The room we were sitting in was both living and working space. There was a large table in front of the window, where Schwitters did his *merzing*. As you entered this room from the corridor, there was a glass cabinet to the immediate right where Schwitters' Merz sculptures were displayed.

There was a room with a grand piano in it adjacent to the work room. There were colourful designs on the walls. Blue and black, if I am not mistaken.

Behind that, there was Kurt Schwitters' very narrow bedroom.

You could see from the wallpaper to the right of the bed that he *merzed* with everything at his disposal even before going to sleep at night. Helma Schwitters deserves a special monument for her loving, ever-patient attitude towards her husband, who used everything he could get his hands on around him. Given the many ideas and materials, it certainly must not have been simple for a housewife, which she must have also been. (s.a.)

Merz Evening

In the winter of 1926/27, I decided to invite Kurt Schwitters to hold a Merz evening in my studio and to perform his 'Ursonate' [Primal Sonata]. I had a huge room at my disposal in the local Pioneer barracks, which at that time was used for civilian purposes. After Schwitters enthusiastically agreed to come, I sent out invitations to 30 or 40 of my friends and acquaintances. Other people, whose interest I could assume, were also invited. The evening came. Kurt Schwitters appeared. With his magnificent wife and a big bag of hard tack which he bought for next to nothing from the Bahlsen family of Hanover. As was the case with all 'independent' artists who had devoted themselves to the avant-garde, he too was obliged to live in a manner which allowed him to impugn his lifestyle. Kurt Schwitters read aloud many short stories, among which, if I remember correctly, were the 'Zoologische Gartenlotterie' and 'Schako'. While all this was received with at least some understanding, the ensuing performance of his 'Ursonate', at the end of which he smashed a dinner plate into pieces on the floor, resulted in a prevailing sense of helplessness and embarrassment among those in attendance. Without caring about how he had gone over, he put on the record player and invited the nearest woman to dance. That was enough to break the tension. The evening passed in happiness and good spirits. People grew closer to each other. The guests had had what was, for Holzminden, an unusual experience.

More important for me was the interest Kurt Schwitters took in the paintings of mine which hung on the walls. Among them were also those works which were exhibited in the 'Sturm' salon of June/July 1924.

That same night he picked out and packed a crate of pictures to send to the exhibition of the 'Abstrakten' at Ruhmeshalle, Barmen, in which Schwitters and Carl Buchheister also had work. An accompanying letter from Kurt Schwitters to the organizer of the exhibition, William Wauer, did the rest. The works were accepted. (s.a.)

Kurt Schwitters
1887-1948

Tristan Tzara

In speaking of Schwitters, it is difficult to separate his literary activity from his pictorial, the sculptor from the agitator. So rounded a personality does not yield to formulas. Elements so multiplex, so varied, are characteristic of his make-up that, to incorporate this special individual in the phenomenon of life, we must alter our summary manner of tossing off generalities. For we are here confronted, in this unique specimen, with the infinite depth of which only poetry – I am thinking of a poetry which abolishes all description – is capable of giving an account.

Schwitters is one of those personalities whose inner structure was always dada by nature. He would still have been dada even if the dada call had not been sounded in 1916. But dada itself possesses so many facets, so many points of departure for new perspectives, that it is far from easy at this early date to formulate an exhaustive definition of it.

Therefore the participation of Schwitters in dada – of which it is said that every member is also president – has a particular nuance; it is perhaps by the very reason of his specific nature that a certain independence, which in any event dada expressly demanded, prompted him to create his own movement: MERZ.

The origin of this appelation is not unknown. In one of his collages he incorporated the word *KomMERZiel*, of which finally, only the central fragment remained visible. Chance, which Duchamp had recognized as one of the most fertile means of creation, was transplanted by dada into a domain where humor and natural laws had long played hide-and-seek.

However, in the choice of this word of 'commercial' origin, there is the nucleus of an idea which Schwitters has particularly

developed in his writings. In Germany, around 1920, a kind of new folklore was born through which a foreshortened language, elliptic, expressive, and derived from advertising lingo, became the popular mode of expression in a world in process of complete regeneration. The droll repercussion on the popular language of this modus vivendi – an ape-like imitation of America – fed Schwitters' inexhaustible verve. And so it was that mechanistic romanticism coupled with *la fleur bleue* by the German petite bourgeoisie, became one of the main sources of his particular humor. In this castigation of the mores, it is difficult to determine which is tenderness and which is raillery. A little like Jarry and Ubu, Schwitters identified himself with his personages, with the result that the natural element and the element of provocation leave to our imagination a margin wide enough to allow us the privilege of not taking a position.

Schwitters' humor is not serene, but disturbing as he intends it to be, and around 1925, when Schwitters seems to turn to the esthetics of De Stijl, he actually integrates in his participation his past activity as a whole, without renouncing any of it. Publicity still takes on a positive value; commonplaces, bromides animated by the mythical elan with which he had infused them, are able also to serve practical ends.

But this is only one aspect of Schwitters' complexity, complexity which only appears in a full account of his rich personality. In fact nothing is simpler, almost of popular evidence, than his œuvre which finds a constant source of freshness and invention in the reality of the language as well as in the reality of the people of Revon (half anagram of H*anover*, Schwitters' residence.)

At the opposite pole of Wagner's orphism, which aspired to reunite all the arts in order to create their exalted, if declamatory synthesis, is situated the confusion of *genres* as commended by dada. The purpose here is to destroy them and permit only to subsist the expression of man in his essentially alive and spontaneous formation.

This is at least one of the reasons why Schwitters' *collages* have a polemic idea as their point of departure. The so-called *noblesse* of art, which prompted so many false sentiments that only the most sordid conventionalism might pride itself in them, Schwitters

opposes with the most 'vulgar' means of expression. At least this is the epithet generally used by the bourgeois to designate that which disturbs their pretentious attachment to established values.

Picasso's *collages* 1912-1913, followed by Braque's were intended to emphasize the density of new materials as plastic elements in the representation of volumes. Van Rees and then Arp desired through *collage* to suppress all illusion of depth by reintroducing the flat coloured surfaces. With Max Ernst the figuration of reversible images appears again through the use of bromides and proverbs in painting. Schwitters, in turn, seemingly neglecting all expression directed towards the *plastic*, realizes in his *collages* a synthesis of these various objectives by removing from the commonplace its figurative quality and at the same time keeping its representative value. The fragmental combination of the poster, the wheel of a child's perambulator or the bus ticket is somewhat like an amplification of the principle of Duchamp's *ready-made*.

Schwitters is a dada who has helped disclose the naiveté of the notions of art and expose their mystification. He is among those who have decapitated the haloed capital A from the word *art* and have placed this word again on the level of human manifestations. Clearly this sacrilegious act could not be accomplished without scandal and it was necessary to oppose the ritual of the high priests with what is alive – man as he exists in the streets and in the country, as against the immaterial notion of phantoms and the initiated. But this process of *humanization* applies also to the objects represented in painting. The apparently superior categories, the elevated or edifying subjects – were to be replaced by the manifestations of daily customs, the most humble and trivial. I remember seeing Schwitters pick up in the streets, scraps of old iron, broken watchworks, bizarre and absurd materials which even junk men would have discarded, to use them in the fabrication of works of art. Here again appears Schwitters' ambiguity. For, in the apparent derision introduced in the creation of these works, the desire to build a new mode of expression is not entirely absent, and these derisive works with which Schwitters took a stand against all that appeared *artistic* at the moment, have the actual merit of bearing in themselves an emotional force revealing the world of freedom, an element which Schwitters, through sheer

natural modesty concealed under a cynical and contemptuous attitude.

This subdued light, so much more intense because it never pretended to shine under the glamour of words or on the sumptuous chandeliers of luxurious ceilings, I take pleasure to evoke here, in the transparent nudity of a remembrance which for me has kept all its purity, the purity of a man with integrity and sensitivity, of a most precious friend, of one whose conscience enriches man because it gives him new reasons to live. (1952)

(translated from the French by Marcel Duchamp)

»Eternal lasts the longest«
Kurt Schwitters

The Man Schwitters

While in Berlin with its Baader, Hausmann and Huelsenbeck, the very globe itself was taken under Dada's wing and Club Dada, with its assigned roles, contributed to the merry continuation of the prevailing non-order, an independent Dadaism played itself out in two less well-to-do German cities, Hanover and Cologne. One which, while quieter, was at least equally, if not more, important.

Already by the beginning of 1918, in his little room in the Hotel Limmatquai in Zurich, Tzara showed me photos of pictures by a certain Kurt Schwitters. These pictures consisted of paper pulp, wood, wire and broken objects. Why these photos were not included in our upcoming Dada issue, I do not know, but one thing is certain, none of us in Zurich had heard of this Schwitters. He was often spoken of in Berlin after the war; Hausmann, in particular, mentioned him:

"One evening, in 1918 in Café des Westens", he recounts in his *Courier Dada*, "Richard the hunch-backed, red-haired paperboy came to my table and said to me: 'There's someone who'd like to speak to you.' So I went over. Indeed, there sat a man of roughly my own age. He had brown hair, blue eyes, a straight nose, a somewhat roundish mouth and a somewhat protruding stomach. All this topped off with a high collar and a dark tie. 'My name is Schwitters, Kurt Schwitters.' I had never heard the name.

We sat down and I asked, 'What do you do?' 'I'm a painter and I nail my pictures.'

This seemed new and likeable to me. We played our game of question and answer and I learned that this man also wrote po-

etry. He quoted a few. They seemed to me to have been influenced by Stramm, but one of them seemed good and new.

Finally this man who called himself Schwitters said, 'I'd like to be accepted into the Club Dada.' – Of course, I couldn't decide that on my own. So I told him that I'd speak with the club and let him know.

On another day at the general assembly at Huelsenbeck I learned that this Schwitters was actually somewhat known. But for some reason, Huelsenbeck had an aversion to him. He also didn't want to accept into the Dada Club just anyone off the street. In short, he didn't like Schwitters."

Unfortunately, even 40 years later and regardless of the fact that he had long ago reconciled with the dead man, Huelsenbeck gave him one more light kick in one of his books because he couldn't stand Schwitters' 'Spießer-Physiognomie' [bourgeois appearance]. In any case, this first snub that Schwitters got in Berlin disposed him to set up his own shop in Hanover, which he named MERZ, a fragment of 'Commerzbank' [Commercial Bank].

Schwitters was absolutely and unrestrictedly and 24-hours-a-day FOR art. His genius had nothing to do with changing the world, or values, or the present or the future or the past, nothing to do with that which was being proclaimed with trombone notes in Berlin. You would never hear anything from him like 'Kill Art' or 'A-Art' or 'Anti-Art'. Quite the opposite, every tram car ticket, every envelope, cheese paper, cigar band, ripped shoe sole, ribbons, wires, feathers, floor cloths, everything that was discarded: all that had a place of honour in life, specifically, in his art.

But instead of being thankful for the luck that he brought us and every neglected thing, for the inexhaustible humour that prevailed in the compilations of tram car tickets with nail-files, cheese paper and girls' faces, and the many poems, sayings, novellas, theatrical pieces in which the higher sense went hand in hand with the deeper nonsense and in an eternal language became one like a girl and boy in spring, we left him, the German painter and poet, to die in the misery of exile without recognition, cared for only by the English girl Edith Thomas and an English farmer by the name of Pierce.

Perhaps it does not belong here, but it should put Schwitters

and his work into perspective, so that in a historical sense, he will live on.

Schwitters' art and life were a living epic. Something dramatic was constantly happening. The battles of Troy could not have been more varied than a day in Schwitters' life. When he wasn't composing poetry, he was pasting collages, when he wasn't pasting, he was working on his column, he washed his feet in the same water as his guinea pigs, warmed the paste-pot in bed, fed the tortoises in the seldom used bathtub, recited, sketched, painted, cut up newspapers, received friends, published *Merz*, wrote letters, loved, designed all of Günther Wagner's printing and advertising business (for a regular income), taught academic drawing, painted appallingly dreadful portraits (which he loved) which he then cut up and used piecemeal in his collages, attached broken furniture to MERZ pictures, called to Helmchen, his wife, to keep an eye on his son Lehmann, invited friends to a very scanty lunch and all the while, he never neglected, wherever he went or stood, to pick up discarded things and to stow them away in his pockets ... all this with an alertness of instinct and spirit, an intensity that never let up.

He got on particularly well with Arp. In many respects, the spoke the 'same language', a kind of highly cultivated schizophrenic idiom, a German, free of all convention, out of which they pulled the most colourful, unsuspected and unheard of associations and forms, and through those, new thoughts, experiences, sensations.

No one could perform as he could. It may very well be, as Hausmann suggested in his letters, that Schwitters' 'Ursonate' [Primal Sonata] is based upon 'Rfmsbwe', one of Hausmann's earlier tone poems. But what Schwitters made out of it and how he spoke it were very different. With Hausmann, one always felt a dark, threatening aggression against the world. His extraordinarily interesting tone poems were, when he performed them, something like rage-distorted plea formulas, sweat-bathed screams of demons tortured in hell.

With Schwitters, everything was free: a spirit prevailed in which nature ruled. No resentment, no repressed impulses. Everything came from the deep up to the surface without hesitation and

perfectly complete, like Athena springing from Zeus' head, fully equipped, never having previously existed.

Having said that, everything he said was in strong Hanoverian, a dialect that one would think inappropriate for poetry and speech. Yet everything was so new that by the end, one was prepared to accept Hanoverian as a new world language. People laughed at him. They were supposed to laugh, but they were also supposed to know why.

There was never a dull moment when our Kurt was there. Whatever he did was deadly serious to him, even when we saw it as a joke. This surprising ambivalence contained an unbelievable energy, which discharged itself in an explosion of laughter fifty per cent of the time. But it was always a special kind of laughter, a spirited laughter that woke people and stimulated them.

Schwitters the Poet

Speaking of which, I remember Schwitters' first public performance of the 'Ursonate' at Frau Kiepenheuer's around 1925 in Potsdam. The 'better' people were invited, and in Potsdam, the military pinnacle of the old German empire, that meant a bunch of pensioned-off generals and other 'upper echelons'. Schwitters stood his two metres tall at the podium and began his 'Ursonate' with hissing, bellowing and crowing in front of an audience that had no experience of anything to do with the Modern. At first, there was total consternation. After two minutes the shock wore off. For another half-minute, respect for Frau Kiepenhauer's fine upstanding house kept whatever protest there may have been in check. But this outward restraint only caused the inner tension to build. I watched in delight as two generals in front of me used all their force to keep their lips pressed together so as not to laugh, how their faces, above their high, stiff collars, turned first red then a pale blue. Then something happened for which they could no longer be held responsible: they burst out laughing and the whole audience, released from the pressure that had been building, exploded in an orgy of laughter. The refined old ladies, the stiff generals, screaming, gasping for air from laughing, slapped their thighs, coughed and wheezed.

All this did not bother our Kurt one bit. He just turned his huge, trained voice up to volume ten, which cut above the storm of

laughter in the audience, becoming almost an accompaniment to
the 'Ursonate'. All around him, it surged against him like the sea
2000 years earlier when Demosthenes had tested the strength of
his voice. As quickly as the hurricane had developed, it subsided.
Schwitters recited his 'Ursonate' to the end undisturbed. The result
was fantastic. The same generals, the same rich ladies who had just
been laughing until they cried where now gazing up at Schwitters
with tears in their eyes, to express to him their wonderment, their
gratitude, almost stuttering with enthusiasm. Something had been
opened up in them, something they hadn't expected: a great joy.

His humour and wit were just part of the freedom that he pos-
sessed as a human being and as an artist. And yet, he was really
bourgeois, sooner stingy than generous, a home-owner who rent-
ed out floors of his house and who personally banked the rent
every month. He knew the value of money. He travelled only 4th
class and always carried two huge folders with him (one on his
chest and one on his back) full of collages (and cartons of all sizes
for future collages that he might want to make on his trip). Wher-
ever he went, he sold collages, that he pulled out of his folders, for
20 marks a piece. He refused to use porters.

At the same time, he seemed to me, with his mystifying beha-
viour that always stayed productive, close to breaking out of the
confines of reason. This ever active restlessness was unsettling,
but only to others, he was never exhausted by it …, so that in the
end one grew accustomed to it and him, no longer suspicious of it
or him.

His sense of advertising was just as well developed as his other
attributes. When he visited me in the early twenties in my studio
in Friedenau, which crowned the 5th floor of a particularly petit
bourgeois house, and in which I was particularly unloved due to
late-night disturbances and suspicious-looking visitors, he cov-
ered the beautifully coloured glass window in the stairwell (Holy
George, Nepomuk or some queen or other) with flyers that said
'Anna Blume' or 'Tretet Dada Bei' [Join Dada]. The glue he used
(soluble glass) resisted washing and, along with many other minor
offences, brought me my final notice.

His signature 'Merz' was not the only thing that appears on his
pictures, but sometimes his real name and address are seen. This

sometimes led to frightfully coarse letters and all kinds of refuse finding their way to his house.

With uninhibited directness, he sought out Van Doesburg with whom he organized a Dada culture trip through Holland. After experiencing Dada once, Doesburg went all the way. With his wife, the pianist Nelly who played modern music, and with Schwitters he completed a one-of-a-kind Dada tour through Holland, in which Doesburg performed as speaker and explained the spirit of Dada. During these explanations, he would be interrupted from time to time by a very realisitic imitation of a dog's bark coming from the audience. As the audience went about throwing the barking joker out, he would be introduced from the podium as Kurt Schwitters. He wouldn't be thrown out, but would now take his place at the podium and in addition to barking, would make other noises as well as reciting other, more or less, naturalistic poem such as 'Anna Blume' or the great 'Revolution in Revon'.

This demonstration never failed to achieve its desired effect of waking the audience from all its comfort and cosiness, and everywhere the public performed as an unwitting part of the cast, without suspecting that it had been planned that way all along. This is how Doesburg, who as a Dadaist had adopted the name Bonset, introduced Dada to Holland.

Everyone who is familiar with Holland's Flemish side, the chunks of meat on the lunch table, the old and young jenever drunk by the bottle, the incomparably enjoyable young herring, the palpably coarse jokes (so I was kidnapped, in my underpants, by strong Philips' executives to a dinner with ladies in my honour), easy women, who, crocheting in pairs in shop windows, try to soften up clients, the Jordaens, Rubens, Brueghels etc., would understand that Dada would strike a juice-like chord in juicy Holland.

Schwitters made so many tours, lecture and sales trips that it is hard to understand how he could have produced so much in Hanover. He was with Hausmann in Leipzig and Prague, with Doesburg in Holland, Switzerland and France. He disarmed everyone who came to the Dadaist battle-feast with his unshakeable conviction and directness. He used a ready wit, a sharpness of repartee the likes of which I had occasionally seen only from Arp, though Schwitters' milder manner was completely different.

One day he decided that he wanted to meet George Grosz. But George Grosz was very poisonous; sometimes the hate that was in his pictures also oozed from his very pores. But Schwitters had no inhibitions. He wanted to meet Grosz and so Mehring took him to Grosz. Schwitters rang the bell and Grosz opened the door, "Good day, Herr Grosz. My name is Schwitters." – "I am not Grosz", he answered and slammed the door. Oh well! They headed back down the stairs and suddenly Schwitters stopped and said, "One moment." Went back up the stairs and rang the doorbell again. Grosz, enraged by the constant ringing, opened the door again. But before he could say a word, Schwitters said, "I am not Schwitters at all." And he turned around and went back down the stairs. Finis. They never met again.

Despite his uninterrupted activity, he knew exactly what he was doing. Behind the seemingly boundless randomness and planlessness of his actions, behind the spontaneity of his decisions, there was a keen, disciplined mind at work.

Every word and form structure was constructed. Number poems, essays, epics (like his 'Ursonate') were classical and almost mathematical in form. In almost all of his work, he proves how strong the classical form is even today; it was capable of including inappropriate content of such vehemence, the likes of which Lessing or Goethe could have never conceived.

The Art Critic

He is an odd animal, the critic, a camel in front and a window behind.

Critics

Tran 27

"Critics are a special breed of people. One has to be born to it. With an unusual sheepsense, the born critic finds out what it is all not about. He never sees the failings of the work of art that is to be criticized nor those of the artist, rather he sees his own failure made visible by the work of art. The critic somehow recognizes through innate sheeepsense his own failings through the work of art. That is the tragedy of all critics, they see faults instead of art. For the critic, looking at art means painting the faults in the work

red and putting a mark underneath. Critics are similar to the rigidly beloved head teacher. Admittedly the critic does not have to take any exams, one is born to be a critic. The critic is a gift from heaven to humanity. Suckled with a headmistress, he feeds on artistic faults to the bleating blessing of the sheeeep breed. When one saws, it pours. Now and then, the critic sips from a glass of red ink. Every critic has an umbrella which he somehow married into. For sawing yourself brings rain pouring, wetting, to the blessing of the sheeeep breed. The headmistress in question, however, is a thick syrupy juice, made from the secretions of the gall bladders of really secret headmistresses and the gastric juices of demented sheeeeeep. The sheeeeeeep in question don't have to take any exams, just like the critic. The umbrella uses the critic to open it inside out. Critics don't have to check their umbrellas at art exhibitions. But the umbrella has to take an exam. Only umbrellas with holes are allowed to go to art critics. The more holes, the more rain, the more rain, the more sawing, the more criticism. To get back to the sheep: critics are a special breed of people. One has to be born to it. Critics are sheep-born, sheep-suckled with the headmistress and sheep-drunk in front of artwork. The difference between the artist and critic is this: 'The artist shapes, while the critic sheeps'."

Wretchedness Games:
A dramatic sketch

a. Sir:
b. Yes?
a. You are under arrest.
b. No.
a. Sir, you are under arrest.
b. No.
a. Sir, I'll shoot.
b. No.
a. Sir, I'll shoot.
b. No.
a. Sir, I'll shoot.
b. No.

a. I hate you.

b. No.

a. I'll crucify you.

b. Not.

a. I'll poison you.

b. Not.

a. I'll murder you for pleasure.

b. Not.

a. Think of winter.

b. Never.

a. I'll kill you.

b. As I said, never.

a. I'll shoot.

b. You already said that.

a. Okay, let's go.

b. You can't arrest me.

a. Why not?

b. At best, you can detain me.

a. Then I will detain you.

b. Go ahead.

b. allows himself to be arrested and taken away by a. The stage gets dark. The audience feels tricked and jeers and whistles. The choir shouts:

Stupid! Poet OUT! Such nonsense!

With all its seeming rape of the normal, that was thought-out, skilful and filled with slippery Schwitters logic.

When I asked him in 1923 to contribute to my magazine *G*, he sent me the following theory of his poetry art:

Consistent Poetry Art

"It is not the word that is the original material of poetry, rather the letter.

Word is:

1. Composition of letters

2. Sound

3. Description (Meaning)

4. Vehicle for idea associations

Art is uninterpretable, unending; material must be unequivocal in a consistent formation.

1. The sequence of letters in a word is unequivocal, is the same for everyone. It is independent of the personal perspective of the viewer.

2. The sound is only unequivocal with the spoken word. With the written word, it depends on the viewer's imaginative ability. That is why the sound is only material for the performance and not for poetry.

3. The meaning is only unequivocal when, for example, the object signified is with it. Otherwise, it is dependent on the viewer's powers of imagination.

4. Idea associations cannot be unequivocal, since they depend only on the viewer's combinatory ability. Everyone has different experiences and remembers and combines differently.

4. Classical poetry counts on people's similarity. It regards idea associations as unequivocal. This is a mistake. In any case, it rests on a fulcrum of idea associations: 'Above the peaks is peace.' Goethe is not merely saying that it is peaceful above the peaks, but the reader should savour this peace just as much as the poet, who was wearied by his official duties and who in general cultivated an urban manner. How little generality such idea associations have, can be seen if one were to hear a heath dweller (from a region with 2 people per square kilometre) read such a verse. 'At the skyscraper, the underground overpass is struck by lightning' would certainly impress him much more. In any case, since peace and quiet is normal for him, the realization that it is peaceful does not trigger any poetic feelings in him. The poet counts on poetic feelings. And what is a poetic feeling? The whole poetry of peace/quiet stands or falls on the reader's ability to feel. Words are not judged here. Apart from a totally insignificant sound rhythm in the intonation, there is only a rhyme relationship between 'Ruh' [quiet] and 'Du' [you] in the next verse. The concurrence with parts of classical poetry is only in relation to idea association, that is, poetic feelings. The whole of classical poetry now appears to us as a Dadaist philosophy, and it had a much crazier effect, the less Dadaist intent was present. Today only the couplet singers in variety shows care for classical poetry.

3. Abstract poetry frees the word from its association, and this is a great service, and judges the value of word against word; special concept against concept, while taking sound into account. That is more consistent than judging poetic feelings, but not consistent enough. What abstract poetry strives for, is attempted in a similar manner, only by consistent Dadaist painters, who juxtapose real objects on a picture by using next-to-one-another-pasting-and-nailing. Here the concepts can be more clearly valuated than their meaning when carried over into words.

2. I also do not consider it consistent to take sound for that which carries a poem, because sound is only unequivocal in the spoken word, not the written word. In only one case is sound poetry consistent: when it exists simultaneously with artistic performance and is not written. There is a stark difference between poetry and performance. Poetry is merely material for performance. It doesn't matter for performance whether its material is poetry or not. One can, for example, perform the alphabet, which is originally merely a utilitarian form, in such a manner as to turn it into a work of art. A lot more could be written about artistic performance.

1. Consistent poetry is made of letters. Letters have no idea. Letters as such have no sound, they offer only tonal possibilities, to be valuated by the performer. The consistent poem weighs the value of both letters and groups. (Kurt Schwitters in G, No. 3, 1924.)"

The Painter, Publisher and 'Paster'

Whether as a poet, painter or organizer, he never allowed himself to be defeated. Since he was comfortable financially through teaching assignments and an advertising contract with Günther Wagner in Hanover, and as he had a well-situated father (who owned rental properties) and, above all, knew how to bring his penetrating convincing powers to bear (he painted oil portraits and sold them to people whether they wanted them or not; he sold his collages by the hundreds and was a first-class salesman in the sense of a greengrocer), he was able to be successful in his more difficult undertakings. He published his periodical *Merz*, distributed the most interesting Merz folders, Schwitters, Arp, Lissitzky etc., accommodated his Merz books, contributed to many period-

icals and undertook performance trips. I wish I still had all these folders, periodicals, flyers, invitations and posters which he seemingly effortlessly produced or had produced (at other publishing houses): 'Auguste Bolte', 'die Blume Anna', 'und', two postcards in *Sturm*, a *Sturm* picture book, 'Anna Blume', 'Die Kathedrale', and seven postcards at Paul Steegemann's 'Memoiren Anna Blume in Bleie' at Weltly, etc. The word 'Merz' appeared as early as 1918 in the first photo of his work that I saw in Zurich. Cut from 'Commerzbank', 'Merz' appeared like a nova in an unknown constellation (...) as a nailed and pasted picture, stuck on with paste and bound with wire. From that sticky scrap of newspaper he transferred his trademark to his little periodical *Merz* and finally on to himself: 'Kurt Schwitters is the inventor of Merz and i, and aside from himself, he recognizes no one as a Merz artist or an i artist with highest regards.' (From 'Die Blume Anna').

He also didn't consider it beneath him to give old works new authorship, as he did with a picture which he painted in 1909 as a student of Professor Bantzer at the Academy in Dresden and sent out, in an improved form, in 1923 as a picture postcard in a poetic transformation with the title 'Ich liebe dir, Anna'. Among other things, he wrote 'Boss, Moholy were here. Now it's flummer in Hanover. Merz wishes, Kurt Schwitters ...'

But he didn't just incorporate newspaper snippets and other of-no-more-value objects, he adopted typography, taken over by Dada from Futurism, and translated it into his own typical Schwitters World. Along with Doesburg and Käthe Steinitz, he wrote and set the picture book *Die Scheuche* [The Scarecrow].

He adopted the technique of optophonetic application of his poems from Hausmann or worked them out with him.

Arp, Lissitzky and others supplied content for his Merz folders from different Art and Anti-Art worlds. Like Arp, he felt at home with coincidence, but one would almost say, more effortlessly than the carefully calculating Arp. Even as Anti-artist, Arp remained always Apolloesque, with Schwitters, Apollo and Dionysis went hand and hand (and sometimes even with the head on the bottom).

He risked everything and didn't seem to care a whit about the aesthetic effect, the aesthetic laws, about harmony and beauty. He

went at it with claws and toes, fists and teeth … whatever was necessary at the time. Co-incidence was a regular incident for him, on the street, in a restaurant, with friends, on a trip. The world was full of it. And it was exactly because of his unconcerned dynamism in seizing and pasting things on, that it resonated, sometimes like a Vermeer, sometimes like the jungle. Coincidence was always his colleague and that is why Schwitters was always Master and the planning thinker.

Hausmann recounts in his *Courier Dada* the story of a detour, made during a performance trip in Czechoslovakia: "Schwitters in Lobosice: The day after the soirée we set off on the return journey. First of all to the small town of Lobosice, because the river Elbe was there and Schwitters wanted to bathe in it and there was also a ruin there. To Kurt's great misfortune, in order to leave Prague in the afternoon and arrive in Lobosice that same evening, we were going to have to take an express train. It was filled to overcapacity, so Kurt and Helma (his wife) got in one railroad car and Hannah (Hoech) and I got in another. When we arrived in Lobosice it was evening. There was only a kind of covered platform on a high railway embankment. We took a step down. When we got to the bottom there was nothing to be seen but a stand of fir trees, nothing, absolutely nothing else, just the station house about 200 metres away. Here we stood. Was this Lobosice? Schwitters said, 'Hausmann, you and Hannah go over there, up forward there, and ask whether it's far to town and whether there's a hotel where one can spend the night.' Okay.

We came back. Beneath and apple-green evening sky, in front of a high black embankment, burned a wretched streetlamp. The gas light cast a miserable yellow light on the pavement. There stood a statue, a woman with outstretched arms, over them unfolded shirts and other clothes. She stood like Lot's pillar of salt. A man knelt on the ground, surrounded by shoes, pieces of clothing, by a briefcase full of papers, like the innards of a butchered animal.

He was busily going at a piece of carton with scissors and a tube of glue. The two people were Kurt and Helma Schwitters. I'll never forget that image: these two in the great, dark night occupied with nothing other than themselves.

Coming closer, I asked, 'Kurt, what are you doing?'

Schwitters glanced up, answering, 'I just remembered that I have to work a little piece of blue paper into the lower left corner of my college 30 B 1, I'll soon be done.'

That was Kurt Schwitters."

The Schwitters Column

And so he pasted, nailed, wrote poetry, set type, sold, printed, composed, collaged, recited, whistled, barked and he loved, bellowing, without regard for the person, the audience, whatever technique, traditional art or his own. He did everything, and most of it at the same time.

His leitmotif was less the *Gesamtkunstwerk* in the sense of Ball or even Kandinsky, the temporal interplay of all arts, but rather much more the uninterrupted blurring of borders and the integration of the arts among themselves, yes even the machine in art, as 'an abstraction of the human spirit', even kitsch, chair legs, singing and murmuring.

In reality, HE was the *Gesamtkunstwerk*: Kurt Schwitters. There was however a work in which he sought to combine all of his endeavours, that was his darling 'Schwitters column' With all his business and propaganda ability, this was holy to him. This his main work was pure, priceless creation. It was neither transportable nor definable, even in his own self-made form of expression. Built into the room (and THE room) in his house, this column was always in the throes of protean transformation in which a new layer constantly covered yesterday's layer, locking it in and making it invisible.

At the end of the corridor on the second floor of the house that Schwitters had inherited was a door that led to a not very big room. An abstract plaster sculpture stood in the centre of the room. At that time, about 1925, it filled about a quarter of the room and reached almost to the ceiling. It resembled, if anything Schwitters made ever resembled anything else, earlier sculptures by Domela or Vantongerloo. But here it was not just a sculpture, it was a living, daily changing document by Schwitters and his friends. He explained to me, and I saw, that the whole structure was a composite of cavities. A structure of concave and convex shapes which hollowed out and inflated the sculpture.

Each of these special forms had a 'meaning'. There was in fact a Mondrian hollow, an Arp, a Gabo, a Doesburg, Lissitzky, Malewich, Mies van der Rohe, Richter hollow. A hollow for his son, for his wife. Each hollow contained very personal details from the lives of all of these people. He cut off a little of my hair and put it in my hollow. A thick pencil removed from Mies van der Rohe's drafting table was in his space. From someone else, a piece of shoelace, a half-smoked cigarette, fingernail trimmings, a necktie (Doesburg), a broken feather. But also some odd things and some odder than odd things, for example a dental bridge with a few dentures on it and even a little bottle of urine with the name of the donor. All of this was in the separate holes that were reserved for the individual entries. Some of us had several hollows, depending on how the spirit moved Schwitters ... and the column grew.

Three years later when I visited him again, the column was completely changed. All the little hollows and swellings that we had 'lived in' were no more to be seen. 'They're all deep in there now' declared Schwitters. They were in fact covered up by the monstrous growth of the column, covered by more sculptural outbreaks, new people, new shapes, colours and details. A type of vegetation that never quit and if the column had looked more or less constructivistic, it now looked more curved.

Above all, since it had grown overwhelmingly and was continuing to grow, the column was bursting the seams of the room as it were. Since he couldn't add anything to the width of it, if he wanted to get around it, he had to go over it. But there was the ceiling. But Schwitters found the 'easiest' solution. As the owner of the house, he gave the upstairs renters notice to vacate, broke through the ceiling and continued with the column into the floor above. I never saw it finished. In fact it was never finished. I left Germany before Hitler and only heard from Schwitters when he arrived in Norway, just one step ahead of the Nazis who had ordered his arrest in Hanover. He did begin a new column in Norway, and then, when he left, a third in England. But he ever forgot that the Nazis destroyed his life's work (it was destroyed by bombs), the work with which he himself identified, more than with any other. That in the truest sense of the word had grown with him, physically and spiritually through every epoch of his life.

The art dealers, museum directors and critics can speak well today and can today declare the high value of the works for which they had only professional contempt not so long ago (for example at the exhibition in 1942 in New York and elsewhere). Nowadays, after he has been buried in England and has become famous and his son is rich, everyone knows what a creative person he was. But what a courageous fellow he was, who lived what he thought, no opportunist but an activist, that is shown in a letter that he wrote to Tzara in 1936 from Nazi Germany, for whom he was under suspicion as 'insane'. In this letter, from Hanover he announced a mysterious 'transmission'. This transmission, Tzara told me, consisted a photo album, the cover of which had been cut open and then glued closed and to which microfilm had been taped. This microfilm out of Hitler's Germany showed Hitler posters ripped from walls in Hanover, ration cards with minimum nutritional allowances and all kinds of other things. The enlargement of this microfilm, this clandestine document, was later made public by Tzara in the French periodical *Regards*.

If Schwitters had been caught, he would certainly have been put in a concentration camp and would have died there. He literally risked his life … but he didn't forget to put the fee 'for printing' in the letter to Tzara!

He had to flee Germany, separated from his Dada column in Hanover, expelled from Germany as a 'Cultural Bolshevist', he finally found asylum in England after fleeing Norway to escape the Nazis.

Collages, collages and more collages were produced. He was still the same old Schwitters, but when I wrote to him in England and signed the letter with 'Your *old* Hans Richter', he stressed that he was not the old Schwitters, but the *young* Schwitters.

In Westmoreland he found a barn belonging to Farmer Pierce that he could use to work in free of charge … And so, already ill, he started his third Schwitters column. But his health was failing. His friend Edith Thomas kept him alive both physically and materially. In his letters, written in strange English, he swore that he would never speak or write in German again. He never got the opportunity. He died, in spite of being selflessly cared for, in 1948, barely 60 years old. Farmer Pierce left the barn, that had served as the

German immigrant's workshop, just as it was: as a museum. In so doing, he documented much earlier, more meaningfully, and less self-servingly than any number of art critics, museum directors or art journalists, the value of this man and the seriousness of his art. (sa)

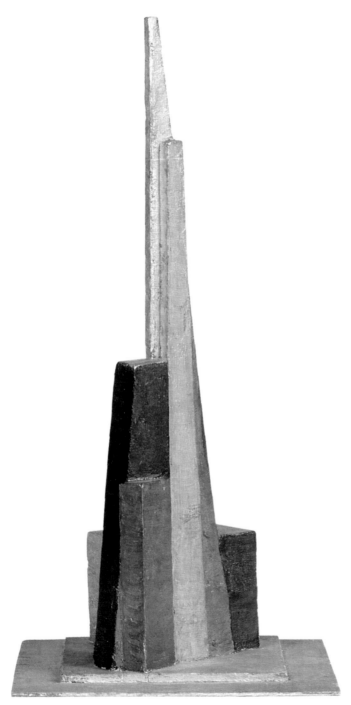

Ohne Titel
(Kathedrale)
1941-42
40 x 19,2 x 19,2 cm

169

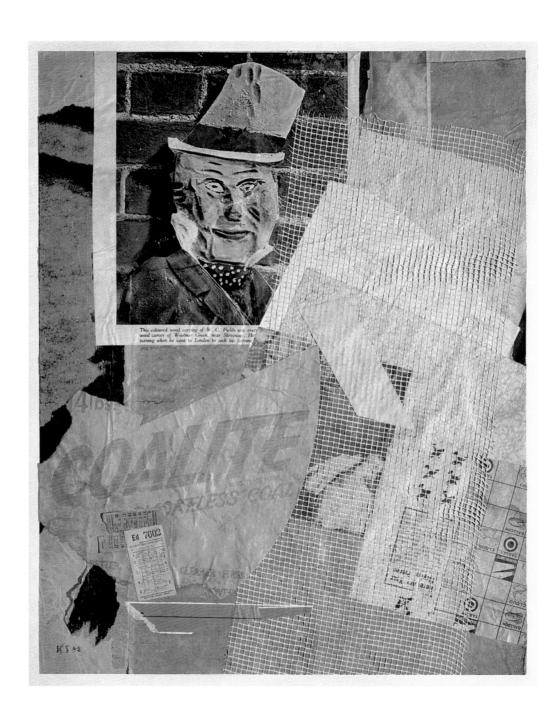

W.C. Fields

1942

50 x 38,7 cm

White, Beige, Brown
1942
41,9 x 32,7 cm

171

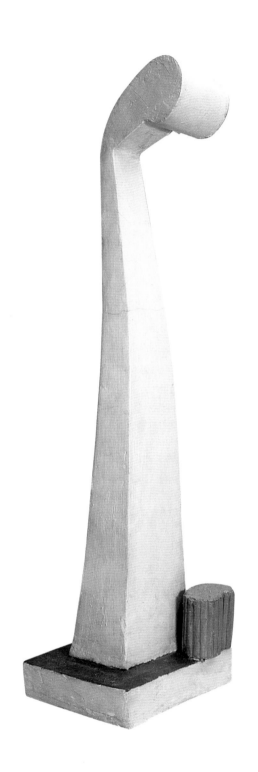

Ohne Titel (Madonna)
1943-45
57,8 x 13,3 x 15,6 cm

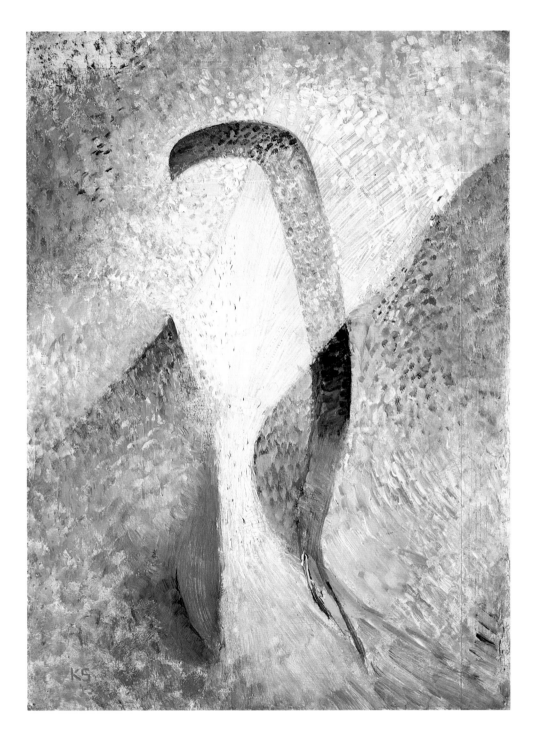

Komposition (Bild mit
Bahnhofsplan), 1943,
104 x 74,7 cm

173

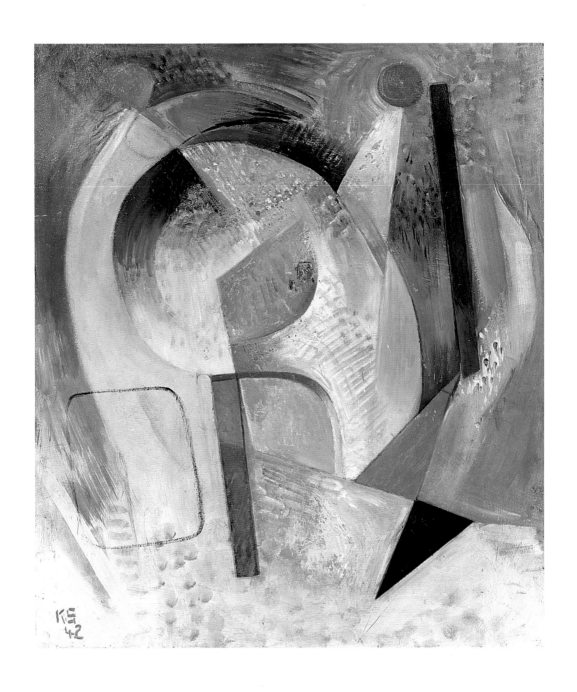

Roter Kreis
1942
109 x 91,5 cm

175

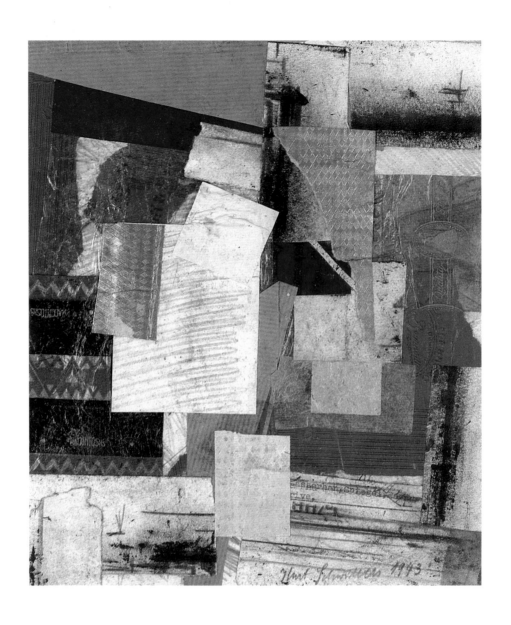

Ohne Titel
(Quality Street)
1943
25 x 20,8 cm

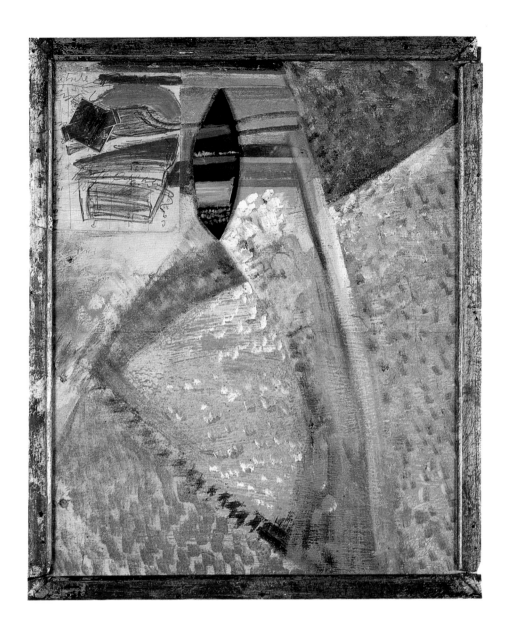

Ohne Titel
(Broken Record)
1942-45
43,5 x 35 cm

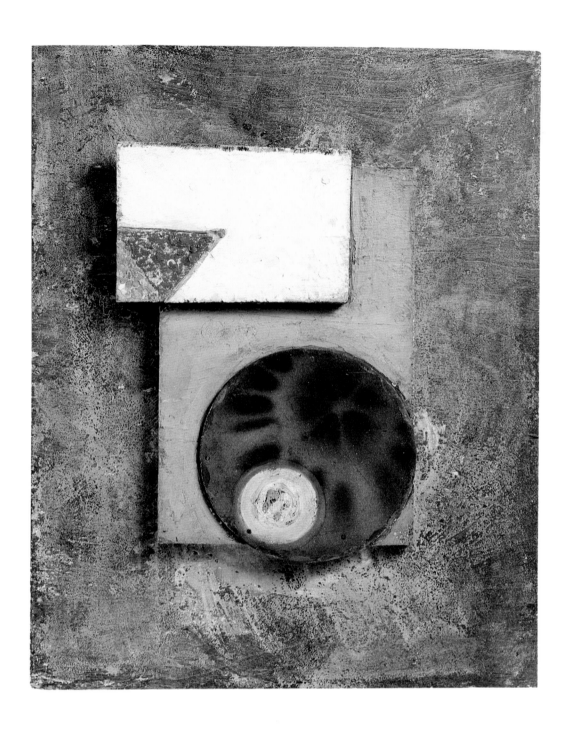

Asbestos chat
1943-45
49,8 x 39,3 cm

178

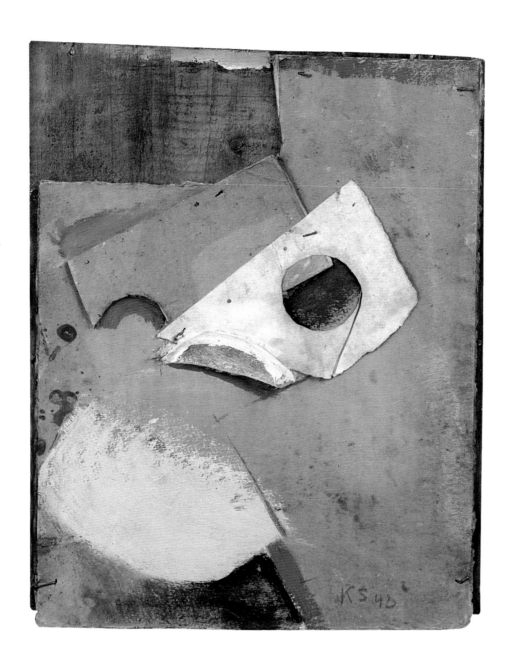

Mask
1942
32 x 25 x 5 cm

179

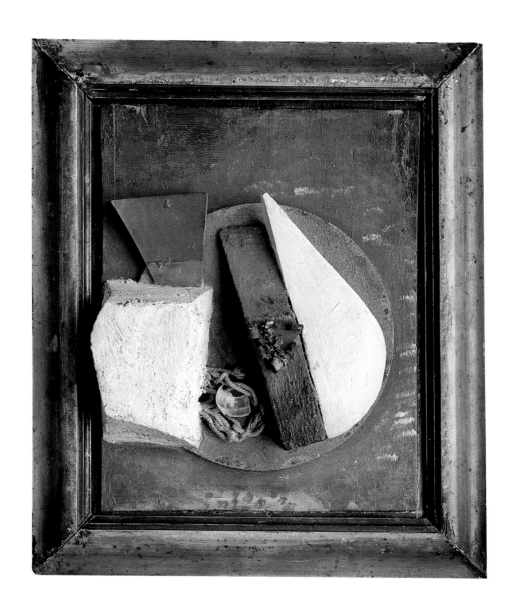

Merzbild mit
Bindfaden
1945-47
26,6 x 21,6 cm

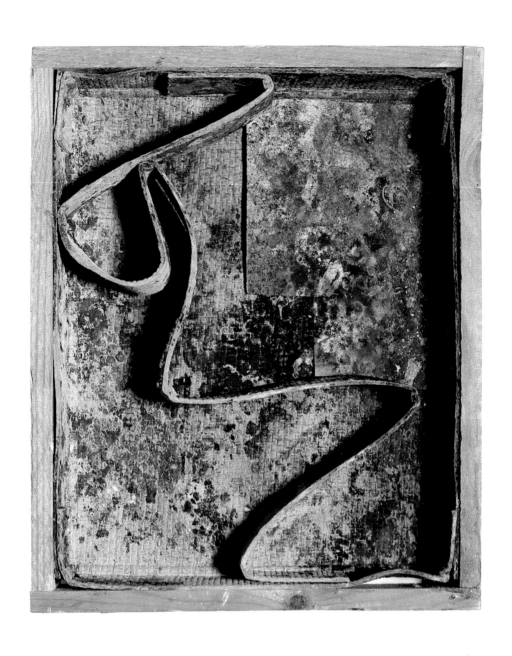

Komposition
1942-45
26,2 x 20,8 cm

181

London nach
Freiheit, kein Geld
1942
28,9 x 23,2 cm

182

Ohne Titel
1943-45
21,3 x 11,5 x 12 cm

183

Nebulös, 1942
106,7 x 61,6 cm

184

Absätze auf Grün
1943-45
33 x 26,5 cm

185

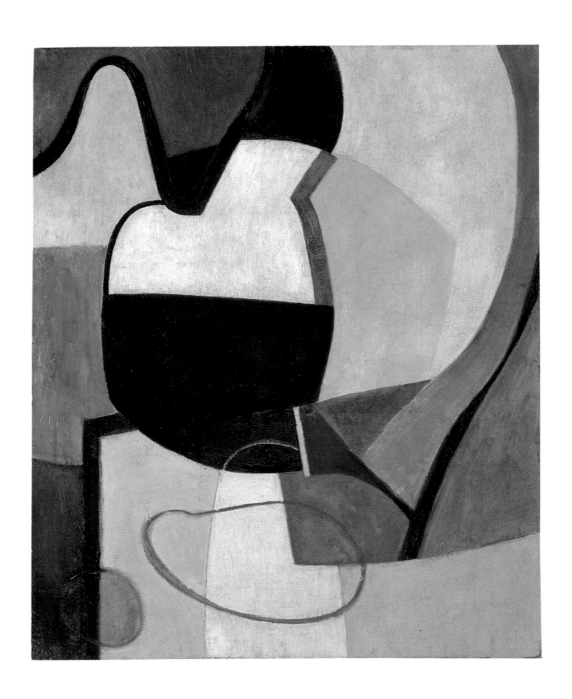

Still Life on
a Table Top
1945
76,8 x 62,2 cm

186

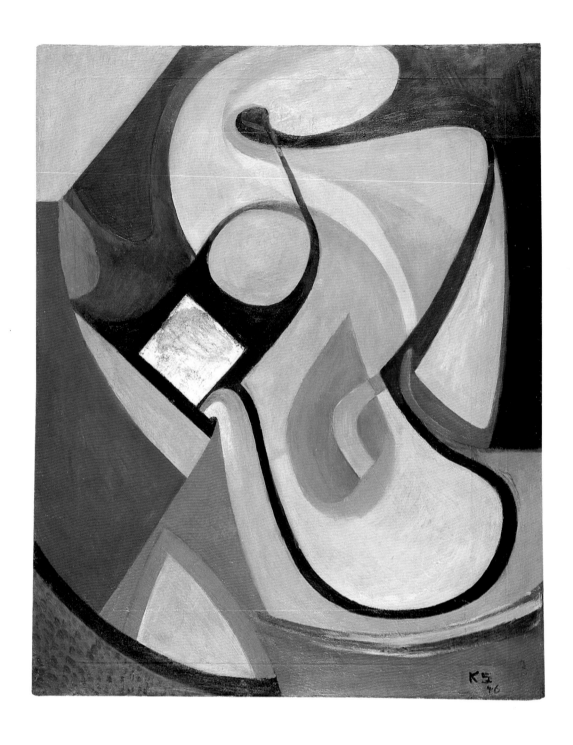

Ambleside
1946
83 x 66 cm

187

Wood on Wood
1947
27,3 x 24,8 cm

188

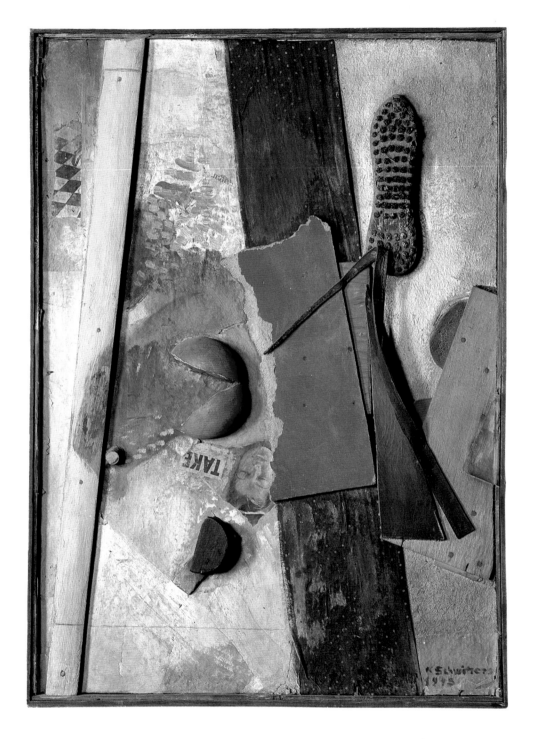

Take
1943
77 x 54 cm

189

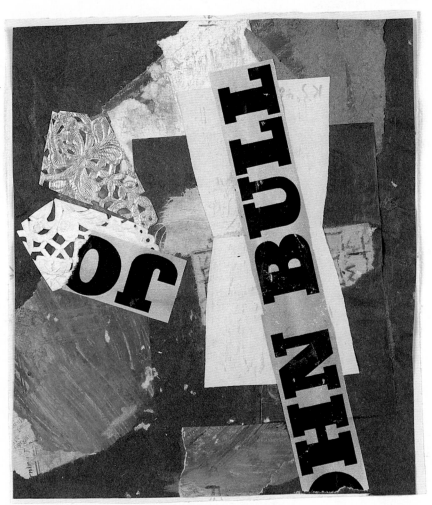

C 21 John Bull
1946-47
19,4 x 16,2 cm

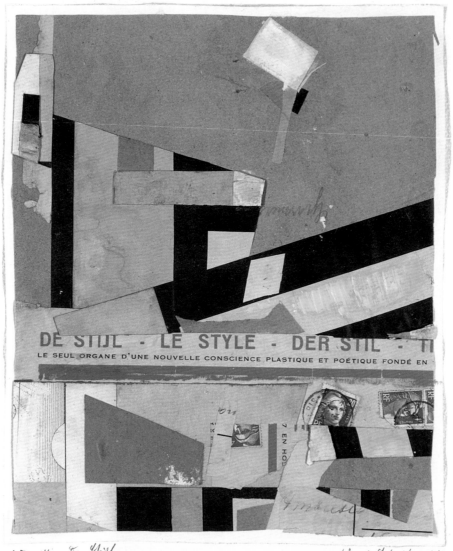

47.14 De Stijl

Chrysanthemun
1946
33 x 25,5 cm

Cottage at Cylinders
ca. 1946-47
40,6 x 54,5

193

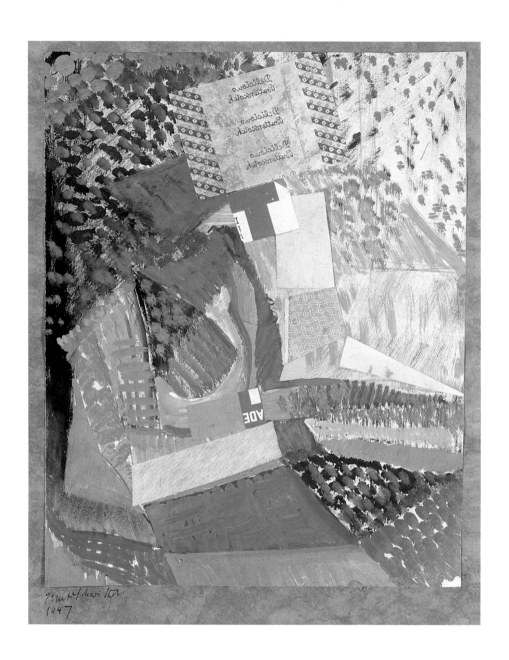

Komposition
mit rotem T
1947
30,5 x 24 cm

194

RMO ITA
1947
26 x 32,4 cm

195

Mz x 19
1947
40 x 38 cm

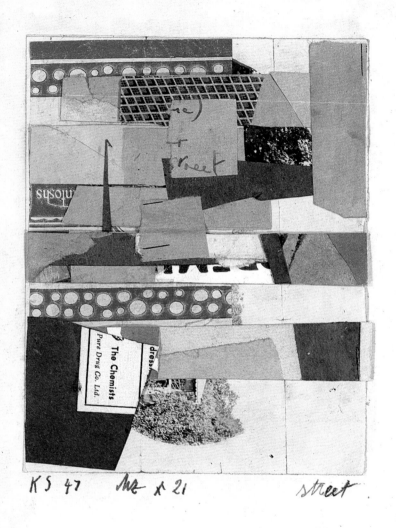

Street
1947
13,2 x 10,2 cm

Young Earnest
1946
19,5 x 16,2 cm

Skulptur aus dem
Merzbau in Elderwater
1947
H: 64 cm

199

Chicken
1947
22,5 x 17,5 cm

List of Works

P. 73
Aq. 36. Das ist das Biest,
das manchmal niest
[Aq. 36. That is the
animal that sometimes
sneezes]
1918
20,7 x 17,2 cm
Water colour
Legacy Kurt Schwitters

P. 74
z 71, Der Einsame (1)
[z 71, The lonely one (1)]
1918
16,1 x 10,6 cm
Charcoal drawing and
pencil
Gallery Gmurzynska,
Cologne

P. 75
z 41, Der Einsame (2)
[z 41, The lonely one (2)]
1918
15,6 x 10,7 cm
Charcoal drawing and
pencil
Busch-Reisinger-
Museum, Harvard
University Art Museums,
Gift of Gallery
Gmurzynska, Cologne

P. 76
Merzbild I B,
Bild mit rotem Kreuz
[Merz picture I B,
picture with red cross]
1919
64,5 x 54 cm
Assemblage on wood
Deutsche Bank AG,
Frankfurt a. M.

P. 77
Merzbild 9 B,
Das große Ich-Bild
[Merz picture,
the big I-picture]
1919
96,8 x 70 cm
Collage, oil and gouache
on cardboard
Museum Ludwig,
Cologne-Sammlung
Ludwig

P. 78
Mz. Bommbild
[Mz. bomb picture]
1919
12 x 9,8 cm
Collage
Baumeister Archives,
Stuttgart

P. 79
Windmühle
[Windmill]
1919
15 x 12 cm
Water colour
E.W.K., Bern

P. 80
Miroir-Collage
1920-22
28,5 x 11 cm
Assemblage and mirror
Musée d'Art Moderne de
la Ville de Paris

P. 81
Merzzeichnung 107
[Merz drawing 107]
1921
17,3 x 14 cm
Collage and gouache
Kunsthandel Achenbach,
Düsseldorf

P. 82
Merzzeichnung 219
[Merz drawing 219]
1921
17,3 x 14 cm
Collage and gouache
Kunsthandel Achenbach,
Düsseldorf

*
Mit Maschinenteil
[With part of machine]
1921
14 x 10,1 cm
Collage
Private collection

*
Oval
1921
ca. 30 x 25 cm
Collage
Private collection

P. 83
Ohne Titel
[Untitled]
ca. 1922
29,4 x 24 cm
Collage
Busch-Reisinger-
Museum, Harvard
University Art Museums
The Frederic Wertham
Collection, gift of his
wife Hesketh

P. 84
n à 3 (Mz 367)
1922
32,4 x 24,7 cm
Collage and charcoal
Busch-Reisinger-
Museum, Harvard
University Art Museums
The Frederic Wertham
Collection, gift of his
wife Hesketh

P. 85
Dordrecht (Mz 344)
1922
20,5 x 17,5 cm
Collage
Öffentliche Kunst-
sammlung Basel,
Kupferstichkabinett

P. 88
Relief
1923
35,5 x 30 cm
Museum Ludwig,
Cologne

*
Ohne Titel
[Untitled]
1923
16 x 23 cm (Relief)
Private collection

P. 113
Abstrakte Komposition
[Abstract composition]
1923-25
76,2 x 50,8 cm
Oil on canvas
Haags Gemeente-
museum, The Hague

P. 112
Blau
[Blue]
ca. 1923-26
53 x 42,5 cm
Assemblage and gouache
on wood
Gallery Gmurzynska,
Cologne

P. 108
Merz 24.18 Kaiser
Friedrich Quelle
1924
11,6 x 9,2 cm
Collage
Private collection
Detmold

P. 87
Hommage à Jean Arp
[Homage to Jean Arp]
1924
20 x 14,5 cm
Collage
Öffentliche Kunst-
sammlung Basel,
Kupferstichkabinett

P. 111
LZER CASSEL
1924-26
23,6 x 18,2 cm
Collage
Private collection

P. 86
Oval (Underberg)
1926
37 x 31,9 cm
Collage
Gallery Gmurzynska,
Cologne

P. 106
Merzbild mit
grünem Ring
[Merz picture with
green circle]
1926
60 x 51 cm
Painted wood
Private collection

P. 117
Konstruktives Bild
(Merz 1926, Nr. 8)
[Constructive picture,
(Merz 1926, No. 8)]
1926
80 x 65,5 cm
Oil on canvas
Staatliche Museen zu
Berlin, Nationalgalerie

P. 118
i-Zeichnung
(für Tschichold)
[i-Drawing
(for Tschichold)]
1927
15 x 11 cm
Collage
Private collection

P. 105
Ohne Titel (Schnurruhr
von Hans Arp)
[Untitled (Hans Arp's
'Schnurruhr')
1928
12,8 x 10,1 cm
Collage
Kunsthaus Zürich

P. 119
i-Zeichnung 'Pferd'
[i-Drawing 'Horse']
1928
17,8 x 13,7 cm
Carved mackle
Sprengel Museum,
Hanover

P. 116
Geklebt in Zürich für
Rudolf Jahns
[Pasted in Zurich for
Rudolf Jahns]
1929
21,3 x 16,6 cm
Collage
Private collection
Detmold

P. 115
Februar
[February]
1929
21,9 x 16,7 cm
Collage
Legacy Kurt Schwitters

P. 114
Mauxio
1930
12,6 x 9,6 cm
Collage
Stedelijk Museum
Amsterdam

P. 109
Ohne Titel
[Untitled]
ca. 1930
13,4 x 10,2 cm
Collage
Stedelijk Museum
Amsterdam

P. 107
Picture from 8 sides
1930
91 x 90 cm
Oil on cardboard
Museo Thyssen-
Bornemisza, Madrid

P. 120
Das ist der Frühling für
Hans Arp
[That is spring for Hans
Arp]
1930
61,5 x 51 cm
Gouache on cardboard
Pinacoteca Casa Rusca,
Locarno

P. 124
Helden des Alltags
[Heroes of everyday life]
1930
34,2 x 27,6 cm
Collage
IVAM Centro Julio
Gonzalez, Valencia

P. 121
Plastische Merz-
zeichnung
[Plastic Merz drawing]
1931
48 x 34,8 cm
Relief, painted
IVAM Centro Julio
Gonzalez, Valencia

*Periodicals, books, miscellan-
eous (all *, except: Merz 11;
Poster for Dada-Soirée)*

Merz 1. *Holland Dada*
Magazine, 22,2 x 14 cm
Compilation Kurt
Schwitters, Hanover 1923

Merz 2. *Nummer i*
Magazine, 22,3 x 14,3 cm
Editor Kurt Schwitters,
Hanover 1923

Merz 3. *Merz Mappe*
Portfolio with 6 litho-
graphs and title-page,
59,9 x 45,2 cm
First portfolio of Merz-
Verlag, Hanover 1923

Merz 4. *Banalitäten*
Magazine, 23 x 14,7 cm
Editing by Merz-Verlag,
Hanover 1923

Merz 5. *Arp Mappe*
7 'Arpaden' by Hans Arp,
45 x 35 cm
Second portfolio of
Merz-Verlag,
Hanover 1923

Merz 6. *Imitatoren watch
step!*
Magazine, 22 x 14,5 cm
Editing of Merz-Verlag:
Kurt Schwitters, Hanover
1923

Merz 7, Band 2, Nr. 7
Magazine, 30,5 x 22,5 cm
Editing of Merz-Verlag:
Kurt Schwitters, Hanover
1924

Merz 8/9 *Nasci*
Magazine, 30,5 x 22,5 cm
Editing of Merz-Verlag:
Kurt Schwitters,
Hanover 1924

P. 106-107
Merz 11. *Typoreklame,
Pelikannummer*
Magazine, 29 x 22 cm
Editing Merz,
Hanover 1924

Merz 14/15. *Die Scheuche.*
Fairy Tales
Sewn children's book,
20,5 x 24 cm
Aposs Verlag, Hanover
1925

Merz 16/17. *Die Märchen
vom Paradies*
Book, 27,1 x 21,1 cm
Aposs Verlag, Hanover
1925

Merz 20. *Kurt Schwitters*
Catalogue, 14,5 x 16 cm
Hanover 1932

Das Kestnerbuch
Book, 28,8 x 23,2 cm
Compilation Paul
Küppers, Heinrich
Böhme Verlag,
Hanover 1919

Kurt Schwitters,
Anna Blume, Dichtungen
Artist's book,
19 x 12,9 x 1 cm
Paul Steegemann Verlag,
Hanover, s.a.

Kurt Merz Schwitters,
August Bolte (ein Lebertran)
Artist's book,
22,8 x 15,2 x 0,4 cm
Verlag Der Sturm,
Berlin 1923

Kurt Schwitters,
Die Kathedrale
Artist's book,
22,3 x 14,2 x 0,2 cm
Paul Steegemann Verlag,
Hanover 1920

Kurt Merz Schwitters,
*Die Blume Anna: die neue
Anna Blume: Eine Gedich-
tensammlung aus den Jahren
1918-1922*
Artist's book,
22,8 x 15,3 x 0,3 cm
Verlag Der Sturm, Berlin
1922

Kurt Merz Schwitters,
*Memoiren Anna Blumes in
Bleie: eine leichtfassliche
Methode zur Erlernung des
Wahnsinns für Jedermann*
Artist's book,
18,5 x 11,4 x 0,2 cm
Walter Heinrich, Freiburg
(Baden) 1922

Kurt Schwitters,
Woll-Renkratzer
Advertisement for
Handarbeitshaus
Buchheister, 13,2 x 4,9 cm
Hanover ca. 1926
Gallery Gmurzynska,
Köln

P. 110
Theo van Doesburg and
Kurt Schwitters
Poster for Dada-Soirée,
1926
Private collection

* not illustrated in this
book

Merz II. Typoreklame
Pelikannummer,
[P. 92]
29 x 22 cm, 1924

Biography
Kurt Schwitters

1887
Born on 20 June in Hanover.

1908/1909
Studies two semesters at the Kunstgewerbeschule [applied art school] Hanover.

1909-1913
Studies painting at the Dresden Art Academy, under Carl Bantzer, Emmanuel Hegenbarth, and Gotthard Kühl, as well as the literature historian Oskar Walzer. First participation in the September exhibition of the Kunstverein Hannover, with naturalistic works.

1914
Studies at the Berlin Art Academy.

1915
Marries Helma Fischer (died 1945).

1917
Military service: from March to June he has a desk job in Hanover, subsequently he is transferred to the auxiliary services and put to work as a technical draughtsman at the Wülfel iron works near Hanover. First expressionist/futurist paintings and poems.

1918
First collages: creation of the term *Merz* (after the second syllable of a newspaper headline used in one of these collages: Com*merz*- und Privatbank). First contacts with gallery 'Der Sturm' and Herwarth Walden, as well as with Dada artists in Berlin. First exhibition in gallery 'Der Sturm'. His son Ernst is born.

1918/1919
Architecture study at the Technische Hochschule (College of Technology) in Hanover.

1919
Publication of the Merz poem 'Anna Blume'. Herwarth Walden stages an exhibition at the 'Der Sturm' gallery, featuring Merz drawings and paintings by Kurt Schwitters, as well as works by Paul Klee and Johannes Molzahn.

1920
Start of his friendship with Hans Arp and Raoul Hausmann. First exhibition at the 'Société Anonyme' in New York. Starts his first *Merzbau* (Merz building).

1921
Together with his wife Helma, Hannah Höch and Raoul Hausmann, he leaves for a lecture trip to Prague. First public lectures and appearances in Dresden, Jena en Weimar.

1922
Attends the Dada convention in Weimar.

1922-1923
Contacts with the constructivists Theo and Nelly van Doesburg, and with Vilmos Huszár. Joint lecture tour of the Netherlands ('Dada Tour').

1923
Foundation of the magazine *Merz*, 24 issues of which would appear until 1932. Starts his *Merzbau* in Hanover (destroyed in 1943). Works as a professional publicity expert and graphic designer.

1924
Exhibition at the Kestner-Gesellschaft in Hanover. Lecture in Leipzig on 4 March 1924.

1923-1925
Summer stays in Göhren and in Sellin, where he is joined by Hannah Höch, Hans Arp and Sophie Täuber-Arp. Exhibition at the Kunstsalon Richter in Dresden.

1926
Stay in the Netherlands. 'Große Merzausstellung' [Great Merz Exhibition] in Moscow, Dresden en Hanover (until 1927).

1927
Co-founder of the 'ring neuer werbegestalter' [circle of new advertising designers) and the group 'die abstrakten hannover'.

1928

Contributes 44 works to the 'Große Berliner Kunst-ausstellung'.

1929

Heads the typography of Walter Gropius' 'Dammer-stock-Siedlung', a housing project in Karlsruhe. Participates in the exhibition 'Abstrakte und Surrealistische Malerei und Plastik' at the Kunsthaus in Zurich. First trip to Norway.

1930

Participates in the exhibition 'cercle et carré' in Paris. His stays in Norway now last longer than those in Germany.

1932

Joins the group 'abstraction, création, art non-figuratif' and becomes an editor of the magazine of the same name. The first complete version of his 'Ursonate' appears as the 24th and ultimate issue of *Merz* magazine.

1936

Participates in the exhibitions 'Cubism and Abstract Art' and 'Fantastic Art – Dada – Surrealism' at the Museum of Modern Art in New York.

1937

On 1 January he moves to Norway permanently and takes up residence in Lysaker near Oslo. Four of his works are included in the 'Entartete Kunst' exhibition. Thirteen of his works are removed from German museums. Starts his second *Merzbau* (destroyed in 1951).

1938

Participates in the exhibition 'Modern German Art' at the Tate Gallery in London.

1939

Collaborates with Sophie Täuber-Arp on her magazine *Plastique*.

1940

Flees to England after the German invasion of Norway. For seventeen months, Schwitters lives in various English internment camps, before settling down in London with his son Ernst.

1945

Moves to Little Langdale near Ambleside in West-moreland, the Lake District. Is awarded a grant by the Museum of Modern Art to renovate the *Merzbau*, which is to remain uncompleted.

1947

Starts his third *Merzbau* (Merz Barn) at Cylinders Farm in Little Langdale.

1948

Dies on 8 January in Kendal near Ambleside. First solo exhibition in New York.

Kurt Schwitters draws the Polfoss, East Norway
Photo: Ernst Schwitters, 1933

Theo van Doesburg
and Kurt Schwitters,
Poster for Dada-Soirée
1926
Private collection

Bibliography
(selected)

I. Publications by Kurt Schwitters

Books

Anna Blume, Dichtungen, Paul Steegemann, Hanover 1919
Sturmbilderbücher IV, Kurt Schwitters, Der Sturm, Berlin 1921
Memoiren Anna Blumes in Bleie, eine leichtfassliche Methode des Wahnsinns für Jedermann, Walter Heinrich, Freiburg im Breisgau 1922
Tran Nr. 30, August Bolte (Ein Lebertran), Verlag der Sturm, Berlin 1923
Die neue Gestaltung in der Typographie, Kurt Schwitters, Hanover ca. 1925
Hahnepeter, Kurt Schwitters and Käthe Steinitz, 1924, (Merz 12)
Die Scheuche, Kurt Schwitters, Käthe Steinitz and Theo van Doesburg, 1925 (Merz 14/15)
Erstes Veilchenheft, 1931 (Merz 21)
Ursonate, 1932 (Merz 24)

Poems and Articles

'Die Merzmalerei', *Der Sturm*, X, no. 5, August 1919
'Die Merzbühne, Sturm-Bühne', in: *Jahrbuch des Theaters der Expressionisten*, Vol. 8., Verlag Der Sturm, Berlin October 1919
'Tran Nummer 7, Generalpardon an meine Hannoverschen Kritiker im Merzstil', *Der Sturm*, XI, no. 1, April 1920
'Kurt Schwitters an den Schweizer Dadaisten Arp', *Die Pille*, I, no. 3, 25 November 1920
'Merz', *Der Ararat. Glossen, Skizzen und Notizen zur Neuen Kunst*, II, no. 1, January 1921, Goltzverlag, Munich
'Das Weib entzückt durch seine Beine/Ich bin ein Mann, ich habe keine', *Mécano*, I, no. 3, 1922
'i (Ein Manifest)', *Der Sturm*, XIII, no. 6, May 1922

'Stil oder Gestaltung', *Documents internationaux de l'Esprit Nouveau*, no. 1, 1927
'Anregungen zur Erlangung einer Systemschrift', *i 10*, no. 8/9, August/September 1927
'Der Zinnoberschlager', text by Kurt Schwitters for the 'Zinnoberfest', composed by Walter Gieseking, *Hannoversche Kurier*, 7 January 1928
'Gestaltende Typographie', *Der Sturm*, XIX, no. 6, September 1928
'Urteile eines Laien über Neue Architektur', *i 10*, II, no. 21/22, June 1929
'Der Ring neuer Werbegestalter' and 'Die Werbegestaltung', in: *Neue Werbegrafik*, exh. cat., Gewerbemuseum, Basel 1930
'Über einheitliche Gestaltung von Drucksachen', *Papierzeitung*, no. 48, 1930
'Kleines Gedicht für große Stotterer', *Plastique*, I, no. 4, 1939

II. Publications on Kurt Schwitters

Monographs and Exhibition catalogues

Heinz Ludwig Arnold (ed.), *Text und Kritik. Kurt Schwitters*, no. 35/36, Richard Boorberg Verlag, Munich 1972
Joachim Büchner, *Kurt Schwitters 1887-1948*, Sprengel Museum, Hanover, Propyläen Verlag, Berlin 1986
Margaret E. Burkett, *Kurt Schwitters. Creator of Merz*, Abbott Hall, 1979
Elisabeth Burns Gamard, *Kurt Schwitters Merzbau: The Cathedral of Erotic Misery*, Princeton Architectural Press, New York 1998
Dorothea Dietrich, *The Collages of Kurt Schwitters. Tradition and Innovation*, Cambridge University Press, Cambridge/New York 1993

John Elderfield, *Kurt Schwitters*, Thames and Hudson, London and New York 1985
Dietmar Elger, *Der Merzbau. Eine Werkmonographie*, Walther König, Cologne, 1984, 2nd ed. 1999
Michael Erlhoff and (from 1987) Klaus Stadtmüller (ed.), *Kurt-Schwitters-Almanach*, Dietrich zu Klampen Verlag GbR, Hanover, 1982-1991
Siegfried Gohr (ed.), *Kurt Schwitters. Die späten Jahre*, Museum Ludwig, Cologne 1985
Rudi Fuchs, *Conflicts with Modernism or the Absence of Kurt Schwitters/Konflikte mit dem Modernismus oder die Abwesenheit von Kurt Schwitters*, from the series: Theme and Objection/Thema und Widerspruch, Vol. 1, Gachnang und Springer, Bern/Berlin 1991
Hans J. Hereth, *Die Rezeptions- und Wirkungsgeschichte von Kurt Schwitters, dargestellt anhand seines Gedichts 'An Anna Blume'*, Peter Lang, Frankfurt am Main 1996
Per Kirkeby, *Schwitters. Norwegian Landscapes, the Zoological Garden Lottery and more stories*, Bløndal, Hellerup 1995
Ulrich Krempel (ed.), Karin Orchard and Isabel Schulz (adapt.), *Kurt Schwitters. Werke und Dokumente. Verzeichnis der Bestände im Sprengel Museum Hannover*, Sprengel Museum, Hanover 1998
Anke van der Laar and Meta Knol (ed.), *Kurt Schwitters in Nederland. Merz, De Stijl & Holland Dada*, Heerlen 1997
Friedhelm Lach, *Der Merz Künstler Kurt Schwitters*, DuMont Schauberg, Cologne 1971
Friedhelm Lach (ed.), *Kurt Schwitters. Das Literarische Werk*, Vols. 1-5, DuMont Schauberg, Cologne 1973-1981
Serge Lemoine (ed.), *Kurt Schwitters*, Centre Georges Pompidou, Paris 1994
Beatrix Nobis, *Kurt Schwitters und die romantische Ironie. Ein Beitrag zur Deutung des* MERZ-*Kunstbegriffes*, Verlag und Datenbank für Geisteswissenschaften, Alfter 1993
Ernst Nündel (ed.), *Kurt Schwitters. Wir spielen, bis uns der Tod abholt. Briefe aus fünf Jahrzehnten*, gesammelt, ausgewählt und kommentiert v. E. Nündel, Ullstein, Frankfurt am Main 1974
Ernst Nündel, *Kurt Schwitters*, Rowohlt, Reinbek bei Hamburg 1981
Volker Rattemeyer and Dietrich Helms (ed.) in collab. with Konrad Matschke, *Kurt Schwitters. 'Typographie kann unter Umständen Kunst sein'*, Landesmuseum Wiesbaden 1990, Sprengel Museum Hanover and Museum für Gestaltung Zurich, 1991
Jasia Reichardt (ed.), *Raoul Hausmann und Kurt Schwitters*, PIN, Gaberbocchus Press, London 1962
Krystyna Rubinger (ed.), *Kurt Schwitters*, Galerie Gmurzynska, Cologne 1980
Karl Ruhrberg (ed.), *Kurt Schwitters*, Städtische Kunsthalle Düsseldorf 1971

Gerhard Schaub (ed.), *Kurt Schwitters. 'Bürger und Idiot'. Beiträge zu Werk und Wirkung eines Gesamtkünstlers, mit unveröffentlichten Briefen an Walter Gropius*, Fannei und Walz, Berlin 1993
Gerhard Schaub, *Kurt Schwitters und die andere Schweiz. Unveröffentlichte Briefe aus dem Exil*, Fannei & Walz, Berlin 1998
Kurt Schaub (ed.), *Schwitters Anekdoten, mit Beiträgen v. Raoul Hausmann, Kurt Schwitters, Kate Steinitz*, Anabas, Giessen 1999
Werner Schmalenbach, *Kurt Schwitters*, DuMont Schauberg, Cologne 1967
Joachim Schreck (ed.), *Kurt Schwitters, Anna Blume und andere Literatur und Grafik*, DuMont Buchverlag, Cologne 1986, 2nd ed. 1998
Klaus Stadtmüller (ed.), *Schwitters in Norwegen, Arbeiten, Dokumente, Ansichten*, Postskriptum Verlag, Hanover 1997
Kate Traumann Steinitz, *Erinnerungen aus den Jahren 1918-1930*, Verlag der Arche, Zurich 1963
Kate Traumann Steinitz, *Kurt Schwitters. A Portrait from Life*, University of California Press, Berkeley/Los Angeles 1968
Stefan Themerson, *Kurt Schwitters in England, 1940-1948. Mit einem Anhang: Dichtungen von Schwitters in englischer Sprache*, Gaberbocchus Press, London 1958
Vicente Todoli (ed.), *Kurt Schwitters*, Centro Julio Gonzalez, IVAM, Valencia 1995
Gwendolen Webster, *Kurt Merz Schwitters. A Biographical Study*, University of Wales Press, Cardiff 1997
Christina Weiss and Karl Riha, *Kurt Schwitters. Eile ist des Witzes Weile*, Verlag Philipp Reclam, Stuttgart 1987

III. Additional Literature

Hans Bolliger, *Résumé chronologique de la vie et de l'œuvre de Kurt Schwitters*, Galerie Berggruen, Paris
Das Gästebuch von Kate T. Steinitz, Galerie Gmurzynska, Cologne 1977
Carola Giedion-Welcker, *Poètes à l'Ecart. Anthologie der Abseitigen*, Benteli AG, Bern-Bümpliz 1946
Richard Huelsenbeck, *Mit Witz, Licht und Grütze. Auf den Spuren des Dadaismus*, Wiesbaden 1957
Horst Liede, *Dichtung als Spiel. Studien zur Unsinnpoesie an den Grenzen der Sprache*, 2 Vols., Walter de Gruyter, Berlin 1963
Robert Motherwell (ed.), *Dada Painters and Poets. An Anthology*, (The Documents of Modern Art 8), Wittenborn & Schultz, New York 1951

Hans Richter, *Dada-Kunst und Antikunst. Der Beitrag Dadas zur Kunst des 20. Jahrhunderts*, epilogue by Werner Haftmann, Dumont Schauberg, Cologne 1964
Henning Rischbieter (ed.), *Die zwanziger Jahre in Hannover. Bildende Kunst – Literatur – Theater – Tanz – Architektur, 1916-1933*, Kunstverein Hannover, 1962
Lambert Wiesing, *Stil statt Wahrheit. Kurt Schwitters und Ludwig Wittgenstein über ästhetische Lebensformen*, Wilhelm Fink Verlag, Munich 1991
Hans Wingler, *Wie sie einander sahen; moderne Maler im Urteil ihrer Gefährten*, Albert Langen-Georg Müller, Munich 1957

Part of a Schwitters' letter to Käthe Steinitz, 8 August 1946

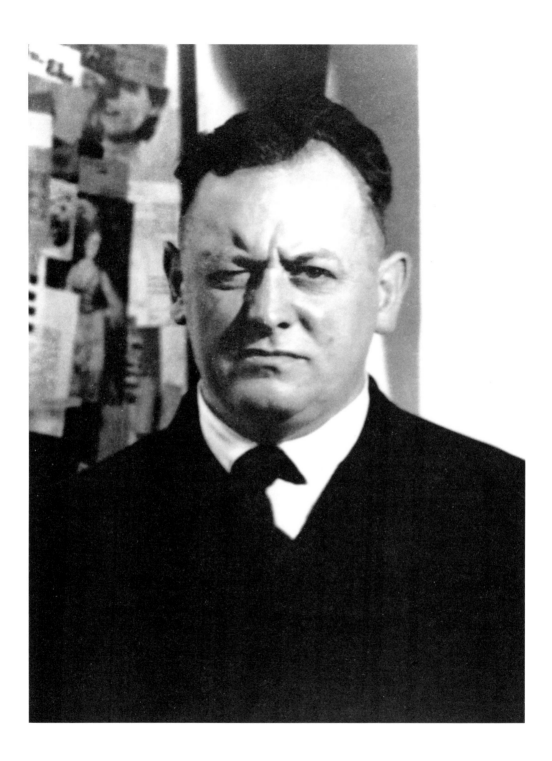

Kurt Schwitters, ca. 1930

This publication *Kurt Schwitters, I is Style* appears on the occasion of the retrospective exhibition at the Museum der bildenden Künste Leipzig,
3 February – 26 March 2000,
and at the Stedelijk Museum Amsterdam,
16 April – 16 July 2000.
The book is compiled by Siegfried Gohr and Gunda Luyken, commissioned by Rudi Fuchs, Director of the Stedelijk Museum Amsterdam.

Exhibition Stedelijk Museum Amsterdam
Concept: Siegfried Gohr, Gunda Luyken, Cologne; Rudi Fuchs, Stedelijk Museum Amsterdam
Organization: Jurrie Poot, Stedelijk Museum Amsterdam

Publication
Concept: Siegfried Gohr, Gunda Luyken, Cologne
Bibliography: Gunda Luyken, Cologne
Biography: Dietulf Sander, Museum der bildenden Künste Leipzig
Translations: Bookmakers, Nijmegen; Pierre Zeevaarder, Haskenhorne; Maria Danielson (for Holländer Translations, Rotterdam)
Copy Editing: Els Brinkman, Amsterdam; Astrid Vorstermans, NAi Publishers, Rotterdam
Design: Walter Nikkels, Dordrecht/Cologne
Production: Astrid Vorstermans, NAi Publishers, Rotterdam
Publisher: Stedelijk Museum Amsterdam Simon Franke, NAi Publishers, Rotterdam,
Lithography and Printing: Heinrich Winterscheidt GmbH, Düsseldorf

Available in North, South and Central America through
D.A.P./Distributed Art Publishers Inc, 155 Sixth Avenue
2nd Floor, New York, NY 10013-1507, Tel. 212 627.1999
Fax 212 627.9484

Available in the United Kingdom and Southern
Ireland through Art Data, 12 Bell Industrial Estate,
50 Cunnington Street, London W4 5HB,
Tel. 181-747 1061 Fax 181-742 2319

This publication is also available in a German and
Dutch edition:
German edition: 90-5662-159-9,
Stedelijk Museum cat. no. 842
Dutch edition: 90-5662-157-2,
Stedelijk Museum cat. no. 840

English edition:
ISBN 90-5662-158-0,
Stedelijk Museum cat. no. 841

Printed and bound in Germany

This publication was partly made possible through Audi
and Sappi Fine Paper Europe

sappi
The word for fine paper